USVI
America's Virgin Islands

Arlene R. Martel

CARIBBEAN

First published 1998 by
MACMILLAN EDUCATION LTD
London and Basingstoke
Companies and representatives throughout the world

ISBN 0–333–65240–1

10	9	8	7	6	5	4	3	2	1
07	06	05	04	03	02	01	00	99	98

This book is printed on paper suitable for recycling and
made from fully managed sustained forest sources.

Printed in Hong Kong

A catalogue record for this book is available from the
British Library

Front cover photograph by Chris Huxley

Contents

Air travel arrangements; Communications; Cruise ships; Currency; Customs; Driving; Electricity; Holidays; Passport requirements; Postal and courier services; Taxes; Taxis; Telecommunications; Time zone; Tourism information; Water

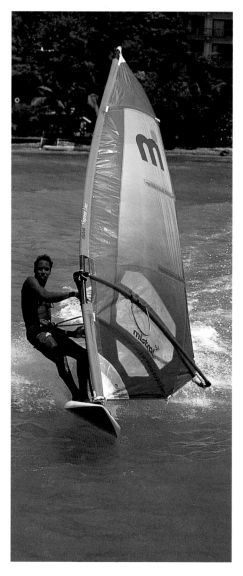

CHRIS HUXLEY

Foreword

Too often the unprepared visitor to the United States Virgin Islands arrives seeking only the pleasures of 'sun, sand and sea' promoted in travel brochures, missing entirely the magic of our vibrant culture, the lessons learned from a history that has altered the destiny of many nations, and the ecological treasures that are our greatest resource.

Offered as an insider's guide to better sightseeing, this book will provide you with a framework for understanding and enjoying the islands I have proudly called home for over a decade. A singular inspiration in authoring this guide is the observation of P. F. Kluge, as noted in *The Edge of Paradise* (University of Hawaii):

> 'What I am starting to believe is that an island doesn't belong only to the people who are born on it or who claim the right to own or sell it. An island belongs to the people who think and care about it, though they cast no votes and own no land. That is the sovereignty of the heart. Everything else is money and noise.'

For instilling in me the wisdom to appreciate Kluge's words, I would like to thank my loving parents, who have unfailingly supported the search for my personal vision of paradise. I hope you find yours.

Arlene R. Martel

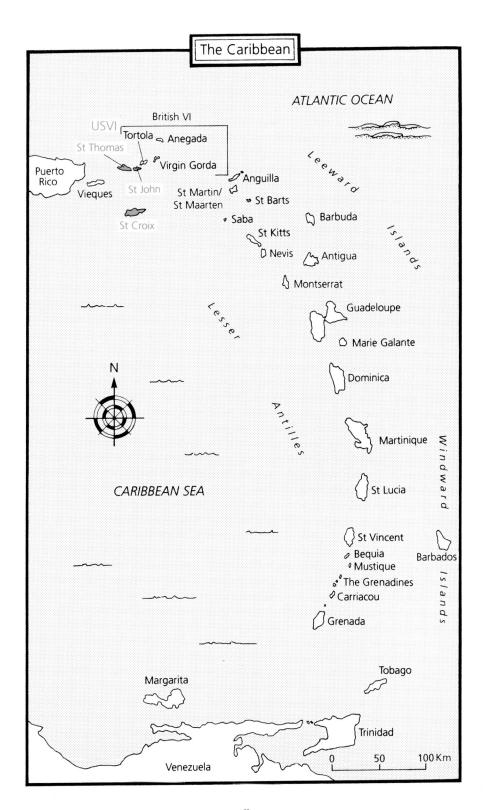

The Caribbean

ATLANTIC OCEAN

USVI
British VI
Tortola
Anegada
St Thomas
Puerto Rico
Virgin Gorda
Vieques
St John
Anguilla
St Martin/
St Maarten
St Barts
St Croix
Saba
Barbuda
St Kitts
Nevis
Antigua
Montserrat
Guadeloupe
Marie Galante
N
Dominica
Martinique
CARIBBEAN SEA
St Lucia
St Vincent
Bequia
Mustique
Barbados
The Grenadines
Carriacou
Grenada
Tobago
Margarita
Trinidad
Venezuela
0 50 100 Km

Leeward Islands

Lesser Antilles

Windward Islands

Welcome to the West Indies

Each year more than a million travelers with vacation visions of palm trees and pearly beaches board cruise ships and planes bound for the United States Virgin Islands, but few realize they are actually headed for the fabled West Indies and the very crossroad of the Caribbean itself. If you find yourself among the geographically confused, take heart in the tale of the Virgin's most famous visitor, Christopher Columbus, who put these islands on the map yet insisted until his dying day that they were the gateway to Marco Polo's mysterious Cipango (Japan), somewhere off the coast of Cathay (China).

Though rooted in misinformation, the names chosen by the New World discoverer to describe this region and its people have persisted. When Columbus set sail from Spain on his first voyage of discovery in 1492, he steered his caravels in search of the East Indies (Asia). Upon making landfall in the New World, he promptly labelled the natives 'Indians' and the region they called home, the 'West Indies'. From the 'Carib' tribe, he adapted 'Caribbean' to describe the vast sea he explored. From the 15th century Portuguese word (for the legendary lands lying between Europe and Asia west of the lost kingdom of Atlantis) he borrowed 'Antilia' to label the Antillean chain of islands that arc northward from the South American continent to carve the Caribbean Sea from the waters of the Atlantic Ocean.

Strategically situated at the geographic center of this Y-shaped necklace of islands, the US Virgin Islands straddle the threshold of the Antillean chain at approximately 18 degrees latitude north of the equator and 65 degrees longitude west of Greenwich. Comprising a total landmass of little more than 150 square miles (including the 50 or so smaller cays associated with them), the mountainous Virgins are separated by a deep ocean trench that technically groups St Thomas, Water Island and St John with the Greater Antilles, and St Croix to their south with the Lesser Antilles. From this unique vantage point in the heart of the Caribbean – in the pathway between the Old World and the New – the Virgins witnessed a succession of seaborne migrations by ancient peoples and the history-shaping clash of cultures from the shores of Europe and the Americas that would influence the destiny of many nations and leave a lasting imprint on its own.

Mere specks of land that rose from the ocean floor more than 150 million years ago, these ancient islands once claimed for the Spanish Crown have harbored pirates who sparked international conflicts, sheltered Jews who changed the destiny of the early American colonies, and fostered Danish settlers who fired the first foreign salute to the nation we now call America. The Virgins fed the bittersweet triangle trade of sugar, rum and slaves that bestowed unimaginable wealth on some, at the price of untold human suffering by many. During the American Civil War, they provided refuge for Confederate ships and later, for heroes of the Mexican Revolution. Their purchase by the United States secured access to the Panama Canal just prior to the outbreak of World War I.

Five centuries after Columbus, travelers to the Virgins are still transforming their dreams into journeys and rediscovering islands that have been swept by the winds of change but jealously cling to their legendary beauty. Airline passengers passing through New York can now arrive in comfort in fewer than four hours; cruise ship passengers departing from Miami make the trip in under two days. Sailors, driven by the whim of wind and current, still travel the great seagoing highways, making landfall on a more uncertain schedule. Regardless of where they begin, those who journey in search of paradise often find it at the place where the past, present and future all converge – at the crossroad of the Caribbean – the US Virgin Islands.

**A native-born Virgin Islander
takes to the sea** DEAN L. BARNES

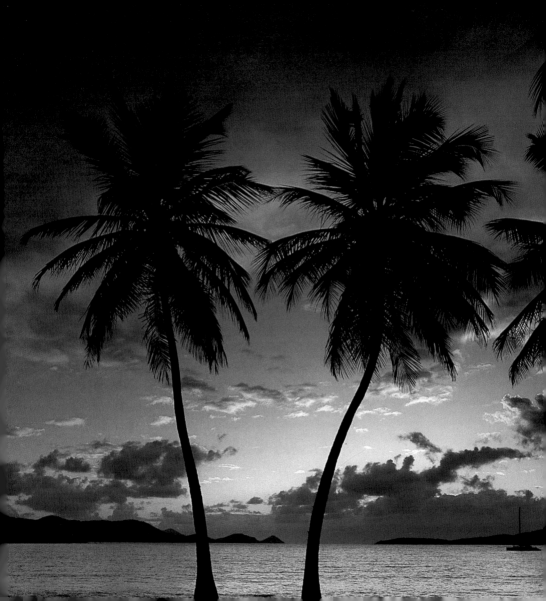

PART 1

In search of paradise

1
Life in the left lane

'Left is right and right is wrong' is as much an instruction on how to drive in the Virgins as a twisted clue to what makes visiting paradise a paradox; an experience that is sometimes frustrating, often amusing, but never dull.

What's in a name?

The fanciful estate names designated by plantation owners are a carry-over from the Danish land surveys. Still used as legal descriptions, they reflect the hopes, fears, fortunes and relationships of those who lived off the land. Some favorites include William's Delight, Judith's Fancy, Good Hope, All for the Better, Wheel of Fortune, Bonne Resolution, John's Folly, Fortuna, Anna's Retreat, Hard Labor, Humbug, Little Profit, Two Brothers, and Two Friends.

Armed with a sense of humor and a healthy dose of patience, you'll make the transition from 'tourist' to 'traveler' if you fall in step with island life and accept the reality that 'We're not in Kansas anymore, Toto.' Furthermore, if this sneak-peak of 'life in the left lane' tickles your funnybone, you may be a candidate for permanent residence, with the added status of 'local'. A 'native' Virgin Islander is a title respectfully reserved for one who is 'bahn here'.

How to spot a local

Locals are the ones that simply carry on when the lights go out and they seldom run for cover when it rains at the beach. Why bother? A surefire sign of long-term residency (and car trouble) is a finger point-ing down when hitchhiking; the conventional upturned thumb will leave you standing on the roadside and mark you as a 'tourist'.

Locals beep car horns to warn of their approach on curves and of their rising temper when other drivers stop without notice to chat. Some say Virgin Islands' drivers are unpredictable, but that's not so. They consistently pass on dangerous curves and they're always in a

◀ JAMES 'HUCK' JORDAN

hurry, unless they happen to be in front of you or pause to chat on their cellular phones. It's advisable for pedestrains to look both ways until they become accustomed to traffic approaching from the 'wrong' side.

Conditioned to laid-back lifestyles and that curious phenomenon called 'island time' that exists in lower latitudes, locals often wear watches to determine how late they'll arrive – within the hour is considered prompt.

How to dress like a local

To camouflage your tourist identity you might want to load up on comfortable clothes that look as if they just barely survived a trip to the laundromat. Neat is nice, but designer outfits with too many matching accessories are a dead giveaway. Unless you're a nurse, spotless white sport shoes and synthetic fabrics scream 'tourist'. If your shoes won't survive a downpour or a trek up the 99 Steps, trade them in for ones that will.

When in town and public places, don't dress for the beach and avoid coifed hair-do's doused with hairspray that block the breeze and attract 'no-see-um' insects. A tee-shirt and shorts wardrobe is a fashion essential in most casual circles, though you may want to up the ante to a collared shirt or skirt for nightclubs and classy restaurants.

Island etiquette

In a community where hurried strangers are plentiful, simple courtesies slow the pace while eye contact acknowledges the person. Anything less may be considered rude. 'Good Morning' should preface any conversation begun before noon. Practice on strangers you pass in the street and announce it to everyone when you enter a room. You'll soon discover why 'Hello' and 'Hi' are pale substitutes. From noon until nightfall, a friendly 'Good Afternoon' will introduce you to polite society and single you out from a crowd demanding attention. When the sun sinks, 'Good Night' is more of a greeting than a farewell and is guaranteed to solicit an echo.

Courtesy is a universal language. As a show of manners when approaching a home, a visitor would call out the word 'inside' while standing outside. If the person inside wants company he'll respond with the words 'outside, inside' indicating it's OK to enter. This curious custom is linked to the need for privacy in tropical houses whose windows and doors are seldom shuttered. An invitation to 'fire one' is an offer to share an alcohol-laced beverage. Anything else may be

illegal. Islanders celebrating birthdays frequently do the buying, encouraging a custom that guarantees a crowd.

Speaking of bars, locals tend to tip beyond the customary percentage for cocktails. Immediate attention from a bartender packs more social wallop than a two-martini power lunch. Visitors should remember that gratuities are seldom built into the check total and that many service industry employees depend upon them for their livelihood. When in doubt, ask. As one menu inscription playfully reminds us, 'Tipping is not a city in China'.

The mating game

Since there are no poisonous snakes on these islands, you can assume that any hissing sound you hear is a mating call from some interested admirer (or that your rental car has a leaky radiator). The persistence of the 'psssst' is an indication of your ranking in the eye of the beholder. On the other hand, if someone 'sucks their teeth' at you, it usually implies impatience. In the boy-meets-girl arena, an invitation to stroll the sands at midnight may sound romantic, but it means you've been marked as a tourist and may be unsafe. Locals go to the beach during the daytime (usually while the laundry is on the spin cycle).

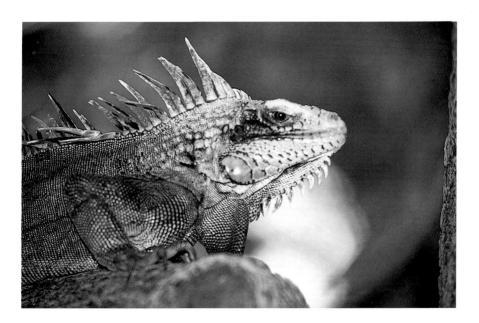

Growing to an imposing size, mating iguana sometimes engage in passionate, but wobbly, treetop courtships that end in disaster for motorists who park underneath. Consider yourself forewarned! DEAN L. BARNES

Questions not to ask

Waiters and bartenders are good sources of information about island life and attractions. The wittiest among them offer clever retorts to the most typical tourist questions:

Q: Do you live here?
A: No. I commute daily from Miami.

Q: Do these islands go all the way down?
A: No. We anchor them to moorings and float them around when we get tired of the arrangement.

Q: Is there a law that all the anchored boats have to face in the same direction?
A: Yes. It's called the law of physics.

Q: Where are all the pink houses?
A: In Bermuda, where they belong.

Learning the lingo

The predominant language throughout the Virgin Islands is English, with a smattering of Spanish and 'calypso' dialects. Some phrases, like 'mash n' go' (automatic transmission) or 'to walk with' (take-out food) are so literal that they defy immediate translation. 'Soon come' is self-explanatory when describing when something will happen or arrive, ('reach'), such as a ferry. The only frustration is that it refers to no particular period of time other than the future. Keep an ear out for charming anachronisms like 'small clothes' (an 18th century expression for underwear).

Try to avoid the temptation to red ink creative spelling on signs and pluralization of words like 'shrimps' and 'beefs' on menus – the longer you remain here, the more correct they seem. If you must pluralize a noun, do it the island way, by adding the suffix 'dem', as in 'sneaker dem' and 'mongoose dem'.

Barking up the wrong gade

Asking directions on a mountainous island can be quite an adventure for travelers accustomed to linear thinking and numbered freeway exit ramps. Islanders tend to use whatever landmarks are handy and think in terms of up and down, not left or right. Invitations to hillside homes frequently include elaborate handdrawn maps with glyphs that would make an archaeologist swoon. A typical set of directions could include: 'Turn up by the tamarind tree; go down, down, down, till you pass the

tethered cow; then up, up, up by Elwood'. To decipher these direct-ions, it helps if: a) you know what a tamarind tree looks like; b) the cow has not moved; c) you pay close attention to the ups and downs and d) you know who Elwood is and where he lives.

Town travel is easier. Caribbean town limits are usually well-defined by a simple arrangement of streets that start at the waterfront and move back toward main street and back street. Again, forget about left or right; townspeople move 'upstreet' or 'downstreet'. Everything outside of 'town' is simply called 'country' and is supplemented by compass direc-tions such as 'I'm heading to the country (East End) or the Northside'.

Although the Danish system of street numbering may defy logic, the names of streets are visible high on the corner of buildings at intersec-tions. When giving directions, locals may use proper Danish names or anglicized names that are all quite logical when you think about them. If you remember that the Danish suffix *gade* means 'street' in English, the following Danish-English primer may ensure that you don't go barking up the wrong one:

Bjergegade/Biergegade (Hill)
Bredgade (Broad)
Compagnietsgade (Company)
Crystalgade (Crystal)
Dronningensgade (Queen)
Dronningensvaergade (Queen Cross)
Fortstrade (Fort)
Gronnegade (Green)
Guttetsgade (Gutter)
Hospitalsgade (Hospital)
Hummergade (Lobster)
Kirkegade (Church)
Kongensgade (King)
Kongenstvaergade (King Cross)

Kronprindsensgade (Crown Prince)
Lille Taarne Gade (Little Tower)
Norregade (North)
Nyegade (New)
Østergade (East)
Prindsensgade (Prince)
Prindsessegade (Princess)
Raadetsgade (Council)
Regieringsgade (Government)
Snegelgad (Snail)
Strandgade (Shore)
Toldbodgade (Customhouse)
Torvegade (Market) and
Vestergade (West)

Weather today is mostly OK

With few exceptions, sunshine is the order of the day with 'partly sunny, partly cloudy, thirty percent chance of showers' a permanent forecast. This casual attitude toward weather is often reflected in local reporting. The *Virgin Islands Daily News* once provided yesterday's weather (in case you missed it), and one radio station announcer paused long enough to report that 'the weather today is mostly OK' before reading the sports scores. Due to our proximity to the equator, twilight lasts just long enough to order a cocktail. Sunset and moonrise are spectacular, but easily missed if you've already ordered too many.

In scarce supply, water is precious and rainfall eagerly anticipated to fill cisterns. Viewed as a blessing, not a hindrance, rain is playfully referred to as 'liquid sunshine' or 'sky juice'. Visitors frequently ask if the seemingly endless summer ever gets monotonous. Not really. Though less distinct than in higher latitudes, the change of seasons does exist and the tropical four seasons – early summer, summer, late summer and next summer – are eagerly awaited.

A sure indication of seasonal change is a shift in the direction and intensity of the gentle south-easterly trade wind. As the name implies, 'Christmas Winds' gusting to 25 knots herald the month of December. A total absence of breeze sends islanders scurrying to prepare for a storm, particularly during hurricane season. The West Indian hurricane rhyme, 'July, stand by; August, you must; September, remember; October, all over' indicates the watchful months when locals squirrel away stashes of batteries, lamp oil and anxiety-reducing junk food. So great was the impact of Hurricane Hugo (September 1989) and Hurricane Marilyn (September 1995) that resident status is often determined along pre- and post-hurricane timelines. Survivors wear humorous tee-shirt reminders of the 'Big Blow' as badges of honor. Anything under a Force Ten on the Beaufort scale is considered just 'a bunch of winds'.

Believe it or don't

Now that you've graduated to neophyte local status, it's safe to reveal some of the most savored tall tales to tell tourists. Loosely anchored in fact, these local-lore tidbits are an island variation of Ripley's well-known newspaper trivia column. A favorite is the story of a leper colony confined to Water Island that buried their dearly departed in lead-lined coffins unearthed during World War II to make bullets. Some local historians swear the story is true that Water Island's bunkers were to have been the secret wartime escape for Winston Churchill if England had fallen.

Another delightful tale involves the perfume tycoon, Prince Machibelli, whose personal clover leaf flag flies, when he is in residence at his villa above Current Cut in St Thomas, as an invitation to come for cocktails. For the record, 'mahogany birds' don't fly (they crawl along the kitchen counter) and there is no bridge connecting St Thomas and St Croix (so don't bother to buy toll-booth tokens).

2
Portrait of a people

Bonded by similarities and distinguished by differences, the people of the US Virgins mirror the varied continents from which they hail. Separately, each has a tale to tell, a culture to cling to and a dream all his own; together they form a human tapestry as captivating as the natural beauty that surrounds them. To call these islands a melting pot would be a disservice to those who have struggled to maintain their ethnic identity; rather it is a feast of many pots that bubble with the flavor of distinctive cultures. Enjoy them all!

Amerindians

From evidence scattered throughout South America and the Caribbean, archaeologists have reconstructed the migration of Stone Age voyagers, collectively called *Amerindians*, who grouped themselves into the independent chiefdoms of the *Ciboney*, *Arawak* and *Caribs*. The Ciboney are thought to have inhabited these shores as early as 300 BC, but little is known about these hunters, fishers and gatherers, except that they were most likely eliminated by the Arawaks (or *Taino*) who populated the islands around 100 AD. The Arawaks, in turn, were trailed by the Caribs, who dominated for more than a hundred years before the arrival of Europeans.

Throughout the Virgins, Amerindians have left mysterious marks of their passing: stone griddles for baking bread; curious volcano-shaped *zemis* (small carvings made of stone, bone, wood or shell) depicting the faces of their gods; evidence of ball courts not unlike those of the Maya and Aztec; and the still undeciphered petroglyphs (rock-carvings) of St John (see page 137). In 1990, construction workers on St Thomas unearthed an archaeological treasure – a thousand-year-old Indian village whose cultural remains indicate a link with tribes from present-day Venezuela. With its initial occupation dating back to 340 AD, the site known as 'Tutu Village' has yielded fascinating artifacts and valuable insight into pre-columbian history.

Like a voice from beyond the grave, the legacy of Amerindians lives on in our language – from the Carib (*Caniba*) people comes the root of the word *cannibal* and the name by which we describe our great sea

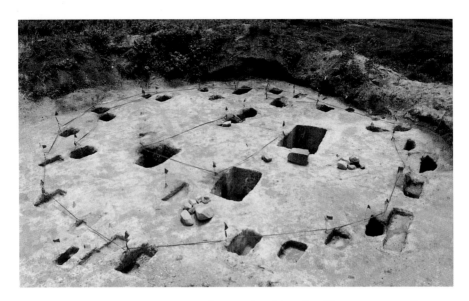

Archaeologists uncover signs of pre-Columbian dwellings at Tutu Village
ARLENE R. MARTEL

and the region that borders it. *Hammocks* are still slept in, *canoes* are still paddled, *hurricanes* remain synonymous with destruction and no *barbecue* is complete without roasted meat. The Caribs, also known as 'People of the Manioc Clan', are credited with introducing the starchy tuber called *manioc* or *yucca*, and the *cassava* bread made from it, that can still be found in local bakeries.

Europeans

The first reported clash between Europeans and New World natives took place on November 13, 1493 at the mouth of Salt River on an island the natives called *Ay Ay*. Fired upon by Caribs while taking on water at *Cabo de Flechas* (Cape of the Arrows), Cristóbal Colón's caravels quickly hoisted anchor, pausing only to rename the island *Santa Cruz* (Holy Cross) and to claim it for Spain. Ironically, history would change Colón's name, too – to Christopher Columbus. Subsequent European contact would end in tragedy for indigenous Amerindians. By the time of the first Danish settlement on St Thomas, only a handful of Caribs remained. Today, sparse Carib settlements survive on reservations in Dominica, but few, if any, Arawaks are alive in the Caribbean.

Sailing 40 miles to the north of Santa Cruz, Columbus sighted the archchipelago that now constitutes the British and US Virgins. Continuing his propensity for naming, he dubbed this seemingly

endless parade of islands *Las Once Mil Virgenes* (11,000 virgins) in honor of the legendary Ursula, martyred by the Huns for refusing to marry a pagan prince. While the islands made a lasting impression on the navigator, for the next hundred years the Virgins were barely noticed by those who sailed past in search of adventure. The next wave of conquerors would change all that.

In 1585 the English circumnavigator, slaver and privateer, Sir Francis Drake, sailed his fleet through the channel that now bears his name. Although the legendary *El Draque* may well have scraped his boat's bottom on the beach at Magens Bay, it is doubtful that his own ever graced the tourist spot known as Drake's Seat (see page 124). By the 1630s, English, Dutch and French settlements occupied Santa Cruz, which over the next half century would acquire many masters and the

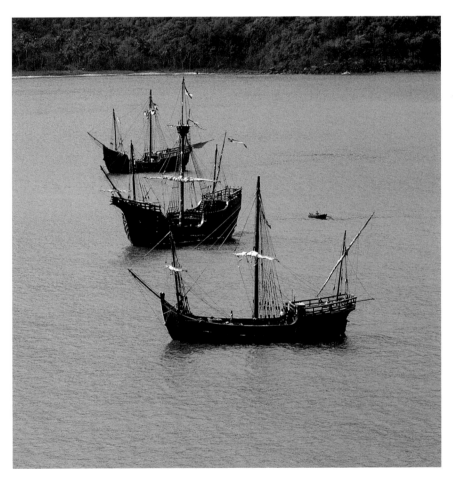

Replicas of Columbus' ship at rest in the New World
VIRGIN ISLANDS FILM PROMOTION OFFICE

Gallic name, *Sainte-Croix* (St Croix). Discouraged by a succession of disasters, France transferred St Croix in 1653 to the Knights of Malta, who discovered that they were better suited to leading Holy Crusades than colonizing, and returned it to France. Admitting failure, the French abandoned St Croix to an infestation of renegade Europeans called *boucaniers* (French for 'smokers of meat') who hunted cattle, smuggled rum and preyed on Spanish commerce in the Mona Passage.

On St Thomas, the Danes were more successful and far more permanent. Expanding from its first harborfront colonization in 1666, on what was then called *Tap Hus* (Beer House), Denmark established a permanent settlement in 1672 under the authority of the Danish West Indian Company[1] and the protective shadow of Fort Christian. Ironically, the importation of African slaves that allowed European planters to prosper likely contributed to the demise of Amerindians as the dominant population of the Caribbean, a decline which began with the introduction of European diseases and the Spanish lust for gold. From its stronghold in *Charlotte Amalie*, Denmark expanded its holdings to include St John, and soon welcomed flagships of all nations when St Thomas was granted free port status. Ripe with potential, St Croix was added to Danish West India and Guinea Company holdings in 1733 and its hillsides soon blossomed with plantations.

Though the *Dannenbrog* now flew over a tri-island colony, it is interesting to note that non-Danish residents continued to control the economy and influence the culture. Dutch, English and French dominated the plantocracy, with a smattering of Irish, Germans, Flemish and Swedes. Danes were a decided minority, though their authority demanded a Danish-speaking lawyer in every courtroom. In the fields, the black population continued to outnumber them all, by a three-to-one ratio.

It's not often that one can trace the history of a people through the telephone directory, but such is the case in the Virgin Islands, where European surnames are a legacy of the colonial era. From the Danes came Petersens, Hansens, Frederiksens and Lawaetzes; from the Dutch, Moolenaars, Van Beverhoudts and de Windts. Even the Irish and Scots left their mark with Flemings, Farrellys and Lockharts. Deeply rooted in the islands since the time of the Danish settlement, Jewish families are remembered in the Sephardic surnames of Monsanto, Maduro and Lindo, and in the Ashkenazim name Paiewonsky, which traveled from Lithuania to grace our Governor's mansion.

1. Various names are given for this company throughout the book, reflecting changes it underwent throughout its history

Brotherhood of the Coast

Through Columbus, Spain claimed a monopoly on Caribbean trade via an edict that would embroil Europeans in a hostile game of predator-and-prey and give birth to the 'golden age' of piracy. If sanctioned by their governments to go marauding against Spanish possessions, English, French and Dutch *privateers* were hailed as heroes, while those who owed allegiance solely to the 'Brotherhood of the Coast' were called pirates. By the early 1700s, piracy had nearly paralyzed Caribbean trade, but it's not surprising that sea-robbers sought refuge in St Thomas. Lured by the rich cargoes passing through its harbor and the hospitality of Governors like Nicolai and Adolph Esmit, notorious outlaws like Jean Hamlin, George Bond and 'Tempest' Roberts were welcomed. The Englishman Bartholomew Sharp liked St Thomas so much he quit his marauding ways and became a planter. Fellow Englishman William 'Captain' Kidd was not so lucky; he was eventually hung as a pirate, though his greatest crime may have been his failure to comprehend backroom politics. A frequent visitor to St Thomas, Edward Teach earned his entry in the 'Who's Who of Ferocious Pirates'

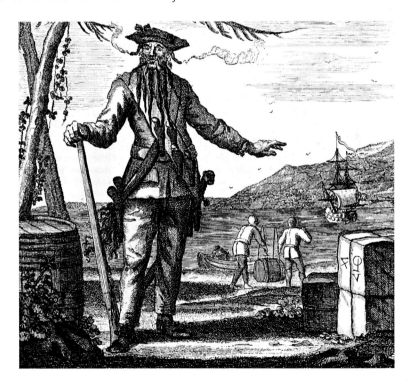

Edward Teach cultivated his enormous black beard, braided and tied with ribbons, to enhance his fearsome reputation

BBC HULTON PICTURE LIBRARY

where his nickname 'Blackbeard' and the ship *Queen Anne's Revenge* are still synonymous with bloody deeds.

The aiding and abetting of brigands (who squandered ducats on rum and women) was simply good business – until it crossed over into politics. Despite the protection of Governor Esmit, the British quest for the French corsair Jean Hamlin's renegade vessel, *La Trompeuse*, ended in 1683 when a frigate succeeded in burning the heavily armed man-of-war in Charlotte Amalie harbor. The explosion that echoed in the hills of St Thomas also rocked the governments of England, Denmark and Franch and ruined Esmit's political career. Reputed to hold one of the world's greatest treasures, *La Trompeuse* still rests where she burned.

The golden age of piracy may have ended in 1725, but the romance of the buccaneer lives on in the lore of the West Indies. Aside from providing us with lusty tales, the Brotherhood of the Coast did much to bring about the demise of Spain as a sea power and weaken her hold on the Caribbean. Some historians have suggested that were it not for pirates, more North Americans might now be speaking with a Spanish accent.

Africans

Lying at the hub of Caribbean commerce, St Thomas earned a reputation as a notorious slave market. While there is little doubt that African labor was crucial to the development of all three Danish colonies, the academic term 'slave trade' does little justice to the millions forcibly shipped to the Caribbean for the bitter work of harvesting cane, or the toll in human misery paid to extract the sweetness of its sugar. Spirited from the West African coast, the Ashanti, Ibo, Mandinka, Amin, Fula, Yoruba, Hausa and Woloff are among the many proud and independent tribes transplanted to the Danish West Indies, where even those of royal birth were stripped of their name and the right to practice their religion or cultural traditions, but not of their spirit of resistance.

In 1733, slaves faced with famine and harsh new laws attacked Fort Fredericksvaern at Coral Bay and incited an insurrection that crippled St John's plantations for six months and resulted in the death of a quarter of the island's inhabitants. The news, in 1792, that Denmark would cease its trade in human cattle, brought no joy to those already enslaved. Some slaves, called *Maroons*, did not wait to be liberated. Fleeing from plantations to mountain communities, they survived the slave era and beyond. Others sailed to freedom in neighboring Puerto Rico, hiding first on St Croix near Hamm's Bluff in a cave called 'Maroon's Hole'.

A too-often ignored footnote to Virgin Islands history, the bloodless revolution on St Croix in 1848, led by Moses 'Buddhoe' Gottlieb, did

Proud Virgin Islander of African descent DEAN L. BARNES

result in the demise of slavery in the Danish West Indies – seventeen years before a better-known emancipation in the war-torn United States. Legally bound to a plantation by an agreement that could be altered only on Contract Day, newly-freed blacks still enjoyed few liberties, though many moved closer to the towns they had helped to build. Working conditions finally improved when 'Queen Mary' led St Croix laborers in the 1878 Fireburn that consumed plantations and the town of Frederiksted (see pages 22, 152).

Although individuals paid dearly during the era of slavery, African culture retained its vibrancy via shared traditions. Today, descendents of former slaves hold high office and form the foundation of the Territory's population, but the struggle for racial identity, ownership of the land and the preservation of culture continues.

Americans

After 50 years of negotiations and the exchange of $25 million in gold, the *Stars and Stripes* peacefully replaced the Dannenbrog as the

symbol of sovereignty in 1917. According to witnesses present, the possession of the newly-named Virgin Islands of the United States was carried out with much pomp, dignity and mixed emotions – sadness to denote the end of 251 years of Danish rule and optimism for a better life under the American flag. By sunset on March 31, the US had secured access to the Panama Canal and purchased its most expensive piece of foreign real estate ever at $300 per acre. Firmly in control of what some historians have called the 'American Mediterranean', the US formally entered World War I one week later.

After the transfer, the scores of Virgin Islanders heading for the US mainland perpetuated the cycle of economic migrations that continue to drain the Territory of some of its most promising youth. With the growth of tourism in the 1950s, however, thousands of 'mainlanders' reversed the process, seeking their own version of paradise in a tropical setting. Likewise, whether they are transient 'snowbirds' who migrate with the seasons, or permanent residents who plant their roots in the hillsides, many 'continentals' have carved an economic niche to call their own and contributed to our ever-changing culture. Once used only to describe native-born black West Indians, 'bahn here' now applies to generations of US Virgin Islanders, regardless of race, who have proudly contributed their Texas Society Chili Cookoffs, St Patrick's Day celebrations and Oktoberfests to our unique blend of Virgin Island traditions. Few places exist where people think nothing of celebrating the Fourth of July with a calypso beat, Thanksgiving with a pot of callaloo and Christmas at the beach.

Mainlanders take pride in their roots at the annual Texas Society Chili Cookoff
JAMES 'HUCK' JORDAN

Although the Territory has flown the red, white and blue proudly for more than seven decades, its Americanized citizens still do not enjoy full political rights and privileges, such as voting for the President. Indeed, throughout its history, seven flags have flown over the US Virgin Islands – some were planted by explorers and conquerors, others bargained for in exchange for gold – but none were chosen by a vote of the people. As it enters the last decade of the millennium, the Virgin Islands may finally have a voice in its own destiny.

French

'French and proud of it' is a tee-shirt slogan that captures the spirit of islanders who trace their ancestry to colonists from Saint-Barthélemy (St Barths) and Saint Christopher (St Kitts) that migrated to the Danish West Indies starting in the 1840s.

As intriguing as any novel, the history of St Thomas' *patois* and creole-speaking residents mirrors that of the Caribbean itself. In 1627 a French nobleman-turned-privateer, Pierre d' Esnambuc established a colony on St Kitts. During the next four decades, colonists who could trace their names to nearly every Old World province of France were shuffled from one island to the next as Spain, England, France and the Caribs battled for control during the 1600s. By the time the families named Aubin, Berry, Danet, Greaux, Magras and Questel settled permanently on St Barths – the island named for Columbus' younger brother Bartholomew – they found many nations had left their mark. When King Louis XVI traded his French colony to King Gustav III of Sweden in 1785 (in exchange for warehouses in Göteborg, Sweden) the proud French who had buried their roots deep in the hillsides of St Barths were forced to live under a foreign flag for nearly 94 years.

Besieged by natural disasters and harsh economic conditions, many fishermen, stone masons and farmers were drawn to the thriving free port of St Thomas, where they established communities on the fertile Northside farmland and around the inlet of Charlotte Amalie Harbor called *Careenage*. The Gallic fishing village air of Frenchtown is still evident in its brightly-colored wooden boats, typical of 18th century Normandy, petite island-style shingle houses, and its very own *Rue de St Barthélemy*. During French Heritage Week, the fall of the Bastille is celebrated on the 'Nordside' with emotional renditions of *Le Marseillaise*, older women wearing traditional Norman *quichenotte* (kiss-me-not) bonnets and the sound of scratch bands with accordion accompaniment.

Originally an insular group, double-rooted to the land and sea, the French have moved into the mainstream of the professional community

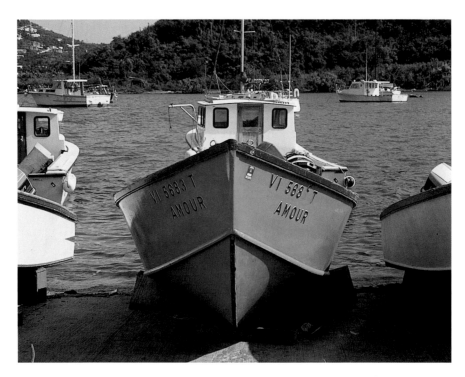

**A wooden boat named 'Amour' reflects a Frenchtown fisherman's
love of the sea** JAMES 'HUCK' JORDAN

and onto the floor of the local Senate, but they still retain the tough-
ness of people who once survived on a ten-square-mile island of
mostly rock. Whether their names have a touch of Swedish, Irish or Old
Norman, or their hair is flaxen or brown, 'Frenchies' are all united in
the spirit of *Liberté*, *Egalité*, *Fraternité* (liberty, equality, brotherhood)
that makes them so distinctly French. And proud of it!

Caribbean Islanders

During the 1950s and 1960s, thousands of immigrants from the
islands to the south came to the Virgin Islands to share in the boom of
the newborn tourism industry. Those in the initial exodus came from
the Leewards, home to English-speaking islanders governed by Great
Britain. During that period, foreign workers entering the US Territory
were required to be 'bonded' or legally bound to an employer. The
practice provided a desperately needed supply of labor, but also led to
exploitation of many 'down-islanders', regarded as 'aliens' and an
underclass of society. Neither term today is complimentary. Until immi-
gration laws in the mid-1980s reduced the flow, thousands of immi-

grants entered from nations as close as the British Virgins and as far south as Trinidad and Tobago. Though bonding would eventually end, the disparity between native-born Virgin Islanders and immigrants from other islands would persist for generations.

On the positive side, cross-pollination of culture introduced by people outside the US Virgins – with common African heritage and traditions – is partly responsible for the preservation of stiltdancing *mocko jumbies* (see page 68) introduced via St Kitts. Resplendent in white flannel, cricketers who learned to bowl and bat on British islands are local folk heroes. Even the steel pan that adds such sweetness to island life was imported from Trinidad to the south. Largely composed of skilled craftsmen, tradesmen and laborers, Caribbean immigrants from other islands arrived laden with cultural gifts; but their greatest contribution may rest not with what they brought with them to the American paradise, but what they built when they got here.

Puerto Ricans

The people of Puerto Rico and the Virgin Islands have interacted for centuries, starting soon after the Danish settlement when Puerto Ricans arrived by sailboat to work on sugar plantations. By the 1940s Hispanics had established themselves in business and political circles. Today, many Virgin Islanders, especially on St Croix, bear proud names of Spanish origin – Morales, Gonzalez, Garcia and Encarnacion – and speak in the language of Spain with a twist all its own. Juan Luis holds the distinction of being the Virgin Islands' first Governor of Puerto Rican descent.

To the Virgin Islands, Puerto Ricans brought their love of competitive sports, delectable dishes and spicy *soca* music (see page 39). Many have distinguished themselves as world-class anglers, in politics, business and professional baseball circles.

Dominicans

During the early part of the 1900s, the decline of shipping and sugar production drove many Virgin Islanders to seek employment in the Dominican Republic, where sugar is still cultivated. Today, the situation is reversed, with people from the Dominican Republic escaping economic hardship on an island shared with Haiti, or awaiting immigration to the US mainland. Many hard-working *Dominicanos* residing in the Virgin Islands are involved in private enterprise, as owners of shops, bars or nightclubs. Few are ever out of earshot of their beloved *merengue* music or heated discussions of baseball.

Arabs

A close-knit Middle Eastern community established itself soon after the 1967 war in which Israel occupied territory on the west bank of the Jordan River. A few Moslem and Christian Lebanese had immigrated earlier, during the 1920s. The majority of the Arab community – with names like Suid, Ali and Abdullah – are Palestinians. Most are owners of retail businesses or employed as merchants, but the growing population now boasts doctors, lawyers and other professionals. Arab store owners are known to be generous in support of community activities and can be found in their place of business from open to close. Commitment to hard work and long hours leaves little time for frivolity. As a rule, such individuals usually prefer to channel their opinion through the voice of respected businessmen and leaders of the Arab Community Organization.

East Indians

Unlike some other immigrant groups who sought escape from poor economic conditions in their homeland, arrivals from India and the Middle East came well-prepared to launch successful businesses. More than two decades ago, the first wave of East Indians arrived in the Virgin Islands. Through the years, this enterprising community has established itself in medicine, education, law and construction. Many join relatives already established in retail. Historically merchants and traders, the Sind of northern Pakistan fled following the partition of India and the creation of the Moslem state of Pakistan. Mostly Hindus, they arrived in the Territory in early 1970s, via Jamaica and Hong Kong. A few hail from the state of Punjab, while others are natives of Guyana, Trinidad and Jamaica.

Names like Mohanani and Daswani represent hard work, education and success. Among first generation immigrants, many East Indians still cling closely to their heritage, speaking Sindhi and observing traditional holidays and religious celebrations, including *Diwali*, the festival of lights. Some still prefer saris and dhotis (pajamas) for special occasions at home. The younger generation may favor Western dress and speak English with a lilting accent, but religion and close family loyalties remain. Photographs of Hindu deities often hold a place of honor in Main Street shops. Though still a self-contained group that tends to socialize and worship among themselves, the East Indian community, through the East Indian Association, has assumed a growing role in community activities and leadership in business.

Celebrated Virgin Islanders

Small in size, big in talent, the Virgin Islands have spawned many who have distinguished themselves at home and abroad.

Arts and letters

Homer Hans Bryant (St Thomas) Solo dancer with the Dance Theater of Harlem and actor who appeared in several movies, including *The Wiz*.

Barbara Christian (St Thomas) Author and professor of Afro-American studies at the University of California at Berkeley.

James De Jongh (St Thomas) Award-winning author, play-wright and university professor.

Doris Galiber (St Thomas) An actress and singer who per-formed with Guy Lombardo; sang in *Porgy and Bess* (with Lena Horne and Ossie Davis), *Carmen Jones*, *The King and I*, *Kiss Me Kate* and *South Pacific*.

Kelsey Grammer (St Thomas) Actor who co-starred as psychi-atrist Fraser Crane on the long-running television comedy, *Cheers*.

Hubert Henry Harrison (St Croix) Considered an intellectual genius, this 'Black Socrates' was a free thinker of the Harlem Renaissance who founded the Liberty League of Negro Americans.

Wayne James (St Croix) Fashion designer whose 1987 debut collection of originals was purchased exclusively by Bergdorf Goodman.

Isidor Paiewonsky (St Thomas) Noted journalist, historian and author.

Camille Pissarro (St Thomas) A leader of the Impressionist movement, Pissarro's early paintings reflect his life on St Thomas. The building that housed his parents' shop in downtown Charlotte Amalie is an historic landmark (see also pages 36, 44, 112).

Human rights

Earl B. Ottley (St Thomas) Founded the Virgin Islands Workers Union.

'Queen Mary' Thomas (St Croix) Led the Fireburn that destroyed Frederiksted and fifty-one sugar plantations, but resulted in the Labor Laws of 1879 and improved working conditions.

Ashley L. Totten (St Croix) Labor union leader credited with aiding in the formation of the Brotherhood of Sleeping Car Porters.

Music

Neal Creque (St Thomas) Pianist and composer who has performed with Quincy Jones, Sarah Vaughan, Melba Moore and Pharoah Sanders, and worked as musical director-arranger for Carmen MacRae, Mongo Santamaria and Leon Thomas.

Andres Wheatley (St Thomas) Pianist and composer whose original compositions have been featured on French national radio.

Politics and government

Edward Wilmot Blyden (St Thomas) One of the most articulate and learned defenders of Africa, its people and their culture, who emigrated to Monrovia where he became president of Liberia College. Many scholars concur that Blyden was the finest black intellectual of the 19th century.

Rothschild Francis (St Thomas) The founder of the Organic Act of 1936 and an avowed civil rights leader who fought to establish a civilian administration and self-government for the Virgin Islands.

D. Hamilton Jackson (St Croix) Upon his return from Denmark where he fought for freedom of the press, Jackson published one of the Virgin Islands' first newspapers and helped organize a labor union that won higher wages and better working conditions. Jackson is honored with a November 1 holiday.

Valdemar Hill, Sr (St Thomas) A prominent legislator and author who sponsored the Virgin Islands' first minimum wage law.

Caspar Holstein (St Croix) A philanthropist who made his fortune in the streets of New York City and financed the lobbying effort that led to American citizenship for Virgin Islanders.

J. Raymond Jones (St Thomas) Began his political career with Marcus Garvey and went on to become the first black leader of Tammany Hall.

Henry Kimelman (St Thomas) Ambassador to Haiti and chief of staff to former Secretary of the Interior, Stewart L. Udall.

Terence A. Todman (St Thomas) Career diplomat, statesman and ambassador to the Republic of Chad, Guinea, Costa Rica, Spain and Denmark; Assistant Secretary of State for Latin American Affairs.

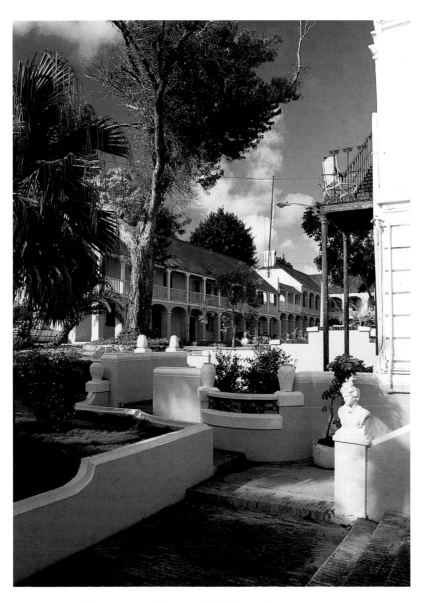

Government House, Christiansted CHRIS HUXLEY

Sports

Jerry Browne (St Croix) Starting second baseman and lead-off hitter for the Cleveland Indians.

Joe Christopher (St Croix) Major league baseball player for the New York Mets and the Pittsburgh Pirates.

Horace Clark (St Croix) Major league infielder for the New York Yankees in 1969.

Elrod Hendricks (St Thomas) Major League catcher for the Orioles in the 1969, 1970 and 1971 World Series.

Julian Jackson (St Thomas) Known to Virgin Islanders simply as 'The Champ', Jackson won the World Boxing Association middleweight champion title. His portrait greets visitors to the Cyril E. King Airport in St Thomas.

Alvin McBean (St Thomas) Major League pitcher for the Pittsburgh Pirates from 1961 to 1968.

Ras-I-Bramble (St Croix resident) Formerly Livingstone Bramble, held the World Boxing Council lightweight title.

The Virgin Island's young generation at playschool in St Thomas
CHRIS HUXLEY

Virgin Island Firsts

Public schools for slaves run by Lutheran Missionaries were introduced to the Danish West Indies in 1787.

Free, public, compulsory and universal school system in the New World was established by Governor-General Peter von Scholten in the Danish West Indies in 1839.

Salute by a foreign nation to the United States of America's Independence was fired from Fort Frederick on St Croix in 1776.

Kidney transplant in the Virgin Islands was performed by a team headed by Dr Roy Lester Schneider, recognized by *Who's Who in the World* as a surgeon and cancer specialist. He was elected Governor in 1994.

Woman elected to the Virgin Islands Legislature under the Revised Organic Act of 1954 was Lucinda A. Millen.

Black Solo Sailor to circumnavigate the globe, Ted Seymour set sail from St Croix aboard his 35-foot sloop *Love Song* in 1986.

Virgin Islander to play major league baseball was Puerto Rican-born, St Croix-raised Valmy Thomas, catcher with the New York Giants, San Francisco Giants, Philadelphia Phillies and the Pittsburgh Pirates.

Virgin Islander to play in the NFL was St Thomian Jeff Faulkner, who joined the Minnesota Vikings in 1987. Renaldo Turnbull of St Thomas was the first Virgin Islander named as a first-round pick in the NFL draft.

Virgin Island World Boxing Champion in three weight divisions, Emile Griffith of St Thomas was inducted into the Boxing Hall of Fame.

Virgin Islander to win an Olympic Medal, St Thomas-born Peter Holmberg took the silver in Finn Class Sailing at the 1988 Seoul Olympics and is leading the Virgin Islands America's Cup Challenge to New Zealand in the year 2000.

Virgin Islander to become a top-ranking songwriter in the US with his 1941 hit, *I Don't Want to Set the World on Fire* was Claude 'Bennie' Benjamin of St Croix.

Virgin Islander nominated for two GRAMMY Awards was Jon Lucien, recording artist and composer of *Lady Love* and *Rashida*. His achievements include top-selling albums,

record-breaking performances at Carnegie Hall and the music video *Listen Love*.

Black US Navy Bandmaster, St Thomas-born Alton Augustus Adams Sr was also an educator, journalist and composer of *The Virgin Islands March*. Awarded a Doctorate from Fisk University and the VI Medal of Honor, Adams started the first music department in VI public schools.

Virgin Islander Collegiate Basketball All-American was St Croix-born US Jr Olympic team member Tim Duncan, whose Demon Deacons jersey number 21 was retired in 1997 by Wake Forest College in North Carolina.

3
Capsule history of the US Virgin Islands

c. **300–400** BC	Ciboneys arrive
c. **100–200** AD	Arawaks arrive
c. **1344–1393**	Caribs arrive
1493	Columbus landing at Salt River; Pope Alexander VI divides New World between Portugal and Spain
1515	Juan Garrido, the 'Black Conquistador' sails to Santa Cruz with Ponce de León to suppress the Caribs
1526	First recorded hurricane
1530	Three hurricanes
1573	Hurricane
1585	Sir Francis Drake sails fleet through the 'Virgins' Gangway' channel on voyage to capture Santo Domingo
1602	Dutch East India Company chartered
1607	John Smith and English settlers visit St Thomas
1625	Dutch and English arrive on St Croix
1645	Dutch and English assassinate each other's Governor; English drive French from St Croix
1650	Spaniards massacre English on St Croix
1651	M. Phillippe de Poincy captures St Croix from Spaniards; purchases island from French West India Company
1652	Hurricane
1653	De Poincy deeds St Croix to the Knights of Malta

1657	Hurricane
1665	Knights of Malta sell St Croix to French West India and Guinea Company
1666	First Danish traders arrive on St Thomas
1671	Danish West India Company receives charter from King Christian V
1672	Denmark establishes permanent settlement on St Thomas; first African slaves arrive in St Thomas
1674	France takes St Croix from French West India Company
1675	Danes claim St John; return it to British
1680	St Thomas' Fort Christian completed
1681	Beginning of mass slavery
1684	Denmark takes possession of St John
1690	English invasion of St Croix fails; second Dutch attack on French in St Croix fails
1691	Tap Hus changes name to Charlotte Amalie
1696	St Croix abandoned by French colonists
1697	Hurricane
1713	Hurricane
1718	Planters settle Coral Bay, St John; Hurricane
1725	Governor Moth restricts slave movement; golden age of piracy comes to an end
1728	St John sugar and cotton plantations flourish
1732	First Moravian missionaries arrive in St Thomas
1733	Hurricane double-header; Danish West India and Guinea Company buys St Croix from French; St. John slave revolt
1734	Bassin on St Croix settled by Moravians; King Christian VI grants new charter to Danish West India and Guinea Company; Danish and Martinique troops quell St John rebellion
1735	Moravians leave Herrnhut for St Croix
1738	Two hurricanes hit within two weeks
1740	First Danish West Indian coins issued
1742	Hurricane
1754	Danish West Indies becomes crown colony

1755	Danish capital moves to Christiansted
1764	St Thomas declared a Danish free port
1766	Hurricane
1772	'Worst hurricane in the history of man'
1776	Declaration of Independence signed; Fort Frederik fires first foreign salute to American flag
1785	Hurricane
1787	Public schools for slaves; Lord Horatio Nelson visits St John
1792	Denmark first country to ban slave trade
1793	Hurricane
1801	British occupy Danish West Indies
1802	British return islands to Denmark
1804	1,200 buildings in Charlotte Amalie destroyed by fire
1806	170 buildings in Charlotte Amalie damaged by fire
1807	British recapture Danish West Indies
1811	Judah P. Benjamin born in St Croix; serves as Secretary of War under Jefferson Davis during Civil War
1815	British exchange Danish West Indies for Heligoland
1819	Hurricane
1825	1,000 buildings destroyed by fire in Charlotte Amalie
1826	Charlotte Amalie fire burns 60 houses
1831	Charlotte Amalie fire destroys 550 buildings
1837	Hurricane
1839	Denmark decrees free compulsory education
1848	Slave rebellion on St Croix leads to Emancipation
1861	US Civil War begins; Charlotte Amalie aids Confederate blockade runners
1867	US negotiations to buy Danish West Indies for $7.5 million disrupted by hurricane, earthquake and tidal wave within 20 days; buys Alaska instead
1871	Charlotte Amalie named capital; two hurricanes within two months

1878	Fireburn destroys Frederiksted, St Croix
1879	Son of King Christian IX, Prince Valdemar visits; US Treaty to buy islands for $7.5 million rejected
1898	Treaty of Paris ends Spanish rule in the Caribbean begun in 1493
1899	Hurricane
1914	World War I begins; Panama Canal opens
1916	Severe hurricane
1917	US buys Virgin Islands from Danes for $25 million preventing German control of Panama Canal; US enters World War I a week later
1920	Prohibition begins; USVI produces bay rum
1924	Hurricane
1927	US citizenship granted to most Virgin Islanders
1928	Hurricane hits St Croix
1931	USVI transferred from US Navy to civilian rule by President Hoover
1932	Sikorsky seaplane begins St Croix–St Thomas service; Radio telephone service to St Croix
1936	Roosevelt signs Organic Act
1838	First election under universal suffrage
1939	Navy establishes submarine base on St Thomas as World War II begins
1941	First minimum wage law; US enters World War II
1942	VI Home Guard established as USVI becomes strategic military base
1946	First black governor
1948	President Truman visits
1960	Alexander Hamilton Airport dedicated in St Croix
1961	Ralph M. Paiewonsky appointed governor by President J.F. Kennedy
1965	Hess Oil buys 400 acres on St Croix for $1.8 million
1966	First flight to US by Pan American World Airways
1967	Antilles Airboats services St Thomas–Puerto Rico
1969	Cyril E. King becomes acting governor; Tekit I aquanauts complete 60-day mission off St John

1971	Melvin H. Evans appointed governor; American Airlines inaugurates services to mainland
1972	Ron de Lugo voted first USVI delegate to Congress; serves until 1994
1978	Husband of actress Maureen O'Hara and founder of Antilles Airboats, Charles Blair, killed in plane crash
1979	Juan Luis becomes governor; Cruise ship burns in St Thomas harbor; Hurricane David and Tropical Storm Frederick
1982	National Park Service buys Hassel Island for $4 million; Alien Adjustment Act ends bonded labor; first organ transplant
1984	Tropical Storm Klaus causes $13.6 million damage
1986	Flora Hyacinth takes gold in 400-meter hurdles at Central American and Caribbean Games
1987	Alexander Farrelly elected Governor; Julian Jackson wins WBA junior middleweight championship
1988	Sailor Peter Holmberg wins Olympic silver medal
1989	Groundbreaking for St Thomas Cyril E. King Airport; Hurricane Hugo '500 year storm' hits
1992	75th anniversary of Danish Transfer; Salt River Bay National Historical Park and Ecological Preserve approved by US Congress
1993	West India Company Docks purchased by USVI Government
1994	Dr Roy L. Schneider elected governor
1995	Near-Category 3 Hurricane Marilyn devastates the US Virgin Islands, taking 10 lives and causing damage estimated at $1.5 billion
1996	St Thomas Yacht Club challenges for the America's Cup to be held in New Zealand in the year 2000; Water Island transferred to US Virgin Island Government

4

Culture and customs

Once a grassroots tradition promoted mainly on home soil, Virgin Islands culture is spreading to the corners of the globe with its African essence and exotic rhythms – from urban Carnival revellers 'playin' mas' in the streets of New York City, to school-age pan players delighting crowds in Taiwan. A new awareness of the African expression *sankofa* ('go back and fetch' what you have forgotten) and a growing market of visitors hungry for more than sun, sand, and sea, have prompted Virgin Islanders to share their distinctive culture – language, literature, art, dance and music – with a world that has warmly embraced its richness and passion.

Language and literature

Many Virgin Islanders trace their cultural independence to the formation of *Creole* languages. You'll quickly discover that our street names (*gades* and *strades*) have a distinctly Danish flavor. A smattering of Dutch and English Creole helps in understanding the expression 'If yoh goh quadrille dance, yoh must dance quadrille' – the calypso variation of 'when in Rome do as the Romans'. Seasoned with phrases from many mother tongues – Dutch, Danish, French, African and English – our Creole mélange has been described as a 'language of the heart' with a wit all its own that describes a troublesome child as 'bad from morning' and friends as 'close as chamber pot an' backside'. Once you've heard the Creole expression 'What a pistarckle!', meaning 'a great confusion' (from the Danish *spetakel*), any other cliché seems bland.

Mixing grammatical forms, playful puns and expressions that are often incomprehensible to mainlanders, Creole dialect displays its full richness when spoken. Authors like Lito Valls and Arona Peterson have done much to preserve the rhythm of 'back time' words and the wisdom of 'ole time' proverbs that Valls so eloquently calls a 'choir of voices passed down through the generations'. Even writers like Herman Wouk (*Don't Stop the Carnival*) and poets who were not 'bahn here' have captured the music of the culture.

Folklore and storytelling

Throughout the Virgins, storytellers who can weave a spell through vocal rhythms and dramatic hand gestures are regarded as caretakers of an oral tradition that has persisted for generations. 'Tim-Tim Time' is the phrase used by storytellers gathered under a shade tree in the 'Big Yard' to introduce folk tales that teach as well as entertain. Drawn from all ranks of the community, modern storytellers still entertain at local cultural events and most local children are familiar with the

Anansi the Trickster – ancient oral tradition captured by a modern artist
PETRINA WRIGHT

misadventures of *Anansi the Trickster* (depicted as a man or spider) that form the basis of *Bruh Nancy* tales ,with origins in West African fables, not unlike *Br'er Rabbit*. Evidence of this rich oral tradition can also be found in collections such as *Tales of the Immortelles* and other writing that have preserved some of the Caribbean's best-loved stories. Of course, not all folk tales are fiction; the exploits of real-life Tortola strongman, Joseph 'Tampo' Fahie, served as inspiration for the contemporary series documented by Dr Gilbert Sprauve of the University of the Virgin Islands.

Superstitions

Not to be confused with the Voodoo religion, *obeah* is the cultural belief in spirits, love potions, charms, herbs and the power of good-and-bad witchcraft practiced by *obeah men*. As early as 1940, *The American Weekly* carried an article by Hamilton Cochran, a government official whose account of obeah in the Virgin Islands is one of the few published. Written during the early days of tourism, J. Antonio Jarvis' 1944 book, *The Virgin Islands and Their People* was banned for discussing the practice. Today, few Virgin Islanders openly acknowledge obeah, but it's not unusual for adults to threaten children with a visit from the obeah man and to claim that someone 'worked obeah' on them when faced with an unfortunate situation or ailment. For a comical look at obeah, Denise Thomas' contemporary play *Obeah Love* takes a look at the interaction of love potions, the obeah man and politics.

Throughout the islands it's not unusual to hear rumors of were-wolves and other creatures that go bump in the night. One West Indian waitress of my acquaintance nearly dropped her tray at the mention of the legendary horseshoe-shod 'Cowfoot Woman' who, according to legend, lurks along wooded roadsides waiting to drink human blood. Ask a Virgin Islander how he's doing and he'll likely respond 'Not so good as you' – to avoid calling attention to good fortune that may tempt the spirits. Children who misbehave can also be coerced with threats that the dreaded *jumbies* will 'getcha' and it's always more fun to blame power outages or anything that goes wrong on the intervention of playful spirits.

If you enjoy a good ghost story, you may want to check out Frenchtown's Villa Olga, the former Russian Consulate, that is supposedly home to the hundred-year-old spirits of two children buried on the grounds. Blackbeard's Castle (see page 113) has a pirate haunting of its own.

Arts and crafts: Tradition bearers

Throughout the Virgin Islands, occupations such as charcoal-making, stone masonry, pot-fishing, joinery, weaving, caning and quilting have sustained a way of life for generations and provided objects of great utility, even a few museum masterpieces. The Annaberg Cultural Demonstrations on St John are a good place to learn how early people earned a living making charcoal, terracing gardens and how they healed with local plants (see also page 59).

From the *pistarckle* broom made of sticks and bush, to home-made charcoal that fuels slow-cooking pots, Virgin Islanders have a flair for making do with materials at hand. Some local artisans on St John and at the St Croix Handicraft Industries still weave market baskets of hoopvine and wist vines (see page 93). If you're well-connected in the French community, you may find someone to plait a made-to-order bonnet or demonstrate the technique of making fish-pots of tied sticks. Local craft shows sell masterpieces of crochet and embroidery.

Visitors who appreciate mahogany will enjoy the collection at Whim Plantation Museum (see page 151), where adaptations of work by St Croix's master craftsmen from the Thurland, Able and McFarland

Silkscreen printing at Tillet Gardens CHRIS HUXLEY

families first went on sale in 1993. Craftsmen at the St Croix Life and Environmental Arts Project (LEAP) have recycled mahogany trees downed by hurricanes into hand-carved works of arts and furniture.

The Virgin Islands are also home to an abundance of cultural artists like Austin Peterson, whose 'painters posse' decorates our roadways with murals, as well as painters and sculptors who draw their inspiration from the environment and exhibit their works in more conventional galleries.

Those in search of unique perspectives on island life should visit St Thomas' Tillett Gardens, home to artisans working in silkscreen, shells, coral, stained glass, wax, copper, painted enamel and clay, as well as more traditional mediums like watercolors, acrylics and oils. If you're lucky, you may catch an Arts Alive! fair or an open-air performance of Tillett's Concert in the Garden series. The Virgin Islands Council on the Arts, which hosts an outrageous Beaux Arts Ball each April, is a good source for specific gallery offerings and names of fine arts and performing artists. Paintings by native-son Camille Pissarro, valued at $300,000 by Sotheby's in New York, can be viewed by appointment at Government House in St Thomas (see pages 21, 44, 112).

Music: Cultural roots and rhythms

Music takes many forms in the Virgins, from Afro-Caribbean-inspired rhythms and 'talking drums' that keep time with the heartbeat of humanity, to sultry jazz melodies at local clubs and the annual St Croix Jazz and Caribbean Music and Art Festival that hosts top names in entertainment. But closest to the hearts of islanders are those extemporaneous musical forms adapted from the ancient Ashanti tradition, like *cariso*, *bamboula* and *quelbe*, that have not only shaped their history, but kept it alive for generations. According to Glenn 'Kwabena' Davis, who is assembling the first Virgin Islands music archive, messages hidden in cariso (carried-like-so) songs spread news from plantation to plantation. A clandestine communication, cariso songs were used to convey strategies when African slaves made their move for freedom and later fought for improved labor conditions. The popular song *Queen Mary* (see page 22) dates from that period and there is evidence that the song relay-system even supported the drive for freedom of the press. Cariso lives today through the efforts of many tradition-bearers like St Croix's Leona Watson and Cariso Singers. Like cariso, bamboula was accompanied by congas, maracas and other percussion instruments and used symbolism in its lyrics to unify protests.

Commenting on everything from current events, marital infidelities and rum-smuggling in ladies pantaloons to society's ills, the colorful

music form known as quelbe entertains as well as educates. Quelbe usually adds a lead instrument (flute, clarinet, saxophone or *bombadine*) and a harmonic (guitar, ukelele or banjo). The 'wash pan an' piece of stick' instrument of Tortola's Elmo and the Sparkplugs is pure quelbe, a music form that is enjoying a revival through an annual Quelbe Music Festival. Quelbe bands like Blinky and the Roadmasters, Stanley and the Ten Sleepless Knights, Jamesie and the Happy Seven, Milo and the Kings, and Bully and the Kafooners are helping preserve the old-style musical expressions.

Tracing its origins to Africa and evolving into an art form in Trinidad and Tobago, *calypso* (from the Hausa word *kaiso*) has now replaced quelbe as the Virgin Islands most popular music form. Although spirited debate surrounds the origin of its name, the link to the Greek nymph *Calypso* (one who conceals) is revealing.

Many Americans got their first taste of commercialized calypso with the 1945 Andrews Sisters hit *Rum and Coca Cola*, adapted (some say pirated) and sanitized from a satirical version about prostitution sung in Trinidad. Jamaican-born Harry Belafonte's 1953 hit *Matilda, Matilda* ('She take me money and run Venezuela') and his adaptations of West Indian work songs (*Banana Boat Song* or *Day-O*) and ballads (*Jamaica Farewell*) were also popular. Booming from car radios and bursting from local bandstands, it's hard to miss the pulsating beat of contemporary calypso; though outlanders might fail to catch the clever double-edged lyrics infused with everything from gossip, scandal and politics to positive social messages.

The ability to improvise is the mark of a true calypsonian. Like cariso and bamboula, calypso carries the voice of its people, so much so that it's even been called the newspaper of the common man. Competitions among poetic calypsonians (whose names are often as colorful as their lyrics) during Carnival have spawned a new generation of artists with something to sing about. At the 1991 Junior Calypso competition, 'Mighty Chicken Wing' (Riise Lafranque) brought the house down with her bright yellow beak, brilliant blue plumage and her four-year-old views on drug abuse.

Although Virgin Islanders do dearly love their high-energy, 'jump-up' and dance music, spiritual hymns of sacred or secular texts have also found a home in places of worship. Especially moving are the Caribbean Chorale's annual rendition of George Frederick Handel's *The Messiah*, Catholic hymns sung in calypso cadence and Protestant hymns that remind us of the Danish colonial era.

'Scratch' (*fungi*) bands produce their spontaneous and distinctive music – ranging from high-pitched to deeply-resonant sounds – by scratching on ridged gourds with wire, accompanied by flutes, ukuleles

**Rising Stars Youth Steel Orchestra is an international ambassador
for Virgin Islands' culture** JAMES 'HUCK' JORDAN

(*cuartro*) or guitars. Contemporary scratch bands often contain in-
genious percussion instruments fashioned from auto exhaust pipes,
wash tubs and even bottles. Once the primary entertainment at
weddings and Christmas serenades, such bands can still be found at
quadrille performances.

Followers of reggae, the Jamaican music of revolution, will find
many bands that have fused this popular sound with touches of 'dub',

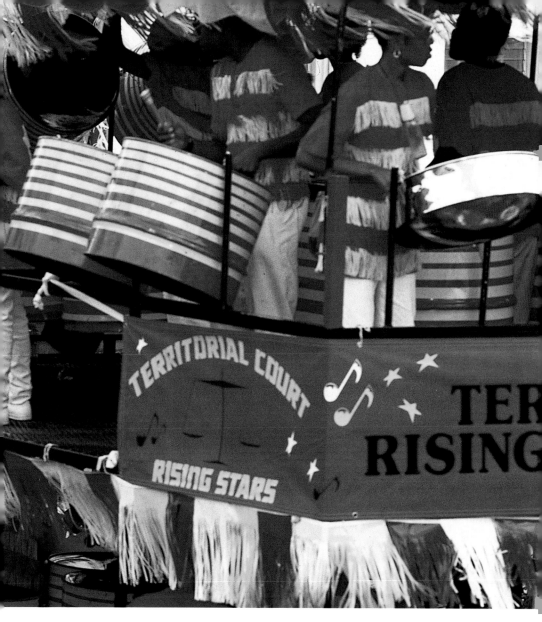

'funk' and dance hall styles. Over the years, all-brass bands have played an increasing role in cultural preservation, qualifying for a Brass-O-Rama Carnival competition of their own (see page 63).

Soca is a spirited fusion of traditional calypso and soul music made popular in the 1990s. Designed to be performed live or with recording studio musicians, soca delivers a punch at parties. Another popular party sound is *Zouk*, which draws its inspiration and lyrics from the French West Indies.

The electrifying sound of metal percussion 'instruments' evolved from early street bands in Trinidad that beat steel rods against brake

drums, buckets and even trash can covers. The only musical instrument invented in the 20th century, the steel pan was hammered from oil drums secured from US military bases in Trinidad during World War II. Cut into lengths (the longer the drum the lower the note), the drum's bottom was heated and hammered into sections that each produced a different note when struck. Steel pan revolutionized metal percussion music and has had a profound influence throughout the Caribbean.

Dance: The essence of life

Virgin Islanders will dance to celebrate most any occasion with a joy and vitality that surpasses mere recreation. Few other art forms so well express their mood, temperament or cultural heritage. Uprooted from their motherland, African slaves carried their dance traditions with them. One that survived near-extinction is the *bamboula*, whose incessant drums and trilling flutes so frightened white planters that the dance was forbidden. Fortunately, groups like the Joseph Gomez Macislin Bamboula Dance Company, composed of schoolgirls in swirling petticoats, are sparking a revival of this energetic and sensual dance form.

Modern Virgin Islanders can also thank ancestors who borrowed formal square-dance steps from French plantation ballrooms, added an African drum beat and called it *quadrille*. A dance much-admired for its hipswaying, full-skirted softness and pulsating melodies played on flute, ukelele and banjo, the quadrille is regarded by many as the first native dance of the Virgin Islands (though bamboula fans may disagree). Traditionally-clad quadrille performers like the St Croix and the St John Heritage Dancers and Mongo Niles Cultural Dancers have done much to revive intricate plantation-era modified minuets, Austrian waltzes, French and Danish lancers, even the spirited polka mazurka.

The Virgin Islands Institute of the Performing Arts (VIIPA) that provides dance training to island youth and the world-touring Caribbean Dance Company of St Croix are important cultural resources. Another outlet for performing artists, the Repertory Theater of the Virgin Islands regularly performs at the Reichhold Center for the Arts, an outdoor amphitheater named for industrialist Henry Reichhold, on the University of the Virgin Islands' campus. Visitors in search of entertainment might plan to catch a performance by the Pistarckle Theater, or visit the Maho Bay Performing Arts Pavilion on St John. St Croix's Island Center attracts top names to its 600-seat theater and open-air amphitheater that accommodates 1,600.

The Virgin Islands dance and music traditions are woven from many threads of Caribbean, African and South American influence. From

Cuba came the spicy *conga*, *mambo*, *rhumba*, *bolero* and *cha-cha.*; from Brazil the sensual *samba*. Popular among Virgin Islanders from Santo Domingo, the *merengue and la bomba* are as hot as ever. While Virgin Islanders of Hispanic heritage have adopted merengue as their own, they also sway to the Latin beat of *salsa*, *jobaro* (country music), the African-inspired *bomba* and the *plena* (Puerto Rico's oldest native music whose lyrics touch on society's foibles). Spanish melodies have also infected calypso, especially the Christmas music called *parang*, performed with guitar, cuatro and mandolin. On the fifth of May, don't be surprised to hear a roving Mexican *mariachi* band celebrating Cinquo de Mayo.

A cultural mutation from New York's Harlem, dances like the *tambou* and the bird-like 'flop' enjoyed popularity during the 1940s. During the 1960s and seventies Virgin Islanders enjoyed the music of night club dance bands centered around piano, guitar, drums and saxophone. The Fabulous McClevertys toured North America's most famous clubs, sharing top billing with stars of the day and appearing on television. Among the islands' most original dance creations are the 'market-woman', designed solely to entertain, and Jam Band's 'Horse Chip' which pranced its way to international popularity at Carnival Road March in 1990 (see page 66).

African celebrations

Designed to celebrate African heritage, *Kwanzaa* (the first fruits of the harvest) is a cultural holiday that is gaining recognition. The Kwanzaa ceremony centers around a candleholder (*Kinara*) bearing seven symbolic candles (*Mishumaa Saba*) – three red (the blood of Africans), three green (the land), and a single black (the people) – that are lit from December 26 to January first.

In a growing effort to 'go back and fetch' what has been forgotten, the Virgin Islands host performers from Africa, such as the Yoruba Bata Drummers (dancers and masqueraders) from Nigeria. Another folklore custom making a comeback is the simple wedding ceremony once practiced by slaves known as 'jumpin' the broom' where bride and groom, often in traditional African dress of *kente* cloth, literally make the leap into married life.

5

Spirit within

Virgin Islanders openly embrace a multitude of religions. Our Jewish synagogues, Moslem mosques, Moravian churches, Catholic cathedrals and other places of worship are monuments to those who struggled to preserve this privilege and protect those portals to the 'spirit within' that sustain us.

Lutheran legacy

Established in 1666, the Lutheran congregation persisted by building the Frederick Evangelical Lutheran Church (see page 111), now the second-oldest in the Western Hemisphere. Celebrating its 325th anniversary in 1991, the church celebrates its Danish heritage and communion with a gold-overlaid silver chalice presented by the Danish West India Company in 1713. Lutheranism spread to St John in 1720 when the Nazareth Lutheran congregation was formed. When the French sold St Croix in 1733, the Lutheran congregations of Lord God of Saboath, Holy Trinity and Kingshill were quickly established under Danish rule.

Due to its heavier concentration of British settlers, St Croix became the first center of the Anglican Church, which grew as more English colonists arrived from Europe and other islands. The Gothic-style All Saints Anglican (Episcopal) Church in St Thomas was built of local blue bitch stone and ballast brick and dedicated 'To the glory of God in thanksgiving for freedom from slavery' in 1848.

Moravian mission

Among the African population, free blacks were allowed to join Christian denominations, but growing slave populations were mostly ignored. After a few failed attempts by Lutherans at establishing missions to convert enslaved blacks, Friederich Martin, a religious refugee with the Moravians in Herrnhut, took charge of the Danish West Indies. Called the 'Apostle to the Negroes' Martin operated his Moravian missions like plantations with slaves and missionaries doing manual work. One of the most enduring of these experiments is the

Bethany Moravian Church (see page 137), established on St John in 1754. The first native Governor General, Thomas de Malleville, eventually became a Moravian convert under the guidance of Brother Cornelius, a former slave.

Though progressive for its time and intended to make slaves more 'manageable' the teaching of European Christian ethics managed to eradicate many African cultural beliefs along with practices such as polygamy and obeahism (see page 34). The persistence of the Protestants is evident in the Virgin Islands today, where dozens of denominations are represented.

Hebrew outposts

Though overshadowed by Protestantism during the colonial period, the Hebrews played a critical role in shaping the history of the Danish West Indies and the British colonies that became the United States. Among those who populated the early Danish settlement, Jewish peddlers, shopkeepers and landowners were few in number and worshipped their Sabbath in private. Hebrew religious freedom was restricted, even during the two-year period when Gabriel Milan served as the first Jewish Governor of the Danish West Indies, commissioned in 1684 by King Christian V. In 1734, St Thomas Jew, Emmanuel Vass, negotiated the transfer of St Croix from France to the Danish West India and Guinea Company. By 1777, the Hebrew population on St Croix had grown a bit, but only a smattering of Jews had yet settled on St Thomas.

When the American Revolution began in 1776, the British learned that Sephardic Jews on the Dutch island of St Eustatius were supplying guns to the 'rebels' and offering refuge to their warships in the waters of the Dutch West Indies. By 1780, confrontations between the Dutch and British led to war. The destruction of St Eustatius by Admiral Sir George Rodney caused Jews to flee to St Thomas, where they set about building a greater trading port than the one they had just left. History tells us that a bitter Rodney once claimed the American Revolution could not have been sustained were it not for the support of the Jewish traders on St Eustatius.

By 1784, Hebrews on St Croix had established a synagogue and the few Jewish families on St Thomas followed suit in 1796, building the small wooden synagogue called 'Blessing and Peace' on Crystal Gade. That temple was destroyed by the great fire in 1804 and replaced. As the congregation grew, the old synagogue was dismantled to make way for a new one in 1823 named 'Blessing and Peace and Loving Deeds'. Spiritual home to 64 families, this synagogue, too, was

The Hebrew congregation welcomes the Sabbath in the oldest synagogue in continuous use under the American flag

HEBREW CONGREGATION

ravaged by fire in 1831, but the name *B'racha v'shalom u'gemilut hasadim* lived on (see page 114). Rebuilt in 1833 to withstand fires, hurricanes and pirate attacks, the magnificent structure on what is now Synagogue Hill was designed by an architect from Paris who also supervised the native stone and brick construction using sea sand and molasses as mortar and multi-colored ballast brick. Required by Sephardic rites, the octagonal funeral chapel *Beth Ha-Chaim* (House of Life) in the Jewish Cemetery on Main Street, was built in 1837.

During the American Civil War, the Danish West Indies flourished as a supply base for Confederate blockade runners. St Croix-born Jew, Judah P. Benjamin served Confederate President Jefferson Davis as Attorney General, Secretary of War and Secretary of State. Countless law students have studied Benjamin's post-war essays, written in Europe. St Thomas-born Jewish painter Jacob Pizarro moved to Paris where he changed his name to Camille Pissarro and fathered the French impressionist movement (see pages 21, 36, 112).

From the 1860s until the early 1900s, the Jewish population of

St Thomas declined as coal-powered steamships replaced the sailing vessels that had created one of the West Indies' greatest trading centers. Some profited from the coal and shipping industry, but many left when the Royal Mail Steamship and other lines departed in 1885. By the 1960s, opportunity in tourism, rum manufacture and small industry attracted a wave of second-generation Jewish-Americans and Ashkenazic families from Europe. During this era, the distinguished names Herman Wouk (author), Ralph M. Paiewonsky (Governor) and Henry Kimelman (US Ambassador) joined the procession of De Castros, Maduros, Pereiras, Pissarros and others who have contributed to development of these islands.

From 1995-1996, the Hebrew Congregation of St Thomas hosted an international celebration to mark its bicentennial as one of the oldest synagogues in the Western Hemisphere. Lovingly restored with original furnishings dating to 1833, the synagogue still welcomes the sabbath with the lighting of candles as did the first Jews in St Thomas. Today, those candles are protected by Baccarat crystal and the treasured 200-year-old Torah scrolls within the Holy Ark are shielded by doors of mahogany and ivory. Architecturally impressive and historically significant, the synagogue's most dramatic link to the ancient past is curiously its simplest – its sand-covered floor.

Catholic community

Like the Jews, the early Catholic settlers in the Danish West Indies worshipped in private, in the shadow of Protestant sects. In 1754, Roman Catholics were allowed to build churches for public worship and to recruit clergy – as long as they did not compete with Protestants for white converts. To expand their congregations, Catholics turned to the black population and Puerto Ricans and eventually became the largest denomination in the Virgin Islands.

St Patrick's Roman Catholic Church in Frederiksted, not far from Market Square, was built in 1843 of local coral stone (see page 155). Impressive for its vaulted ceiling murals, Saints Peter and Paul Cathedral in St Thomas was consecrated as a parish church in 1848 (see page 115). The late 19th century Biblical paintings by Belgians, Brother Ildephonsus and Father Leo Servais, are local Catholic treasures.

Perched like a canary on the peak of Gallows Hill in St Thomas, St Anne's Church is home to the Catholics of Frenchtown. Selected by the Redemptionist Fathers in 1921, the site of pirate hangings seemed a likely spot to begin construction of a church and the work of saving souls. Parishioners at St Anne's still walk in funeral procession down

steep steps to the cemetery across the street while local businesses close their shutters as a sign of respect. A small outdoor altar decorated with fish nets is erected beside the fishing boats at the water's edge in Frenchtown to mark the start of hurricane season (Supplication Day, see page 163) and the annual Blessing of the Fleet.

Bishop O'Malley presides over the ordination of priests at Saints Peter and Paul Cathedral in St Thomas ARLENE R. MARTEL

Hindu traditions

Though many Hindus claim a direct link with India, some have migrated via former British colonies and homelands on several continents. A strong religious tradition of responsibility for family and friends has produced a small but cohesive Hindu community whose people demonstrate their spirituality in the privacy of their homes or at the workplace.

In East Indian shops all along Main Street, photographs of various deities and the divine trinity – *Brahma* (the creator), *Vishnu* (the preserver) and *Shiva* (the destroyer) – occupy a place of reverence in gilded shrines tucked into corners. The religious celebration of *Diwali* (festival of lights) is one of the most visible Hindu traditions practiced by East Indian people within the Virgin Islands community.

Islamic envoys

According to Danish records that refer to slaves who refused to eat pork, the earliest followers of Islam (Muslims) in these islands were probably from West Africa. Today, the majority of Muslims are found within the closely-knit Arab community that arrived from the Middle East to establish businesses.

Founded in 622 AD by the prophet Muhammad, to whom it is believed Allah revealed the Muslim holy book the *Koran*, Islam today is followed by Muslims of many different sects who maintain their devotion through the giving of alms, daily prayer in the privacy of their homes and the keeping of the fast of Ramadan. Those who can make a pilgrimage to Mecca. A center of the Arab community, St Croix' Islamic mosque is located in Estate Catherine's Rest.

Rastafarian roots

When Ras Tafari was crowned King of Ethiopia in 1930 and adopted the name Haile Selassie, this 'Lion of the Tribe of Judah' was embraced as the living God by countless blacks who saw him as the savior who would redeem them from bondage as promised in the Psalms and the teachings of Marcus Garvey. From its roots in Jamaica, Rastafarianism has evolved worldwide to include sects including the Twelve Tribes of Israel (dedicated to the Back-to-Africa movement), the Bobo Dread (composed of craftsmen) and the Niabinghi (composed of musicians and chanters).

True *Rastafari* brethren, also called *Rastas*, practice naturalism and simplicity in their lifestyle, preferring *I-Tal* diets of natural grains, fruit,

47

**A statement of African identity, nature dreadlocks are
never cut by Rastafarians who have taken the 'Nazarene vow'.
They are sometimes worn by others who identify
with Rasta culture** DEAN L. BARNES

roots and vegetables. Most are vegetarians, avoiding pork, beef and even shellfish. Some, not all, smoke *ganja* (marijuana) as a spiritual practice. Garvey's teachings – which urged the black man to reclaim his African heritage – have had a profound influence on generations through reggae musicians like Bob Marley, Burning Spear, Jimmy Cliff and Peter Tosh, as well as the poet Claude McKay and the Muslim activist, Malcolm X.

6
Tropical treats

If Caribbean cooking evokes visions of goat-on-a-spit, hold onto your taste buds because contemporary island cuisine is sweeping the globe in a tropical heatwave, fired by an insatiable appetite for exotic and spicy foods. Chefs at chic eateries are wrapping entrees in banana leaves, waking bored palates with fiery peppers and reworking recipes once regarded as purely native fare to please an international palate.

Traditional tastes

Virgin Islands cooking, properly called creole cuisine, is a culinary melting pot of recipes handed down through generations who each contributed a unique gift – a cooking technique, spice or method of preservation – to the cultural dinner table. If there's hidden treasure in the Virgins, it can be found in its lush fruits, exotic-looking produce and aromatic spices displayed at any market square. Sharing a common geography and climate, ingredients throughout the Caribbean vary little, so regional cooks using basic provisions that often taste bland by themselves, have relied on seasonings and preparation techniques to make their cuisine special, adding zest with creative sauces. A favorite for meat is *tamarind* made from the sticky substance scraped from fuzzy brown pods that also produce a tangy drink, chutney or candy.

Well-established before Columbus began his search for spices, Amerindians grew *cassava* root (*yucca* or *manioc*) as a staple. Cassava can be grated to produce a flour used in breads (that can be sun-dried then stored for months without refrigeration) or as a thickening agent in stews and sauces. Archaeologists are still uncovering stone griddles that establish this thousand-year-old 'cassava connection' between ancient and modern residents. The Spaniards and later Europeans added pigs, poultry and dairy products to the pot. The New World explorers didn't return to the Old World empty-handed: the corn, squash, tomatoes, potatoes, pumpkin, avocado and spices that survived the voyage transformed the diet of Europe.

Unwilling travelers to the Caribbean, African slaves brought their preparations of root vegetables and beans, their taste for stews and

secrets for cooking with coconut milk. Africans are credited, too, with the introduction of okra, said to have been hidden in the hair of women who believed it had magical powers to assist in childbirth. Forced to subsist on rations of salted fish, cornmeal and bacon doled out by plantation owners, slaves grew cassava, yams and corn to supplement their diet, a practice that gave rise to open-air markets now found on every island. Simmered in coal-fueled clay or cast iron pots, simple but hearty stews of African origin remain a cherished part of our culture, like the spicy meat stew called 'pepperpot,' flavored with cassava-based *cassareep*. Later immigrants from India and China contributed new ingredients (wheat, rice, mango, eggplant, ginger, cloves, nutmeg, curry) and cooking techniques (stir fries) to the mix.

Fruits of our labors

The cool mountain slopes of the Virgins produce an amazing variety of fruit and vegetables such as collard greens, scallions, kidney beans, squash, eggplant, avocado, banana, soursop, cocoplums, cashew, guava, mangoes and mamey apple. Equally enthralling are the various names given to foodstuffs and the diversity of ways to prepare them: the squash-like vegetable *christophene*, which tastes like a cucumber-potato cross, is known alternately as *chayote*, *cho-cho*, *choko*, *vegetable pear*, *sousous* and *xaxu*. Green papaya (*paw-paw*) can be cooked as a vegetable, or enjoyed as a fruit or beverage when fully ripe. The same is true for mangoes.

Starches are a staple of the West Indian diet, so variations of rice and plantain (cooking banana) are a must with every meal; fried as a salty snack (Caribbean potato chip) as well as baked, boiled or sauteed as a starchy substitute for bread or potato. Tropical sweet potatoes (*batata*) used in stuffing are sometimes mistaken for yams. Sweet potato, pumpkin, brown sugar and coconut combine to produce the traditional *docouna*, a dumpling cooked in banana leaf wrapping. The West Indian pumpkin (*calabaza*) can be boiled, baked or mashed, served as a side dish or simmered into a delicious soup. Fried in oil or cooked on a grill like a pancake, fritters can be flavored with sweet potato, pumpkin, banana, papaya, saltfish or conch. A cooking liquid made from the meat from a fully ripe nut, coconut milk imparts a richness, flavor and fragrance to traditional dishes like peas (or beans) and rice. There are as many variations of traditional beans-and-rice as there are cooks, with bean types ranging from 'pigeon peas' to kidney beans, black beans and black-eyed peas.

Known as 'ground provisions', root vegetables such as yams, cassava and *tannia* are widespread. *Dasheen* (*taro root*), a tuber that tastes like

**Introduced by Captain Bligh of *Bounty* fame,
breadfruit has nourished generations of Virgin Islanders**
JAMES 'HUCK' JORDAN

a potato, can be served as a vegetable. Dasheen's green leaves are used to make the popular *callaloo* soup.

Made from cassava flour, cornmeal or wheat flour, dumplings are found floating in stews, soups and as side dishes. Originally called 'journey cakes' and still eaten on the move, *johnnycakes* are made from fried or baked flour and best when served hot with fried fish or salted codfish. A stiff pudding-like mixture of milled cornmeal (with okra as an option) known as *fungi*, is usually served with boiled fish and topped with gravy. Arguably the official dish of the Virgin Islands, fish-and-fungi is as popular as burgers-and-fries among US mainlanders.

The spiny (rock) Caribbean lobster needs only a little butter to make a meal, but stands up well to spicy sauces. Unlike its giant-clawed cousin in the Atlantic, the Caribbean lobster hides most of its succculent meat in its tail JAMES 'HUCK' JORDAN

Harvest from the sea

Like the Amerindians before them, Virgin Islanders enjoy a rich harvest from the sea and shoreline. Boiled, baked, stewed, broiled or grilled, fish and seafood favored among native cooks include triggerfish (old wife), grouper, grunts, hardnose, yellowtail, red snapper, whelk (West Indian Top Shell), snails, crab and squid. When questioned about the freshness of the yellowtail snapper he had provided to a Frenchtown restaurant, a fisherman haughtily replied that 'it was swimmin' dis mornin'. Regardless of which fish they choose, islanders insist that it still be kicking when they cook it.

Not to be confused with the mammal, dolphin (*mahi mahi* or *dorado*) is a meaty game fish that takes well to seasonings. Other good-eating game fish include kingfish, tuna and wahoo. Reminiscent of pre-refrigeration days when clipper ships plied the seas, dried salt

cod or 'saltfish,' has long been a staple of island kitchens. A popular fish dish prepared with lemon or lime juice and vinegar is called *ceviche*.

Some fish-lovers prefer to avoid predatory fish such as barracuda that feed on other reef-grazing creatures that may contain ciguatoxin (CTX), a natural substance produced by marine microorganisms that concentrates at each link in the foodchain. A neurotoxin that cannot be easily detected or killed by cooking, CTX affects the gastrointestinal and nervous system causing ciguatera fish poisoning, that while rarely fatal, is always unpleasant.

Prized for its beautiful shell and succulent meat, the Queen Conch is a local delicacy. Sliced thin and marinated, conch salad can be served as an appetizer, ground and combined with savory vegetables Creole-style over rice as a main meal, or used in chowder and fried fritters.

A sip of sunshine

Virgin Islanders are clever when it comes to utilizing every local fruit, flower, pod, root and berry available to make tantalizing beverages.

Coconut adds distinction to native food and drink, but breaking into a green nut is best left to someone with a steady hand and a sharp machete. Don't miss the opportunity to savor a spoonful of the partially-formed meat inside called the jelly, or sip refreshing coconut water straight from the nut. A popular cocktail is a gin-and-coconut water mix. Made from ripe white meat, coconut cream lends a taste of the tropics to the frozen colada made with fresh pineapple (*piña*).

A tart thirst-quencher as a juice, the bright yellow *carambola* (star fruit) makes a fanciful garnish when sliced crosswise, or dried and candied as a dessert. Passion fruit juice is as exotic-tasting as its name (derived from the crown-of-thorn flower and the symbol of crucifixion Christian missionaries envisioned in it). The non-alcoholic beverage known as ginger beer is made from ginger root fingers; also used to season everything from sauces to cakes and to remove the scent from fish.

The deep pink flesh of the guava (*guayaba*) makes a colorful fruit juice that gives rum punch its smoothness and color. Made from the steeped sepal of the sorrel bush, a deep-red tea that resembles cranberry juice is best served icy cold. Frothy *maubi*, fermented from the bark of the carob tree with an abundance of spices and brown sugar, is an island favorite that will slake any thirst.

Processed from the seeds of the plant by the same name, hand-rolled *cacao* (chocolate) can be boiled with water, sugar and cinnamon for a pleasant morning wake-up. A creamy concoction made from

seaweed, sea moss tastes better than it sounds, as does the seedless citrus, ugli fruit.

A drink with a link to the past, planter's punch is a concoction of dark rum, water, sugar syrup, lime juice, fruit and bitters that soothed the thirst of overseers after a day in the saddle. Indeed, rum has an intriguing history all its own. It is a spirited elixir with an affinity for fruit juice, though it adds zing to cooked dishes as well. Made from the distilled juice of crushed sugarcane (which can also be boiled to produce sugar crystals or molasses) Virgin Islands rum is produced mainly in St Croix and marketed under the duty-free Cruzan, Old St Croix and Brugal labels. A brand that has come a long way from the yo-ho-ho tipple associated with pirates, Cruzan's specially-aged Estate Diamond is so precious its can only be purchased in the Virgin Islands.

Fancy recipes aside, the traditional rum punch formula is easy to remember: one part sour (lime or lemon juice);
two parts sweet (sugar syrup);
three parts strong (rum);
and four parts weak (water or ice).

Homemade maubi makes a frothy treat
ARLENE R. MARTEL

Bursting at the seams, a hand of fig bananas is ripe for plucking JAMES 'HUCK' JORDAN

The combination of frozen custards with tropical fruits like coconut, mango and soursop (*guanabana*) and spices such as nutmeg creates sensational homemade ice creams that make commercial blends seem bland. Visitors usually get their first taste of fresh bananas in frozen concoctions, but locals prefer theirs plucked right from the tree (in a range of colors and sizes), sliced and deep-fried as a snack or sauteed as a side dish. Add a touch of sweetness and you have a great dessert.

Preservation and preparation

The difference in many native meat recipes lies not so much in the ingredients but in the method of cooking. Not so long ago iron pots heated over charcoal (coal pots) were used to steam food in a process called 'sweating' that delivered tender meats to the table. Foods were served smothered in gravy ('daubing') with seasonings. Kerosene stoves were commonly used for cooking and stone Dutch ovens for baking. Originally cooked on coal pots in India in the *dum* style of cooking, modern *dum* or *dumb bread* is a dense crusty loaf best savored with butter or filled with cheese.

The most common cooking techniques still include the use of coconut. Freshly-shredded ripe coconut can add a tropical fillip to most any dish. Coconut milk and oil used in cooking is worth the added cholesterol and the tedious work of producing it. Stewed or preserved in jars as condiments, wild cherries, mango, passion fruit, tamarind, guava, and papaya make great jellies, jams and chutneys.

The darling of the Caribbean kitchen, fiery Scotch bonnet peppers or *habaneros* ('from Havana') – potent, yellow or red, walnut-shaped chillies – are devilishly hot additions to any recipe or pepper sauce. Avoid the seeds unless you want to sizzle. Laden with capsaicin chemicals that give them their heat, hot peppers do more than flavor food, they help preserve it.

Meaty mealtime traditions

Locally raised goats, sheep, pigs, fowl and cattle find their way into someone's cook pot sooner or later. A hearty soup that belies its name in content and consistency, 'goat water' is made from mutton. Oxtail and bullfoot soups are more literal. 'Souse' is made from pig parts and is traditionally prepared on Saturday.

Made from a combination of pork and veal, traditional Danish meatballs (*Frikadellar*) are a reminder of the Dansker days. A reference to the flavor of allspice tree wood transferred in the cooking process (not a characterization of the chef), 'jerk' chicken, beef and pork recipes have been imported from Jamaica and adapted with great success. As popular as hamburgers in the US, Middle Eastern *kibbe kabobs*, *kufta kabobs* or *shish kabobs* are usually made of lamb. Synonymous with Caribbean cuisine, 'pepperpot stew' is a butcher's delight, combining oxtail, calf's foot, pork, beef and chicken with a single fiery pepper.

A fried pastry filled with meat, vegetables, herbs and spices, the *pate* is the quintessential Virgin Islands fast-food. Favorite fillings include beef, conch, chicken, shrimp, lobster and saltfish. Tracing their ancestry

to the French island of St Barth's, many islanders enjoy the cuisine of the Normandy region which relies heavily on rabbit, tripe and sweet-breads. Those of Hispanic heritage borrowed beef stew and roast pork dishes from Spain. A reddish sauce made from sweet peppers, onions, garlic, herbs and spices, *sofrito* adds both color and flavor.

The Caribbean cousin of the Mexican *burrito*, with goat, shrimp or chicken instead of beans and beefs, *roti* keeps its taste even when served cold. Some of the best recipes for this flat-bread envelope stuffed with curried meat and served with mango chutney, migrated from Trinidad and Tobago. The Portuguese, too, have contributed a splash of the Mediterranean in garlic pork, *fava* bean and saltfish dishes.

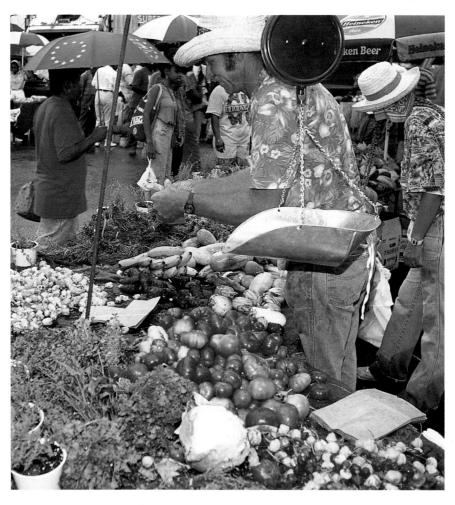

Rain or shine, crowds turn out to sample the Food Fair JAMES 'HUCK' JORDAN

Special occasion favorites

Nowhere do the flavors of Caribbean mingle quite as well as at Carnival Food Fair, an event that has expanded to include so many arts, crafts, plants, local produce and music performances that organizers altered its name to Market Fair. Centered around Carnival celebrations on each island, Food Fair is a chance to sample many delicacies at once.

Keeping ole' time traditions alive, Food Fair cooks still prepare homemade candies like stewed 'gooseberries-on-a-stick', coconut sugar cakes, *dundersloe* (peanuts encased in shiny glass-like sugar), peppermint candies and 'jawbone' (peppermint-flavored red candy wrapped around sticks of white cooked sugar). 'Shingle cake' (whose cross-hatched dough resembles roof shingles) and tropical tarts filled with grated coconut, crushed pineapple or stewed guava, satisfy any sweet-tooth.

A combination of Danish and Caribbean flavors are in order to celebrate the Transfer Day holiday with Danish desserts like 'red grout' (*rødgrød*), made of guava compote or red prickly pear fruit juice, instead of the traditional strawberries and raspberries found in Denmark. The Crucian delicacy made of marinated herring smacks of Denmark, as does the almond *kranse* cake.

Thanks to the Danish love of butter, which has filtered down to Caribbean cooking, the Virgin Islands pioneered the preparation of conch in butter sauce. Similar to a traditional Danish drink served at Christmas, *guavaberry liqueur* is made from a red or yellow fruit that ripens in the fall, is mixed with rum, spices and dried fruits and allowed to stand. Tradition holds that when holiday well-wishers come singing 'Good morning, good morning, I've come for me guavaberry,' the only polite thing to do is share a glass or two and sing some more.

Bright-red sorrel (*roselle*), with spices and liquor added, is served as a Christmas treat. Tiny crisp batter-fried *croustada* shells – traditionally made from odd-shaped cast iron molds – can be filled with creamed chicken, oysters or vegetables for any special occasion, though most cooks reserve them for Christmas celebrations.

Boiled or Danish baked ham, salted beef and sweet breads baked with dried fruits and spices, grace many a Christmas table. Tradition has it that when the Christmas ham was eaten to the bone, it was tossed in a pot with greens and seasoning to make *callaloo* for Old Year's Night (New Year's Eve). A dish to share with neighbors and friends, callaloo brings good luck to all who eat it, including lovers who are guaranteed to 'jump the broom' by June. Speaking of weddings, no traditional celebration would be complete without the much-loved 'black cake,' a mix of fruits, nuts, spices, liqueurs and sugar so rich that it bakes to the color of a moonless Caribbean night.

Bush tea relief

Long before scientists scrambled to save rain forests, Virgin Islanders relied on the curative power of various wild grasses, roots and herbs. Herbal or 'bush medicine' is a tradition of long-standing in the Caribbean where generations of practical experiments with local plants, leaves and roots have provided relief from a multitude of minor ailments, aches, pains and internal disorders. Prized for their medicinal effects, bush teas made from some 420 local herbs, plants and leaves are still touted as cures. Begun in 1991 by Jacquel Dawson, Project Bush Tea pioneered commercial ventures to grow, package and market local teas.

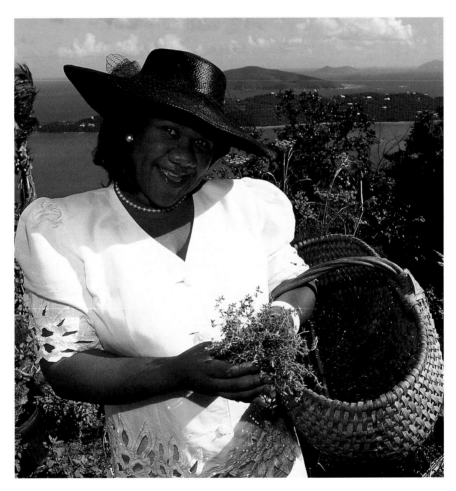

Jacquel Dawson hopes to make the Virgin Islands the 'bush tea capital' of the Caribbean DEAN L. BARNES

Teas named for the 'bush' on which they are found include sugar apple, mango, tamarind, sorrel, mint, bay, sage and lime. Those named for the cure with which they are associated include 'belly ache bush', 'inflammation bush', 'worm grass' and 'worry vine'. Some of the more interesting examples of teas and cures include japona (colds), red clover (blood purifier), ginger root (gas), inflammation bush (menstrual pain, inflammation), worm grass (worms, stomach ache), black wattle (colds), cattle tongue (colds), soursop leaves (relaxant, insomnia, fever), Spanish needle (inflammation, internal cleansing), anise (gas), lemon grass (colds and fever) and *maubi* bark (fish poisoning). Growing freely in the hillsides, hibiscus flowers form the basis of soothing herbal teas. A syrupy beverage, it's also used as a cough remedy.

Spice island influence

The Virgin Islands herb and spice cabinet is dominated by allspice, thyme, curry, cilantro and *sofrito*. Still harvested in late summer from shallow ponds, natural sea salt contains many essential minerals other salts lack. Outdoor markets are the perfect place to stock up on fresh bay leaves and spices like nutmeg, mace and cinnamon stick (bark of the cinnamon tree). The dried bean of an orchid, vanilla is treasured when found in its natural state. It's fun to discover what these seasonings look like before commercial processors put them in jars and attach fancy labels and even fancier prices.

7

Carnival is very sweet

The first organized Caribbean *carnival* (Latin *carne*, meaning 'flesh' and *vale*, meaning 'farewell') held in Trinidad in 1783 had its roots in the masquerade traditions of West African slaves who added their own twists to the pre-Lenten festivals of wealthy plantation owners. After emancipation, freed slaves transformed the bourgeois masquerade balls and heartier *canboulay* (post-harvest burning of cane fields) celebrations into rambunctious street parties where they played *mas* (masquerade) disguised as devils, wild Indians and demons.

Carnival is the cultural glue that has bound Caribbean people for generations and created today's global audience for what the North American-England International Carnival Association estimates are over fifty Caribbean-inspired festivals held each year throughout North America, the United Kingdom and the Caribbean. It's been said that wherever you find more than a handful of Caribbean people – be it tropical island or big city street – there's bound to be a *bacchanal*; but don't be misled by its billing as 'the ultimate party' because carnival is really so much more.

Carnival is a reunion of families and friends. It's a grand *fête* that expresses freedom through the fusion of music and dance; a cultural birthright passed down through the generations. It's a celebration of the best of times that goes on even in the worst of times; a sweet celebration of life itself, so let the party begin!

St Thomas Carnival

First staged in 1912 during the final years of Danish occupation and allowed to lapse during World War I, modern St Thomas Carnival was revived in 1952 with the help of former VI congressman Ron de Lugo. The Caribbean's second-largest cultural festival – surpassed only by Trinidad's pre-Lenten spectacular in Port-of-Spain – St Thomas Carnival is officially celebrated during the last two weeks of April, though opening activities begin weeks earlier.

A month-long series of glittering pageants and talent shows at Lionel Roberts Stadium present reigning carnival royalty candidates – pint-sized princes and princesses, and stately queens – whose

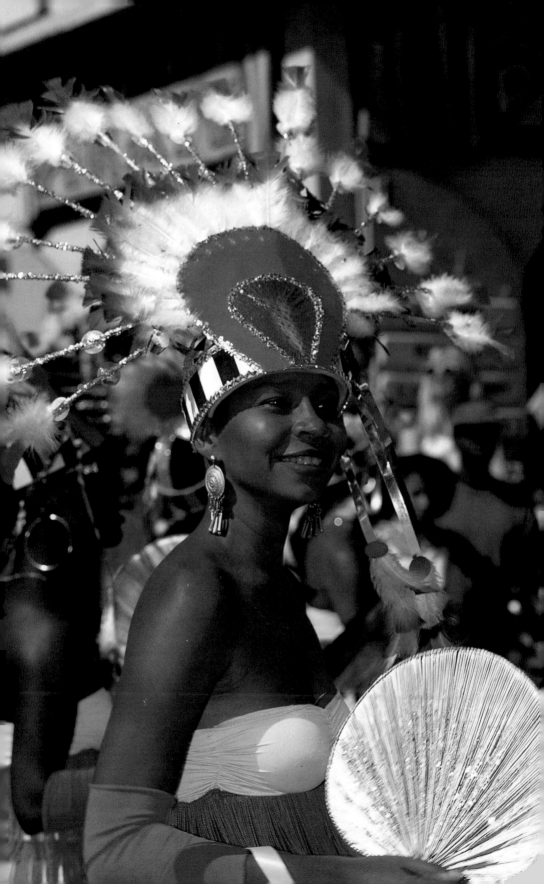

coronation is held later in Emancipation Garden, followed by the formal Anniversary Ball. On the silly side, there's a Greased Pig Contest and Toddlers' Derby-and-Dolls Competition, a perennial favorite among parents. Competing for the public's attention, nightly concerts called Calypso Eliminations present a musical clash between local calypso-king hopefuls. At the Junior Calypso Competition, the voice of youth rings loud and clear through singers like the Mighty Simba and Lady Charlotte, whose witty lyrics often poke fun at adult foibles. Vying for King and Queen of the Band honors, participants parade in magnificent costumes that will later form the centerpieces of parade troupes. The pace picks up during the final week, as powerboats and traditional wooden *batteaus* race on the Charlotte Amalie waterfront. Once the calypso crown has been bestowed, the Calypso Revue serves as an international showcase for rival calypsonians to exchange quips and risqué lyrics.

The liquid sound of steel pan music reigns supreme at Pan-O-Rama. Judging by the wealth of school-age panners – Pan Iguanas, Mellow Hawks, Our Guys, Young Stripes, Devil Rays, Chalkbusters, Sunrays, Meteors and more – the future of sizzling steel pan music is safe. A favorite at Pan-O-Rama and the parades, the Virgin Islands Territorial Court-sponsored Rising Stars Youth Steel Orchestra is a roving ambassador for the Virgin Islands, playing to audiences around the globe. Lovers of the big-band sound of horns pack Lionel Roberts Stadium for the Brass-O-Rama competition where Mandingo Brass, Imagination 'Imagi' Brass, Jam Band, and Milo and the Kings blare well into the night.

The official opening of Carnival Week begins with the dedication of Carnival Village. Lined with booths selling food day and night for weeks, nightly entertainment can range from live bands to bouts of drinking rum-and-coconut water with friends. A traveling Coney Island amusement park provides local tots with a twirl on a merry-go-round. Carnival lovers of all ages join the Pre-Teen Carnival Tramp and Senior Citizens' Quelbe Tramp from Rothschild Francis Market Square to Carnival Village. Saving the best for last, the five most popular carnival events are packed into the last three days, during which loyal carnival-goers seldom sleep.

A mixture of ethic foods and colorful displays of arts and crafts, Market Fair signals the start of the countdown. Usually held in Rothschild Francis Market Square, the much-awaited food-fest panders to every taste with a spread of native delicacies like saltfish, flaky patés,

◀ **St Thomas Carnival** CHRIS HUXLEY

Sunburst costume contender for King of the Band JAMES 'HUCK' JORDAN ▶

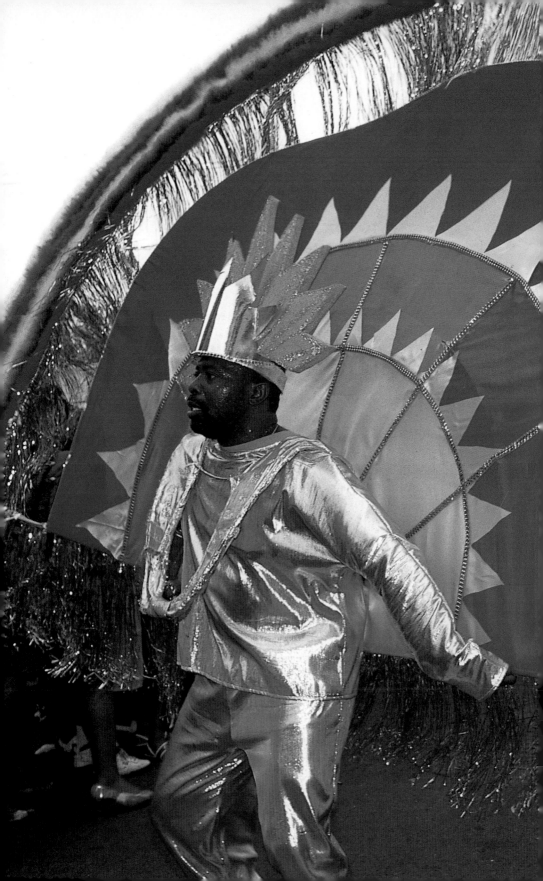

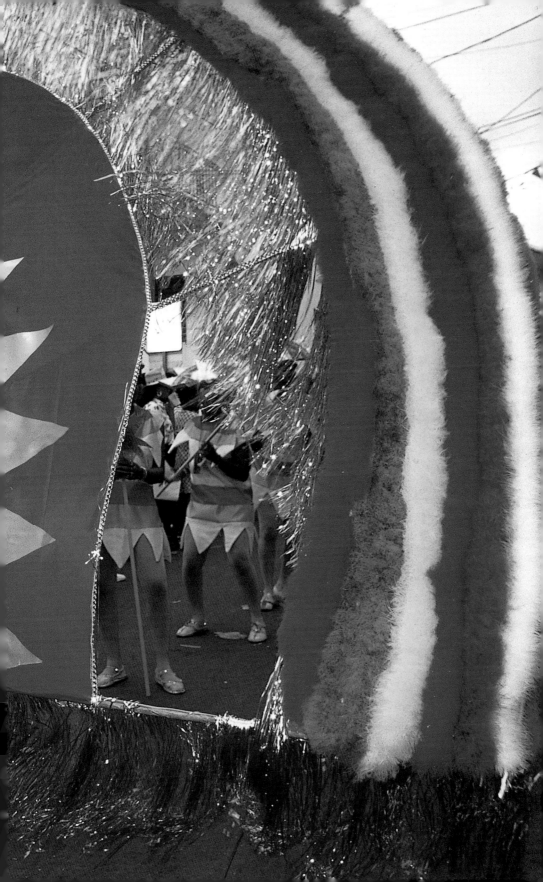

stewed tamarind and potato stuffing that stretches for blocks. Homemade pastries, candies and drinks are displayed next to locally-grown plants and produce. Women sporting 'market lady' skirts and headscarves chop stalks of sugar cane. Just after Market Fair, revelers gather for the VI Calypso Competition featuring local talent like 'Mighty Pat', 'Dr Liburd', 'Trash Row' Cromwell and 'China Dan'. Those still standing after midnight move on to Carnival Village for the J'Ouvert Warm-Up.

From the Village, all roads lead to what many regard as the most popular event of Carnival, the pre-dawn street tramp along the water-front known as *J'Ouvert* (French for the 'opening of the day') that heralds the coming of the parades. Moved by sensual rhythms and the warming rays of the rising sun, thousands of dancing bodies flow as one behind blaring bands on flatbed trucks. Wearing sneakers, tee-shirts, glitter and sometimes little else, whistle-blowing dancers out-perform each other in the spirit of outrageous fun. Needless to say, J'Ouvert is not for the claustrophobic or faint-hearted.

Next morning, the Children's Parade begins its one-mile route through Charlotte Amalie. Gyrating to infectious rhythms and camouflaged as ghosts, iguanas, butterflies and mongoose, hundreds of energetic youngsters dance, whirl and twirl batons on their way to Lionel Roberts Stadium. Following this parade, a trip to the eastern end of the island will ensure that you arrive in time for the annual Carnival Horse Races. For some, a trip home means they'll get some sleep.

The Adults Parade takes center stage on the final day when *troupes* (clubs) showcase spectacular costumes composed of ostrich plumes, pearls, peacock feathers and glittering lamé fabrics. Based on fanciful themes selected the year before and guarded until the morning of the parade, troupes with as many as 500 members transform themselves into African tribesmen, Samurai warriors, giant flowers, musical instru-ments and other outrageous creatures that defy the imagination. One *floupe* (a troupe with a float) of award-winning masqueraders, the 200-member Hugga Bunch, employs the St Croix native son and Mardi Gras maestro Neal Henderson to design its imaginative float and majestic centerpiece costumes that introduce each division. Some of Henderson's masquerade masterpieces are on display in a Smithsonian Institute museum, Washington DC.

Following close behind, rival bands blast spectators with original selections competing for 'road march' honors (song played most during the parade). Road March champions like Jam Band are guaran-teed their tunes will become party 'jam' favorites for years to come. Troupes spend weeks choreographing intricate dance steps to accom-pany their chosen band. An all-day event that often continues after

sunset, the parade is a seemingly endless procession of imaginative creations, a symphony of sight and sound that ends with the traditional troupes of clowns, Indians and Zulu warriors.

St Thomas is ready to breathe a sigh of relief and get some sleep by the time the dazzling Thunder Over Charlotte Amalie fireworks signals the end of yet another carnival and the stroke of midnight closes the Village.

July Fourth Celebration

The only Virgin Islands carnival held in conjunction with America's Independence Day, the St John Fourth of July Celebration is a doubly-delicious treat. A scaled-down version of the festivities on the other two Virgins, St John's Carnival Village is based in Cruz Bay. Surrounded by perfect anchorages, St John is a favorite place for yachtsmen to party or watch the boat races. Revelers in Cruz Bay can stop at the Food Fair to eat, drink and make merry. Just for fun, there are greased pole contests and bun-on-a-string races.

More laid back than its counterpart in St Thomas, J'Ouvert in St John is the perfect occasion for novice carnival-goers to 'jump-up' with the rising sun. Starting at the Village, street trampers circle their way around Cruz Bay before heading home or to the beach for some sleep prior to the start of the Adults Parade. Smaller in population than St Thomas or St Croix, St John compensates by involving a larger cross-section of locals whose parade troupes, floupes and floats display a wit peculiar to St Johnnians. As a final salute to the Fourth of July and the spirit of carnival, a brilliant display of fireworks lights up Cruz Bay.

Crucian Christmas Festival

As in St Thomas, the Crucian Christmas Festival was first celebrated during the Danish occupation, lapsed for decades and was revived in the early 1950s. Contrary to its name, the mid-winter festival begins well before Christmas and continues into the wee hours of Three Kings' Day (Feast of the Epiphany) on January 6. Held at Island Center for the Performing Arts, the Miss St Croix Pageant kicks-off the two-week celebration in mid-December. Noted for its stunning and talented ladies, St Croix Pageant winners have gone on to international competition.

St Croix's Food Fair sometimes goes one better than St Thomas by displaying its edible feast in both Frederiksted and Christiansted. Local delicacies like callaloo, conch and whelk can be found in nearly every booth. The largest of the Virgins, St Croix traditionally hosts Festival Villages at each end of the island.

In olden days street performers 'playing sport' enacted stories of David and Goliath, King Arthur's Court and whatever community or social intrigue captured their imagination at the moment. Close to extinction, but surviving on St Croix as 'Bull-and-Bread', this tradition is closely associated with Christmas celebrations.

From a tiny princess in a very big dress to dazzling troupes of high-stepping majorettes, 'children dem rule' on the day of the Children's Parade that dances through historic Christiansted on its way to the wharf. Boasting over 40 troupes, floupes and floats, the Adult Parade snakes it way down King Street in Frederiksted for the finale of the Crucian Christmas Festival. So explosive are the colors of their costumes that many of St Croix's Adult Parade troupes, like Sanchez and Associates, have waiting lists of new-member hopefuls.

With its strong French heritage, the term *bambooshay* (live it up) is appropriate to describe St Croix's special spirit of sheer abandon. Where else can you spot a local Senator dancing in the middle of the street dressed in silver lamé jumpsuit or toga?

Mocko jumbies

Each region of Central and West Africa has a different word for what we know today as *mocko jumbie*, but regardless of the tag applied, the awesome presence of these scary-masked stilt-dancing spirits during carnival parades has been deeply imbedded in the cultural beliefs of Virgin Islanders for over two hundred years. Once found presiding over weddings, funerals, harvests and festivals as protectors endowed with supernatural powers, the towering height of those who 'mimic the spirits' enabled them to protect villages from evil.

St Croix's John Magnus Farrell and Fritz Marshall Sealy are credited with re-introducing the art form into the Virgin Islands during the 1940s and 1950s. Ali Paul's Original Mocko Jumbies (now the VI Traditional Mocko Jumbies), Hugo Moolenaar's World Famous Mocko Jumbies, Naomi Baylarian's Moko Jumbi 'N' Fren Dem (friends), and Gerry Cockrell's Mocko Jumbie Jamboree have carried on this physically-demanding tradition. Many troupes have performed as cultural ambassadors at CARIFESTA in Trinidad and celebrations throughout the world.

Mocko jumbies protect their anonymity with masks meant to frighten and colorful costumes. Traditional African troupes wear goat skin masks covered with cowrie shells, baggy pants decorated with leather strips and mirrors (evil spirits are afraid to see themselves), beaded vests, skirts and headpieces made of raffia. Ali Paul introduced glamorous costumes of satins, cottons and taffetas with sequin trim, ribbons, feathers and ruffled shirts worn with pants or skirts.

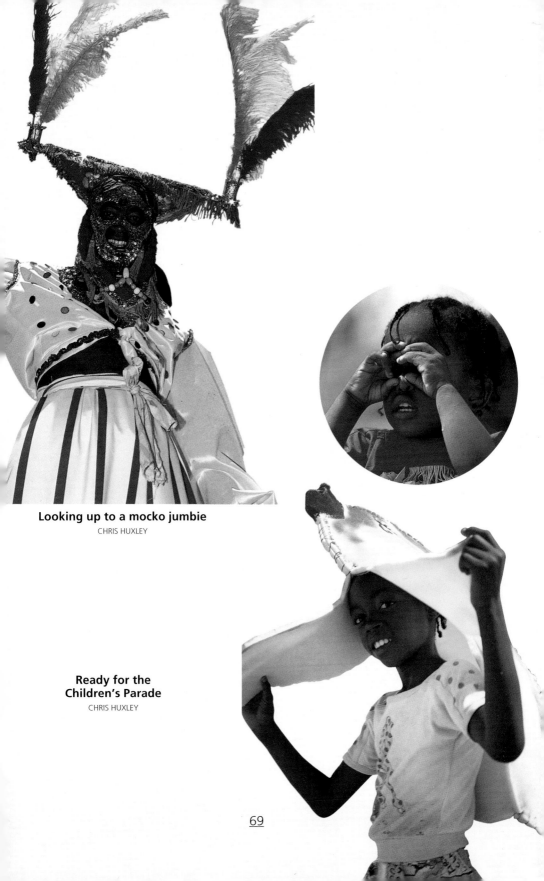

Looking up to a mocko jumbie
CHRIS HUXLEY

**Ready for the
Children's Parade**
CHRIS HUXLEY

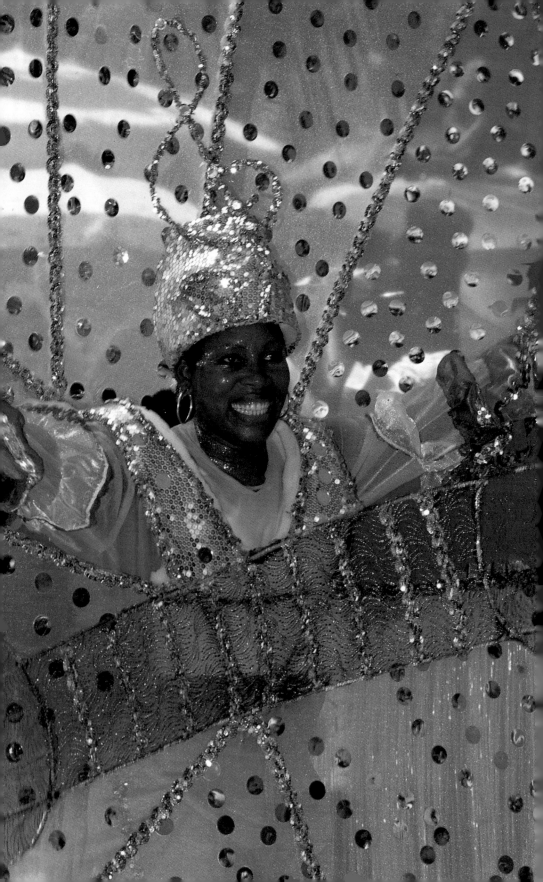

Visitors welcome

As a major tourism product, Virgin Islands carnival celebrations annually attract thousand of visitors and leave a lasting imprint on the Territory's cultural, social and economic landscape.

If you feel you're ready to 'wine yuh waist' and jump-up at carnival on any of the Virgin Islands, don't worry about securing a costume; all you need is a willing spirit and a desire to let loose. 'Playing mas' is after all, a state of mind!

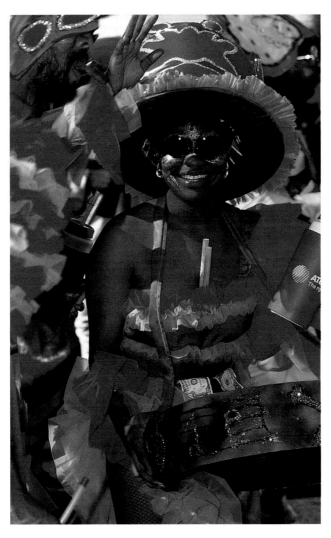

The drum is silent, but the costume says it all CHRIS HUXLEY

◀ CHRIS HUXLEY

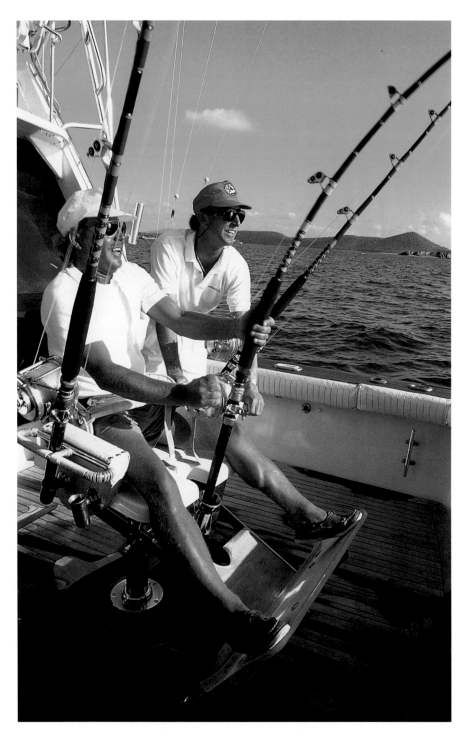

Enjoying the challenge – sportfishing in St Thomas CHRIS HUXLEY

8
Sporting life

Whatever your energy level or athletic ability, you'll soon discover that our islands are a paradise for lovers of sport and the great outdoors.

Sportfishing

The Virgin Islands are among the world's finest sportfishing grounds for amateur and professional anglers. Captains Johnny Harms and Tommy Gifford are credited with pioneering sportfishing in the 1950s and discovering the North Drop, a 100-fathom abyss located 20 miles north of St Thomas in British waters, that draws migrating marlin from June through October and anglers from around the globe. Harms established the first fishing charter at St John's Caneel Bay resort, not far from the South Drop, a popular spot for kingfish, dolphin and wahoo. Our shorelines promise catches of bonito and mackerel, while our mangroves harbor snook and bonefish. Charters are a breeze to book.

Since the Virgin Islands Game Fishing Club (VIGFC) was begun in 1963, anglers fishing the Virgins have recorded dozens of International Game Fish Association (IGFA) world-record catches. Weighing 1,282 pounds, Larry Martin's 1977 record-breaking Atlantic Blue Marlin greets visitors at the Cyril E. King Airport. The August USVI Open/ Atlantic Blue Marlin Tournament, founded in 1972, has earned its reputation as one of the world's top six billfish competitions and the 'Olympics' of Blue Marlin Tournaments.

Held in St Thomas each July, the American Yacht Harbor Billfish Tournament is a team competition for anglers chasing blue and white marlin. Held over the July Fourth holiday since 1964, the July Open Tournament is the Territory's longest-running sportfishing competition and generally coincides with the World Cup Blue Marlin Championship.

The St Croix Game Fishing Club-sponsored Golden Hook Challenge, first held in October 1994, features a sportfishing and billfishing competition that begins at its own 100-fathom drop-off just two miles offshore – one of the deepest troughs close to shore on the face of the planet. Another favored spot is Lang Bank, a mere ten miles off the

coast. Surrounded by a narrow shelf, St Croix boasts fine bonefishing closer to shore.

Boating

Wherever there are wind, water and boats, there are people who dream of crossing the finish line first, cruising to the next exotic port-of-call or leisurely sailing to the nearest anchorage in time for lunch. Blessed by tradewinds that seldom sleep, the Virgins are home to year-round sailing and power boat activity centered around yacht clubs, charter companies and marinas of every description.

> *Per capita, the Virgin Islands have more professional women captains than anyplace else on earth, so don't be surprised if your ferry or charteryacht skipper is a she instead of a he.*

Yacht racing

From mega-buck maxis, to eight-foot dinghies for kids, the Virgin Islands racing scene is nothing short of spectacular. Held over the Easter holiday in the waters off St Thomas, the International Rolex Cup Regatta – the 'Crown Jewel of Caribbean Yacht Racing' – anchors the three-regatta race series known as the Caribbean Ocean Racing Triangle (CORT). Sponsored by Rolex Watch Company of Switzerland since its inception in 1973, this St Thomas Yacht Club-hosted sailing championship consistently attracts top-ranked international racers and the world's yachting press. A repeat winner at Rolex, St Thomas' Peter Holmberg took the silver medal in Finn Class at the 1988 Seoul Olympics and is ranked among the world's top ten match race sailors. In 1996, Holmberg began the Virgin Islands America's Cup Challenge campaign for the America's Cup 2000 in New Zealand. On frequent display in Charlotte Amalie Harbor, the syndicate's first training boat is the former America's Cup trial horse, *Stars & Stripes '92* (see page 118).

Junior skippers from several continents converge on St Thomas each June for the Caribbean International Optimist Regatta that features the pram that has introduced over 150,000 youngsters in 80 countries to the lifetime sport of sailing. Begun in 1986 to encourage sailing by women in the Caribbean, the Veuve Clicquot Women's Laser Championships are hosted each September in St Thomas.

St Croix attracts racing yachtsmen from the Caribbean for the annual Mumm's Cup Regatta, an open-ocean 'Champagne Regatta' hosted by the St Croix Yacht Club on Memorial Day weekend. The

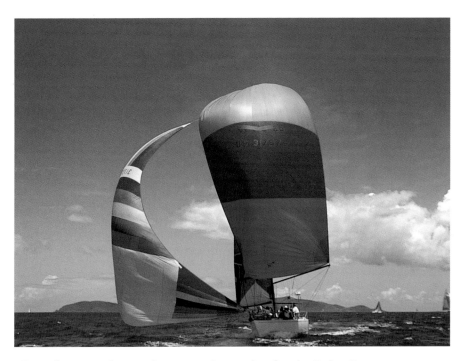

Two chutes are better than one when racing for the Rolex Cup DEAN L. BARNES

The Virgin Islands' America's Cup team in training A.J. BLAKE

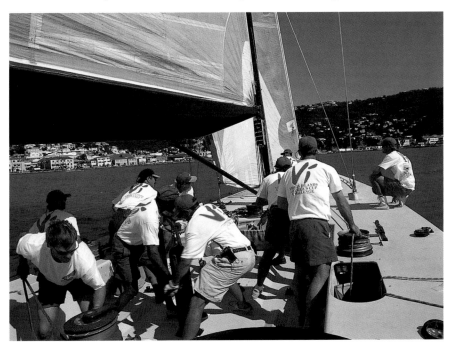

oldest continuously run sailing race in the West Indies, the Memorial Day Regatta has pitted sailors departing from the St Thomas Yacht Club on a run straight across the Mona Passage to the St Croix Yacht Club since 1954.

In any given month, local clubs and organizations will usually host racing events open to the public. Some of the more offbeat competitions include the Conch Shell Regatta, Boxing Day Race, the Pigs-In-the-Water Race, and the infamous Foxy's Wooden Boat Regatta in the British Virgins.

Cruising adventures

Considered one the world's finest cruising grounds, the Virgins attract yachtsmen searching for the perfect anchorage or making a passage to the Pacific Ocean via the Panama Canal. First run in 1990, the West Marine Caribbean 1500 Cruising Rally annually shepherds sailing yachtsmen from North America on a 1,500-mile offshore passage to the Virgins. Other visitors in the winter include luxurious mega-yachts (complete with private helicopters and starched-uniformed crews) that migrate from the Mediterranean and keep locals wondering which mysterious foreign prince, movie star or Greek tycoon will step ashore next.

Vacations afloat

Home to the Caribbean's first charter yacht fleet, the Virgin Islands offer affordable fully-crewed (captain and chef provided) or bareboat (you're on your own) vacations for couples or families who prefer to spend a custom-made holiday afloat. Theme charters like 'swing-and-sail' (golf and sailing) let vacationers enjoy the best of both land and sea. The Virgin Islands Charteryacht League holds its annual boat show each October to showcase the fleet to charter brokers and travel agents.

Day sails aboard monohulls, catamarans and power yachts can easily be arranged on-island. Most excursions include lunch at a secluded anchorage and snorkeling. Whether you choose to take a ride on America's fastest certified passenger vessel, *Wild Thing*, or enjoy a tranquil sunset sail with dinner and cocktails, be sure to reserve at least one day to see these islands afloat.

A spectacular sea fan dwarfs a snorkeler CHRIS HUXLEY ▶

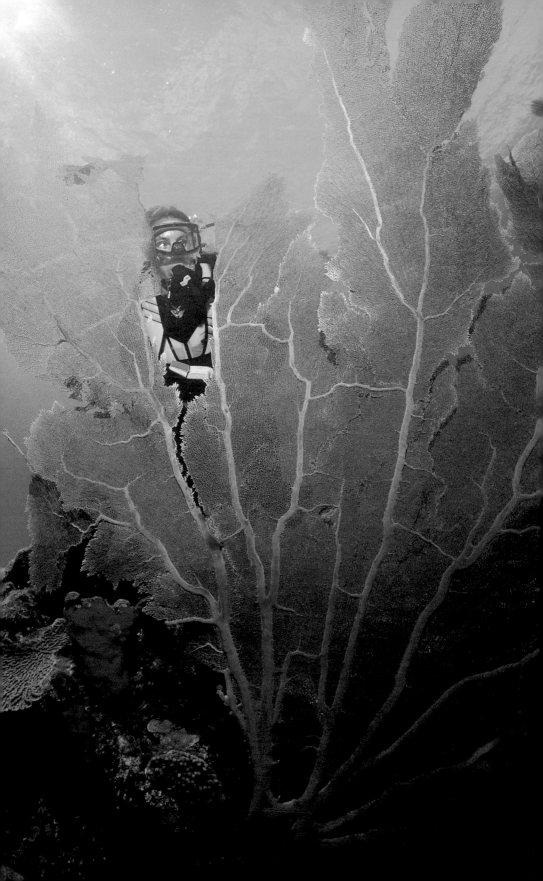

Wet and wild watersports

Deciding whether to fly high above the waves on a parasail or splash among them on a surfboard, jet-ski or wave runner, is often the toughest task for watersports enthusiasts. If a paddle in the Caribbean Sea strikes your fancy, you can even embark on an ocean kayak adventure.

A windsurfer and boardsailor's paradise, the Virgin Islands serve up warm waters, sunny skies and steady tradewinds so consistently that St Thomas was selected as the venue for the 1997 US Windsurfing Association National Boardsailing Championships. Beginners find our calmer bays perfect for refining the subtleties of tacking and jibing, while experts enjoy the stronger winds and heavier seas between islands. The St Thomas Wind Surfing Association and local clubs regularly host professional and amateur competitions, like the Caribbean Team Championships, and the Virgin Islands oldest boardsailing regatta, the Windsurfing Games. Star athletes represent the Virgins in the Pan Am Games and the Olympics.

Surrounded by the world's largest and wettest playground, the Virgins are the perfect venue for swimming. Surprisingly, a lot of local youngsters have yet to learn, so organizations like Kids and the Sea and the St Thomas Swimming Association hold regular classes and competitions.

Diving and snorkeling

Plunge into some of the world's finest underwater scenery while snorkeling or sports diving. Our warm clear waters offer maximum comfort and visibility for shallow water dives or deep-water adventures. Major resorts or independent dive shops can arrange short resort courses or full certification programs that allow you to explore spectacular reefs, marine life, wrecks, coral canyons and caves, or even search for sunken treasure. From afternoon beach dives to week-long live-aboard excursions into 'nature's secret garden', packages are available to suit every level of experience and area of interest.

Sticky wickets

Cricket was introduced into the Caribbean in the mid-1800s, when the Duke of Wellington mandated matches on every British military base, and is well-suited to the leisurely pace of the tropics – a match can last from one to five days. Once likened to 'baseball on Valium' this sport should be respected as a passion, not a pastime. Cricket stars selected to play on the West Indies team – that once seized victory from

England on the hallowed grassy oval known as the Lord's Cricket Ground – approach immortality.

The starched game of English cricket takes on a new exuberance when played before local spectators. Don't let the peculiar vocabulary of the game – with positions like short leg, silly mid-on, batsman and bowler – keep you from experiencing a sport of great subtlety and grace.

Other spectator sports

Spectator sports such as baseball, softball, basketball and soccer are played in most communities as school competitions or recreational activity for 'over-the-hill athletes' who usually retreat to local bars to lick their wounds after the game. Individual sports, such as fencing and martial arts, are also popular. Proud of home-grown champions like Julian Jackson and Emile Griffith, dedicated boxing coaches train hopeful youngsters in gyms and fitness centers. Horse racing tracks in St Thomas and St Croix offer year-round excitement, while races planned around carnival festivities attract speedsters from other islands.

Tee-off by the sea

The challenging 18-hole championship course at St Croix's Carambola Golf Club (see page 147), designed by Robert Trent Jones, is open to guests for a nominal fee. Set in a valley sprinkled with lakes, tropical groves and mountain views, Carambola has been hailed as one of the world's finest resort courses by *Golf* magazine, which designated the botanical beauty a 1989 Gold Medal Award winner.

St Croix's other world-class 18-hole course, designed by Bob Joyce, is located on the grounds of the Buccaneer Hotel (see pages 97, 146). The scenic Buccaneer Golf Course features views of the Caribbean Sea and its trademark sugar mill. The Reef at Teague Bay (see page 146) offers a quick 9-holes for beginners or experts.

The 18-hole championship course at the Mahogany Run Golf and Tennis Resort in St Thomas was designed by George and Tom Fazio to provide breath-taking vistas while challenging a golfer's skill. Golfers are warned as they enter the 'Devil's Triangle' overlooking the Atlantic, and those who survive the signature 13th, 14th and 15th holes without a penalty stroke receive a certificate to prove it. Cruise ship passengers with only a day to play can arrange special packages.

The St Thomas–St John Golf Association and the St Croix Golf Association have each hosted numerous competitions, including the

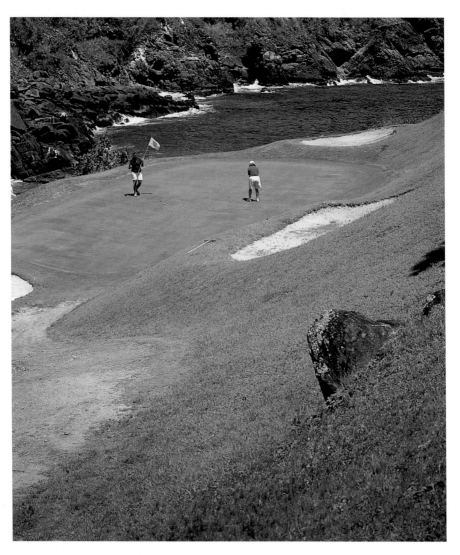

Enjoying the game at the Mahogany Run golf course
CHRIS HUXLEY

Ladies Professional Golf Association (LPGA) Pro/Am Tour and the St Thomas Open, which attracts golfers from the Caribbean and US mainland.

Tennis anyone?

St Croix boasts 43 private tennis courts at various hotels and tennis resorts (some reserved for members and guests only) as well as free

public courts in Christiansted's DC Canegata Park and Frederiksted's Buddhoe Park. St Thomas has nearly 50 courts scattered among hotels and resort locations, and several 'first-come, first-served' public courts. St John's Caneel Bay (see page 129) and other resorts have some 17 courts between them and two public facilities.

Triathlon

The scenic harbor and mountains of St Croix test the mettle of the world's finest triathletes in the annual St Croix International Triathlon that boasts a grueling 2k swim, 55k bike and 12k run competition that is broadcast around the globe. The four-stage world-class bicycle race, the Tour de Croix, is held at the same time. If you plan to do any recreational running or jogging, take a tip from top athletes and avoid the noon-time sun and traffic on curving roads.

Horseback riding

Visitors who'd like to see the sights from horseback can make arrangements with local stables and riding clubs. Paul and Jill's Equestrian Stables on St Croix offers trail rides to the rain forest and moonlight excursions. Pony Express Riding Stables on St John trots through the woodland trails and beaches of the National Park. Starting at Bordeaux Mountain (see page 136), they'll customize a romantic ride by moonlight.

Now we're camping!

If the idea of spending a week or more communing with nature at some seaside campsite – wearing a swim suit and little else – is your idea of fun, then be sure to visit the VI National Park's Cinnamon Bay and Maho Bay Campgrounds on St John (see page 134), complete with tents, wandering donkeys, and perfect vistas. The rustic Cinnamon Bay offers cottages, tents and self-guided nature trails to introduce you to local greenery. History buffs will enjoy the museum and amphitheater slideshows.

Campers at environmentally-correct Maho Bay Camps can expect a tent-cottage resort whose raised boardwalks keep them from trampling the native vegetation. Built largely by hand to minimize damage by heavy equipment, Maho's low-impact design offers an intimate brush with nature. Maho's developer, Stanley Selengut, has been recognized by conservationists for utilizing recycled materials for construction and furnishings at the more luxurious Harmony Resort – cited as

one of the world's top eco-sensitive honeymoon destinations (see page 96). His other St John projects include Estate Concordia and Concordia Eco-tents.

Hiking

Self-guided hiking tours of Butler Bay Nature Preserve on the northern shore of St Croix offer tropical forests, waterfall, wildlife and ruins. The St Croix Environmental Association and Take-A-Hike sponsor eco-hikes and town tours. The Environmental Association of St Thomas (EAST) sponsors interesting hiking tours of beach and wooded areas as well as seasonal whale watches.

Let it snow!

While the notion of a tropical bob sled team may tickle your funny bone, it's no laughing matter for the serious athletes who train on sand and snow for coveted positions on the USVI Olympic team in two and four-man bob sled. Heated competition between Caribbean teams keeps this cold-weather sport exciting – to those who dream of building sandcastles in the snow at far-away Olympic competitions and those who stay at home to cheer them on.

Virgin Islands' Olympic Bob Sled team
taking time out ARLENE R. MARTEL

◄ CHRIS HUXLEY

9
Nature's playground

When the Antilles chain was thrust from the ocean floor more than a 150 million years ago, nature began carving intricate seascapes and cultivating exotic landscapes on what is now the US Virgin Islands. Still fabled for their beauty, the Virgins form a vast ocean playground where the history of man mingles with the magic of nature in the tangles of the rain forests, at the water's edge and in gardens beneath the sea.

Seascapes

Our beaches and coastline provide a habitat for wildlife and a barrier against the sea. Composed of mangroves, salt ponds, seagrass beds and coral reefs, our aquatic ecosystems alone support over a thousand species of plants and animals.

Shorebirds

During the winter, shorebirds that migrate from as far as Alaska or the Canadian Arctic – the plover, sandpiper, yellowlegs, short-billed dowitcher, sanderline and whimbrel among them – can be found along our beaches and salt ponds. Shorebirds that transit during annual migrations include the white-rumped sandpiper and red knot.

Birdwatchers may spot our most rare visitors, the Hudsonian godwit, Wilson's phalarope, piping and snowy plovers, or others that qualify as permanent residents, such as the black-necked stilt, Wilson's plover and killdeer. Masked boobies and sooty terns prefer the quiet of off-shore French Cap and Saba Cay.

Mangroves

Rooted to the land but extending protection to marine life, the red mangrove (*Rhizophora mangle*) is one of our most vital plants. Found on sheltered shorelines, this evergreen forms colonies called 'manglars' that are nesting and feeding sites for heron, egrets and hummingbirds. Mangroves provide protection from wave erosion as well as a nursery for spawning lobsters, crabs and fish. The black mangrove (*Avicennia germinans*) is a favorite habitat of honey bees, while the white

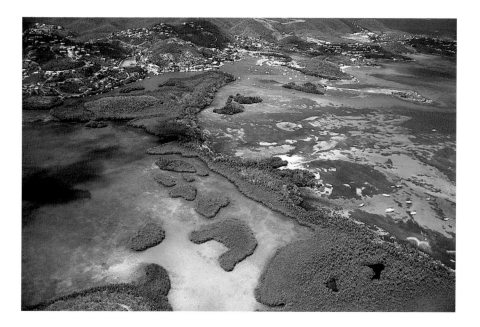

Mangrove lagoon, St Thomas CHRIS HUXLEY

(*Laguncularia racemosa*) survives by excreting excess salt through pores at the base of leaves.

The 500-acre salt pond near Sandy Point, St Croix (see page 152) is a habitat for marine and wildlife. Set aside in 1994, the Compass Point Pond Marine Reserve and Wildlife Sanctuary on St Thomas encompasses an extensive mangrove lagoon and salt pond inhabited by the locally endangered Bahama duck, the great blue heron, and other species.

Seagrass

Flowing plants that live underwater, seagrasses grow from underground roots called *rhizomes* and are essential to maintain clear water, stabilize the ocean bottom and provide habitats and nursery areas for marine life. Not to be confused with seaweeds (colonies of algae), seagrasses include the flat-leaved shoal-grass (*Halodule wrightii*) that grows in the shallows, turtle-grass (*Thalassia testudinum*), whose ribbony leaves can grow to a foot or longer, and the rounded leaf manatee-grass (*Syringodium filiforme*).

Coral reefs

Coral polyps are animals that feed on plankton. When they die their hard skeletons accumulate to produce coral reefs, sometimes taking

centuries to do so. The underwater equivalent of rain-forests in complexity, reefs support hundreds of species of marine life which grow only in water that remains above 68 degrees Fahrenheit. Stony corals like brain coral, star coral and plate coral, grow less than a half-inch per year and even the fastest-growing coral in the Virgins, the majestic staghorn, grows only four to six inches annually. Even more slow-growing than corals and incapable of movement, animals called sponges (*Portifera*) have carpeted our aquatic gardens with color for more than 300 million years.

Beaches are replenished by deposits of marine organisms, such as shells and coral fragments, pulverized over time to sandy softness. It is illegal to remove any marine growth or natural material from the water or beach. Island-fringing reefs support both hard and soft corals.

Among the multicolored tropical fish which inhabit this underwater region, beach-lovers will appreciate the efforts of the coral-chewing parrotfish (*Scaridae*) that can produce 30 pounds of sand per year. The boldly-striped clownfish (*Barbus everetti*) may look the part, but when a predator approaches, this clever creature seeks the protection of a sea anemone (*Condylactis gigantea*) that comes armed with stinging tentacles. The removal of tropical fish like the delicate seahorse (*Hippocampus*) for aquariums, requires a special permit.

Most ocean-dwellers are harmless, but those to avoid include the Portuguese man-of-war (*Physalia pelagica*), fire corals (*Millepona alicornis*), long-spined sea-urchin (*Diaderma antillarum*), spotted scorpionfish (*Scorpaena plumieri*), stingrays (*Dasyatidae*), bristle worm (*Chloeia viridis*) and moray eels (*Muraenidae*).

Sea turtles

After surviving for over 150 million years, the seven species of sea turtles remaining in the world are in danger of extinction. Designated as a National Wildlife Refuge in 1978, the St Croix Leatherback Turtle Recovery Project protects the Sandy Point habitat of the leatherback turtle (*Dermochelys coriacea*) (see page 152). The largest of all sea turtles with a six-foot upper shell or *carapace*, leatherbacks can weigh as much as 1,300 pounds. They have been know to swim 3,000 miles to return to the beach of their birth and can dive to depths of 3,900 feet. The leathery eggs of these marine reptiles are laid in batches on the beach, where they are threatened by natural predators and human poachers who consider them an aphrodisiac. Protected by federal law, it is illegal to molest, kill or remove marine turtles or eggs.

Coral off Buck Island CHRIS HUXLEY ▶

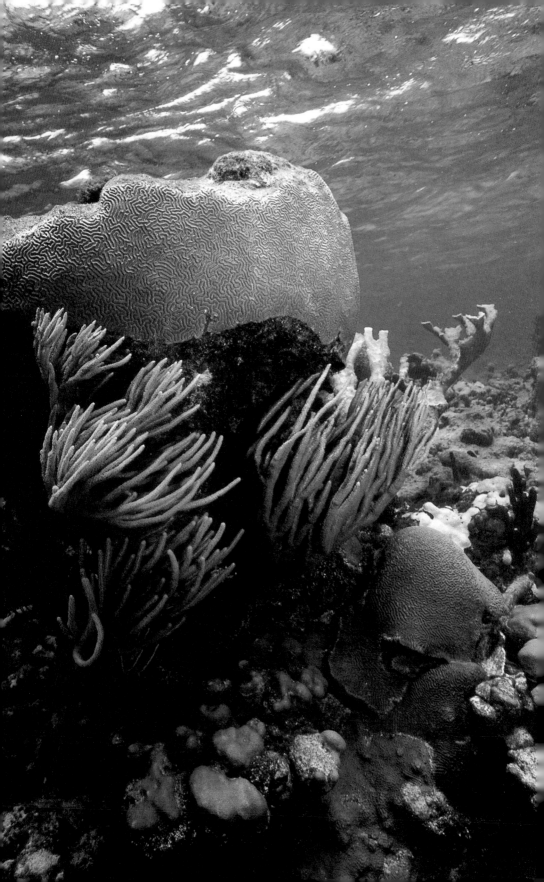

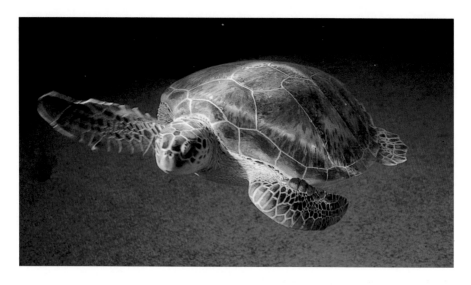

An endangered species, the hawksbill turtle (*Eretmochelys imbricata*) can reach 36 inches and weigh 200 pounds. Hawksnest Bay on St John is a nesting site MICHAEL BOURNE

The smaller green sea turtle (*Chelonia mydas*) grows to about 40 inches and ranges from 300 to 350 pounds.

Fishery conservation

Fishery reserves now protect areas where popular eating-fish, like the mutton snapper (*Lutjanus analis*), gather to spawn. Listed on menus as 'old wife', the queen triggerfish (*Balistes vetula*) is rapidly diminishing.

To preserve our resources, regulations prohibit spearfishing in National Parks and restrict the taking of undersized or egg-laying female spiny lobsters (*Panulirus argus*) and queen conch (*Strombus gigas*), as well as the tasty West Indian topshell known as 'whelk'.

Efforts to protect blue marlin (*Makaira nigricans*), a primary sportfish, have led to the tagging and releasing of more than 75 percent of all billfish catches. Under local law, blue marlin, white marlin (*Tetrapturus albidus*) and sailfish (*Istiophorus platypterus*) catches cannot be sold and can legally be captured only by rod and reel.

Whales

The largest animals inhabiting the planet, endangered whales such as humpbacks (*Balaenopteridae*) migrate through the Virgins on their way from the Atlantic to the warmer waters of the Caribbean, where they mate and return to calve nearly a year later. Weighing as much as 53 tons, the majestic humpback is known for its cosmic songfests that

can last for hours and distinguish individual members of a pod. Whale watchers commonly spot humpbacks from December through April and some have sighted breaching pilot, finback, minke and sperm whale species. Smaller members of the whale family, bottlenose dolphins (*Tursipos*) occasionally play alongside swimmers or surf in the bow-wave of boats.

Sharks (*Selachii*) may not be everyone's idea of a perfect ocean play-mate, but these predators who have survived for 400 million years are vital to the health and balance of the ocean ecosystem.

Landscapes

When you eventually turn your back on our turquoise seas, you'll discover that our landscapes and the wildlife that inhabit them are what give each island its unique character.

Birds

Many species of bird have been hunted into extinction, though the cooing morning dove (mountain pigeon) still thrives in wooded hillsides. Migratory visitors include the bobolink, yellow-bellied sapsucker, the Caribbean martin and Jamaican vireo.

It's hard to ignore the pearly-eyed thrasher, the 'hit-and-run bandit' of the bird world, and the sight of a red-tailed hawk soaring on the thermals or a peregrine falcon dropping like a missile is quite unforgettable. So too that miracle of motion, the green-throated hummingbird, as it hovers above a flower, delicately sipping its nectar.

The power-diving brown pelican is a dedicated fisher whose pouch can hold two gallons of water. The scissor-tailed frigate (man-o-war) will pirate fish from others, while the scavenging laughing gull (*Larus atricella*), noted for its distinctive cry, will do the same to a pelican. Local lore tells us the gull may sit on a pelican's head and snatch any fish hanging from its beak in exchange for crying 'have, have, have' throughout its lifetime.

Other birds that add color are the screeching flocks of wild parrots that make their presence known in remote areas and the wild parakeets, flashing green and yellow in the treetops at dawn.

Amphibians

Once endangered, a population of ground lizards (*Ameiva polops*) has been discovered on St Croix's Green Cay. Six species of native lizards can be found scurrying in the bush feeding on insects, but the fierce-looking iguana is usually reclusive and prefers to nibble on hibiscus.

**The official bird of the Virgin Islands,
the sweets-loving yellow breast *(Coereba flaveola),*
is also known as the bananaquit or sugar bird**
RICHARD FFRENCH

Fond of digging test holes before laying a batch of leathery eggs, female iguanas can turn a backyard into a moonscape in a matter of days (see also page 5).

Coki frogs and several species of toads are common and can create a ruckus when it rains, but they keep the insects in check. Though several species of small snakes are reported in the Virgins, specimens are rarely spotted. Harmless to humans, the Virgin Islands tree boa (*Epicrates monesia granti*) likes to hide in coconut palms. To save boas from extinction, some have been bred in captivity and reintroduced to Congo Cay.

Mammals

The islands' only surviving indigenous mammals, the Jamaican fruit bat (*Artibeus jamaicensis*), cave fruit bat (*Brachyphylla cavernarum*) and red fruit bat (*Stenoderma rufum*) contribute to the survival of forest ecosystems by dispersing seeds and pollens.

Introduced from India in the late 1800s, the furry brown mammals called mongoose were favored by planters for rat control in the canefields. Nocturnal rats no longer compete with day-foraging mongoose so the mongoose density in the Virgins is among the highest in the world. Because they eat eggs of some endangered species, the cute little creatures are not universally adored, though they have worked their way into children's books and folklore as the unofficial mascot of St John.

Plants

Whether they are native to the soil (indigenous) or introduced by man (exotic), plants have played an important role in the evolution of our islands. When Europeans arrived, they discovered that the West Indies could provide precious woods, spices, fruits and medicines. What forests survived the clearing of land for timber and crops were ravaged for making wood charcoal.

First domesticated nearly 12,000 years ago in New Guinea, sugarcane (*Saccarum barberi*) has probably shaped the face of the Caribbean more than any other single species of plant. Sugarcane became the center of a vicious triangle: grown and refined by slaves to make molasses, then sold to rum-making North Americans and Europeans, who traded for slaves in Africa and shipped them to the Caribbean – to grow yet more sugarcane.

Utilized in its entirety – for making everything from thatch roofs, soap, cooking oil and hats to brooms and brushes – the coconut palm (*Coco nucifera*) is one of the most useful trees in the world. Its clustered fruit are among the largest seeds in the world and can be fatal when dropped from 60 feet.

The manchineel tree (*Hippomane mancinella*) is so toxic that a drop of its milky sap or leaf run-off can blister skin or cause blindness. Early islanders tipped their arrows with its poison. Found near beaches, its tempting yellow-green fruits, dramatically called 'death apples', have dispatched the unwary to the infirmary.

Among the tallest in our forests, the turpentine tree (*Dacryodes excelsa*) exudes a fragrant resin used to make incense. Its straight logs were hollowed for canoes. The closely-related gumbo limbo (*Bursera simaruba*) has a medicinal sap that smells like turpentine and is used in perfumes (see also page 94), inks and varnish.

The Spanish cedar (*Cedrela ororata*) is highly valued for its fragrance, while the white cedar (*Tabebuia heterophylla*) is popular for furniture and its leaves for medicine. Likely the most valuable timber tree in the tropics, the Honduras mahogany (*Swietenia macrophylla*) features a straight trunk, but larger leaves than the West Indies mahogany (*Swietenia mahagoni*) introduced to the Virgin Islands.

A popular ornamental, the fiddleleaf fig (*Ficus lyrata*) gets its name from its violin-shaped leaves. The termite-resistant wood of the shady gre gre (*Bucida buceras*) is useful for building and its bark for tanning leather, and the Brazilian rose (*Cochiospermum vitifolium*), used as natural fencing bursting with yellow flowers, has bark that's used for rope.

Orchids are well suited to the Virgin
Islands' climate CHRIS HUXLEY

Noted for its cascading colors, the
papery bougainvillea was named
for Frenchman Louis Antoine de
Bougainville, who introduced it to
the region. Today, bougainvillea
blooms throughout the Virgins

DEAN L. BARNES

Papaya are hard to reach but
worth the effort DEAN L. BARNES

Native to Asia, the coral bead (*Adenanthera pavonina*) tree has heavy wood used in construction. Its bright red seeds, known locally as 'jumbie beads', are favorites for jewelry.

Native to Mexico and South America, the shady raintree (*Samanea saman*) can grow to more than 60 feet. One popular story links its name with the rain-like sound of the wind rattling its pods.

Used for making brooms, the brittle thatch palm (*Thrinax morrisii*) is related to the teyer palm (*Coccothrinax alta*), seen growing in groves. Its flexible leaves are valued for weaving rope and hats. The stately 60-foot royal palm (*Roystonea borinquena*) can be recognized by its swollen trunk and clustered fruits that hang in strings.

Imported from Madagascar, the flamboyant can be spotted on hill-sides when it bursts with crimson blossoms tinged with orange and yellow. A favorite 'Johnny Flamboyant Seed' story on St Thomas remembers Ariel Melchior Sr who scattered seeds by plane in 1950. Older yet, is the Caribbean legend that has immortalized the flamboyant as a symbol of undying love. During winter, brilliant red or white poinsettias bloom freely in front yards.

Widely recognized by its red flower that only opens for a day, the hibiscus (*Hibiscus rosa-sinensis*) blooms year-round. Hybrids have produced a variety of colors and added petals.

A fast-growing evergreen known as ginger thomas or yellow cedar (*Tecoma stans*) bears a trumpet-shaped bloom throughout the year that has been designated the official flower of the US Virgin Islands. Originating in humid climates, more than 500 species of orchids are well-suited to island survival. Orchids compose the largest plant family with 30,000 species worldwide, not counting hybrids.

Found everywhere, the colorful but poisonous oleander adds to the landscape. A useful member of the pokeweed family, the hoop-vine (*Trichostigma octandrum*) is a favorite among basket makers and fishermen who weave it into fish pots (see page 35).

Locals are quick to attach whimsical names to plants like the 'cutlass tree' with its scabbard-shaped blooms, the 'sensitive plant' that curls when touched, 'man's heart' that changes color daily, 'woman's tongue' whose dry pods rattle, the parasitic 'love vine' that smothers its host, and the fast-growing 'quick-stick'. The thorn-spiked 'monkey-don't-climb' tree is self-describing and the 'cock-a-locka' and 'clashie melashie' make good tongue-twisters.

Sea grapes (*Coccoloba uvifera*) thrive on sandy coastal areas and can be identified by leathery round leaves with a distinct red vein. The grapes are used in jelly and beverages. Cultivated for its dark green fruit, noted for fleshy spines and pulpy white flesh, the soursop (*Annona muricata*) fruits in the fall. Lovers of papaya (*Carica papaya*) have to race other

creatures to the yellow melon-like fruit when it ripens. The quick-growing papaya can reach 20 feet. Best known for its rosy fruit that adds flavor to rum punch, guava (*Psidium guajava*) can be cultivated.

Wild burros especially like tamarind (*Tamarindus indica*), whose brownish pods bear a pulp that makes tart but tasty preserves and beverages (see page 49). Sometimes sold on roadsides, the grapelike bunches of the sweet-sour genip (*Melicoccus bijugatus*) have been called 'poor man's candy'.

A member of the *Agave* family of succulents, the century plant can take as long as 60 years to produce its golden blooms, shooting up a stalk that can reach 20 feet or more. When cut, dried and decorated, the century serves as a recyclable Christmas tree. A member of the Lily family, the aloe (*Aloe vera*) clings to rocks and thrives in arid areas. Its sword-like leaves contain a bitter yellow latex used for treating burns and ailments. The succulent flowers from January through May by shooting a stalk topped with a yellow flower.

The African tulip (*Spathodea campanulata*) is an exotic tree with medicinal value. It has winged seeds and scarlet blossoms fringed with yellow, and birds sip rainwater trapped in its flowers.

The islands host many species of grasses that prevent erosion and provide habitats for creatures. Some, like guinea grass (*Panicum maximum*), seem to infest every square inch of soil and are capable of cutting human skin, while others like Bermuda grass (*Cynodon dactylon*) can be cultivated into lush lawns even when water is in short supply.

Botany in a bottle

Most visitors take their botany home in a bottle of hand-blended perfumes like jasmine, frangipani, white ginger, hibiscus and gardenia. An environmentally-conscious company, Island Fragrance, packages its scents in recycled beer bottles and its hand-gathered sea salts in re-usable burlap bags.

Named by Christopher Columbus after the 12th century perfumer, Emilo Frangipani, who created a legendary scent for Catherine de Medici, frangipani (*Plumeria alba*) is a green leafy tree with milky sap and delicate pink, yellow or white flowers that exude an intoxicating scent. At its scent-producing peak in the evening, the petals of the moonlight-shaded white ginger (*Hedychium coronarium*) are said to resemble a moth in flight.

Leaves from the bayberry tree and citrus scent from local limes add freshness to many fragrances. Men enjoy the tingle of St John Bay Rum, a mixture of bay leaf and orange peel extracts, alcohol and spices

Hibiscus and frangipani – two of the many plants whose perfume is skillfully captured in a bottle by Island Fragrance
CHRIS HUXLEY

made by the West Indies Bay Company and packaged in palm fronds, hand-woven in traditional fish pot designs. The original bay rum was made by crushing wild bayberry leaves and soaking them in rum or hot water to make a soothing cure for sore muscles, fever or headaches. The Danish chemist Albert Heinrich Riise experimented until he perfected the extraction of the oil to make bay-rum, popular during Prohibition as a substitute for alcohol.

Back-to-nature places

More than half of the heavily wooded mountains and shores of St John are part of the 12,900-acre Virgin Islands National Park, including 5,600 acres of offshore water and reefs. Established in 1956 as one of the smallest and most beautiful of National Parks, St John's was a gift of conservationist Laurance Rockefeller who acquired its 5,000-acre core following World War II. Its designation as a Biosphere Reserve by the United Nations Educational, Scientific and Cultural Organization (UNESCO) makes it a living laboratory. A five-minute walk from the ferry dock, the Cruz Bay Visitor Center can fill you in on scheduled hikes through woodland trails, as well as snorkel trips, historic programs, cultural demonstrations and exhibits. Ask about orientation videos, wildlife lectures and a hiker's map that details 20 miles of foot trail and more than 250 historic structures available for self-guided or ranger-led tours (see page 129).

Internationally-acclaimed Harmony Resort adjacent to the Maho Bay Campground (see page 134), is a case study in conservation. Each double-decker guest house complex is powered by renewable energy resources (wind and solar) and constructed almost entirely from recycled materials. Rubber tires and crushed glass have been turned into tiles; soybean and paper into lumber; plastic bottles into insulation and newspaper into flooring. Each unit has an interactive computer that reports solar energy available to run appliances and the daily sunburn index.

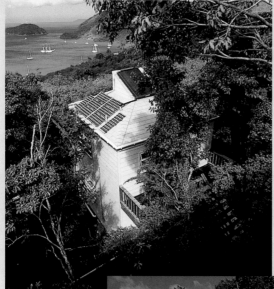

Site-sensitive construction at the Harmony Resort
STJ HARMONY RESORT

Harmony Resort uses the sun to make ice
STJ HARMONY RESORT

Part of the fifty-seven-acre Magens Bay Park deeded to the Virgin Islands by Arthur S. Fairchild (see page 122), the Magens Bay Arboretum in St Thomas is home to some of our most rare and exotic treasures. Efforts are underway to restore this once elaborate botanical garden.

A surprising number the Arboretum's palms grow nowhere else in the Virgin Islands, like the Martinique magnolia (*Barringtonia asiatica*), an ornamental from Asia that grew from a single seed imported in 1932. Nearly extinct in the wild, the blue latan (*Latania loddigesii*) is native to Mauritius. Comfortable in semi-arid areas, the Canary Island date palm (*Phoenix carnariensis*) has fruit used to produce palm sugar and leaves used for thatch. Valued for its oil, the African oil palm (*Elaeis quineensis*) is also a source of thatch, lumber and wine.

The banyon (*Ficus indica*) sends out accessory trunks large enough to walk under. Also known as the Indian fig, it is sacred in its native India and Pakistan. Another native of India, the queen of the flowers (*Lagerstroemia speciosa*) has purple blooms. Small in stature, but one of the most dense woods in the world, the ironwood (*Krugiodendron ferreum*) is used sparingly for cabinet-making. One of the largest trees in tropical America, growing to 80 feet, the kapok or silk cotton (*Ceiba pentandra*) trunk was used for canoes and drums. Pillows were made from the fluffy fiber (kapok) found in its seedpods.

Something special in St Croix

A magical web for nature enthusiasts, St Croix has it all – rain forests, botanical gardens, turtles and the newest national park in the United States. The creation of the 912-acre Salt River Bay National Historical Park and Ecological Preserve in 1992 will protect in perpetuity both a rich archaeological site and an ecological treasure. Jointly administered by the US Park Service and the local Government, the park consists of 600 acres of water and 312 of land that preserve the largest remaining mangrove forest in the Virgins, 27 species of threatened or endangered plants and animals, an Indian burial ground dating to 1150 AD (with a rare ceremonial ball court), a spectacular submarine canyon, a bird sanctuary and the historic Columbus Landing site (see also pages 10, 147).

One of the first underwater nature trails in the Caribbean, the Buck Island Reef National Monument (see pages 120, 139) has been a National Park Service site since 1961 and its snorkel trails are perfect for beginners and more experienced divers can explore its spectacular coral formations.

Visitors to St Croix can drive or horseback to the towering 15-acre rain forest. The Buccaneer Hotel (see page 79, 146), near Christiansted, conducts nature hikes through its gardens and woodlands.

St Croix's 17-acre St George's Village Botanical Garden, situated around the ruins of a Danish sugar-plantation workers' village, includes 500 species of trees and plants for self-guided tours and provides a shady retreat CHRIS HUXLEY

A global non-profit environmental organization, the Nature Conservancy has formed a partnership with the St Croix Environmental Association to preserve the historical 24-acre Estate Little Princess property near Christiansted. It contains an 18th century rum distillery, sugar factory, two great houses, overseer's house, bell tower, sugar mill and other ruins. The organization also donated the 10.7-acre Triton Bay Preserve – a mangrove with the largest heron rookery in the Territory – to the Salt River Bay National Historical Park and Ecological Preserve.

As eco-tourism continues to be the fast-growing phenomena in the travel industry, we must all continue to respect the tenets of responsible tourism. Protect a bit of paradise by safely discarding plastics, fishing line and other refuse that poses a threat to wildlife. Think twice about souvenirs made from endangered species such as turtle shell, ivory and reptile skins, as well as protected corals, shells, plants and animals. Careless boaters can cause damage by anchoring in seagrass beds, among coral reefs, or mooring vessels to mangroves. Snorkelers and divers should avoid damaging fragile coral formations. Water is precious, too, so consider the cost of taking a lengthy shower. Future generations will thank you.

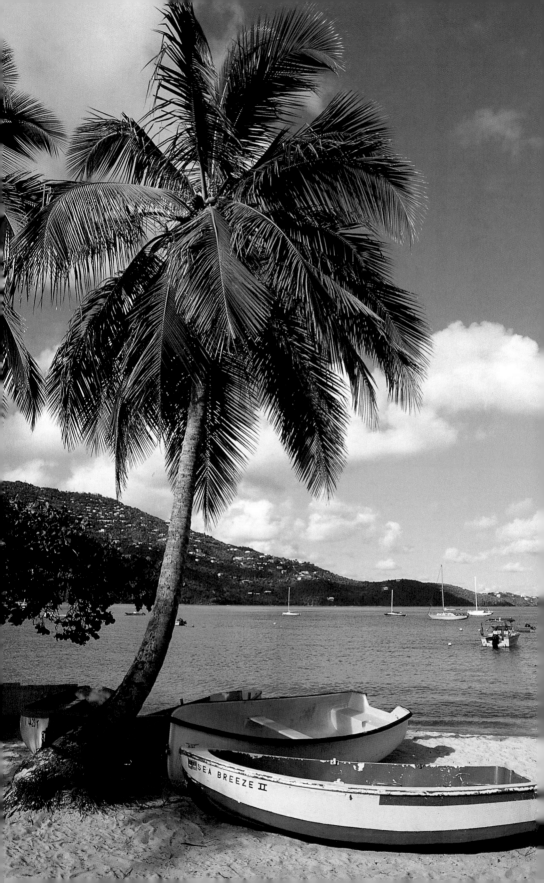

PART II

Day-Tripping

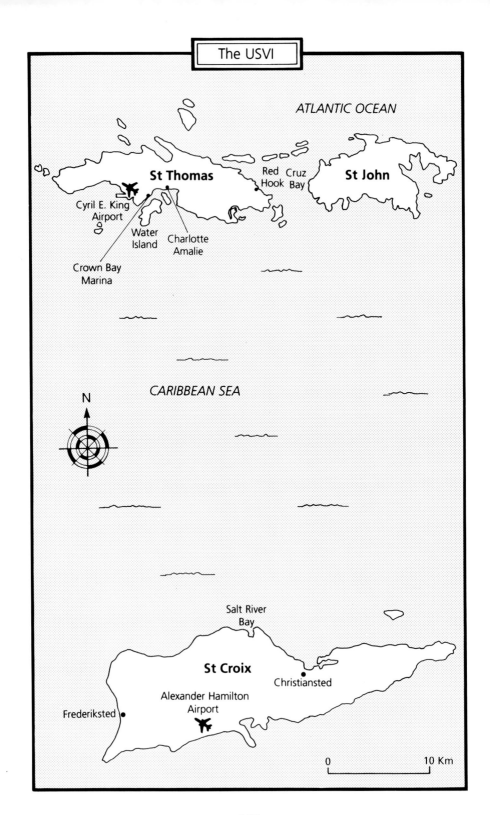

The USVI

ATLANTIC OCEAN

St Thomas

Red Cruz
Hook Bay

St John

Cyril E. King
Airport

Water
Island

Charlotte
Amalie

Crown Bay
Marina

N

CARIBBEAN SEA

Salt River
Bay

St Croix

Christiansted

Alexander Hamilton
Airport

Frederiksted

0 10 Km

10
Deciding which Virgin to visit

The US Virgin Islands of St Thomas, St John and St Croix are often referred to as 'sister' islands, but they are siblings that display personalities, physical appearances and minds of their own. In December 1996, 40 acres on Water Island, the 'long-overlooked' sister, were formally transferred from the US Department of the Interior to the USVI.

St Thomas

The emporium of the West Indies, St Thomas sports a cosmopolitan spirit, where vistas of the wild Atlantic Ocean and the placid Caribbean compete for attention with stone-paved alleyways and a labyrinth of duty-free boutiques. The spectacular harbor and historic town of Charlotte Amalie seldom sleep as St Thomas prepares for the daily arrival of cruise ships and vessels of every description who continue the twin traditions of trade and tourism that have nurtured this middle-sized sister.

At the eastern end of St Thomas, the village of Red Hook has prospered as a link to St John and developed a sporty ambiance of its own. Vacation hideaways of every description cling to the hillsides or sprawl to the water's edge in secluded sandy bays and coves carved into St Thomas' coastline. Active vacationers can easily fill their days with sightseeing or sampling water sports and their nights with dancing or fine dining. An island of contrasts, St Thomas offers a little or a lot, and lets you do the choosing.

St John

St John is the Virgin with an impish sense of humor and the one that beams with natural beauty from her rugged mountains cloaked in green to her seashores bathed in more tones of blue than a Greek tile shop. St John is a refreshing tonic for the world-weary. Just a ferry ride away from the bustle of St Thomas, the intimate town of Cruz Bay invites visitors to mentally kick off their shoes and stroll through beguiling shops, until breathtaking beaches and the urge to explore National Park ruins and nature trails lure you from your repose.

Remnants of St John's plantation era past lurk around every curve and visions of tropical splendor reward every hilltop climb. Whether you succumb to her luxurious resorts or casual campgrounds for a lengthy stay, or blissfully submerge yourself in her sparkling waters for a day, St John is the sister that will steal your heart.

St Croix

The largest of the US Virgins, St Croix boasts the most diverse terrain, from rugged mountain rain forests that reach to the clouds, to arid hillsides that bloom with cactus, and rolling coastal plains with seas of grass that disappear into the ocean. Her beaches are uncrowded and fringed with coral reefs. Protected as a National Park, Salt River is an historic and ecological treasure.

Picturesque Christiansted harbor opens its arms to the sea and shelters a town that is an architectural showplace and a shopper's delight. The deep-water harbor at Frederiksted greets cruise ships whose passengers wander through the 'gingerbread'-splendor of a town steeped in history.

The sophisticated sister that glitters like a Danish jewel set entirely within the Caribbean Sea, St Croix offers lush vacation retreats that pamper, as well as gentle hillsides sprouting with stone sugar mills and plantation great houses that let you peek into the well-preserved past.

Water Island

Lying a quarter-mile off St Thomas, Water Island is accessible to visitors via a five-minute ferry ride from Crown Bay Marina. A former World War II military installation, this tiniest of the sisters at a mere 490 acres is still largely undeveloped save for scattered homes, and boasts a secluded anchorage at tranquil Honeymoon Beach. Planned renovations include a new ferry dock and construction of a resort. (See also page 118.)

To learn more about the US Virgins you want to visit, read on, then contact a USVI Department of Tourism regional office in Atlanta, Chicago, Los Angeles, Miami, New York, San Juan (Puerto Rico), Washington, DC or Toronto (Canada). You may also call 800–372–USVI or visit the USVI Internet site at http://www.usvi.net on the World Wide Web.

11
St Thomas: Emporium of the West Indies

Charlotte Amalie

Since its colonization by the Danish West India Company, the harbor town of **Charlotte Amalie** (*A-mahl'-ya*) has been the hub of the 28-square-mile island of St Thomas, measuring only 13 miles long and three miles at its widest point. One of the Caribbean's finest natural ports, Charlotte Amalie has sheltered settlers, merchant vessels, slave ships and marauding pirates. All have left their mark on what has become the emporium of the West Indies and the capital of the US Virgins.

The town is listed in the National Register of Historic Places and once greeted its visitors at the **King's Wharf** on the waterfront. Its boathouse, a relic of Dansker days, was used by the harbor pilot which visited ships at anchor. The green-washed Italian Renaissance structure with ornate fencing on the waterfront once housed US Marines and served as a school. Originally built in 1874 as barracks for Danish *gendarmes*, today the 'Green Barn' that served as the site of the historic transfer of the Danish West Indies to the United States is home to the Legislature of the US Virgin Islands.

Now a National Historic Landmark, **Fort Christian** was begun in 1666 and still under construction when the Danes arrived in 1672 to parcel plantations. Its crenellated clock tower was added during 1874 renovations. The earliest structure in town, the brick and rubble masonry fort has garrisoned troops, served as the Governor's residence, a jail, and sheltered religious congregations. By 1674 the Danish West India and Guinea Company began establishing St Thomas as one of the largest slave trading centers in the West Indies. To accommodate the boom, the governor approved four taverns west of the fort. The popularity of these taverns led to the settlement's nickname 'Tap Hus' (Beer House) which stuck until 1691, when the more dignified name Charlotte Amalie was designated to honor the Queen of Denmark.

Charlotte Amalie harbour is the hub of St Thomas DEAN L. BARNES ▶

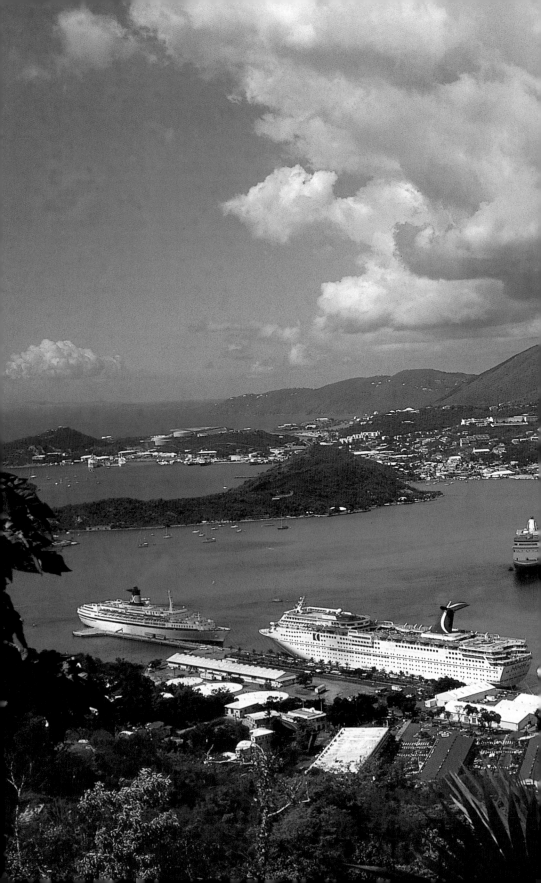

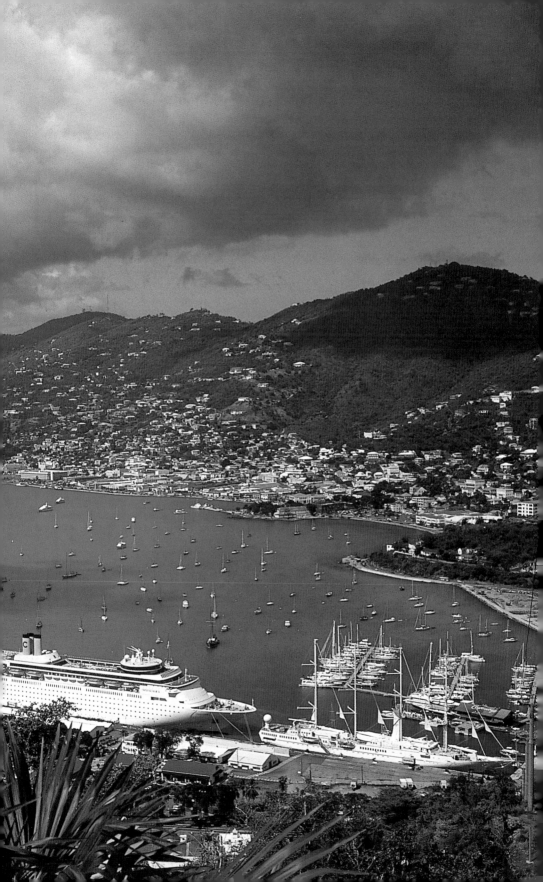

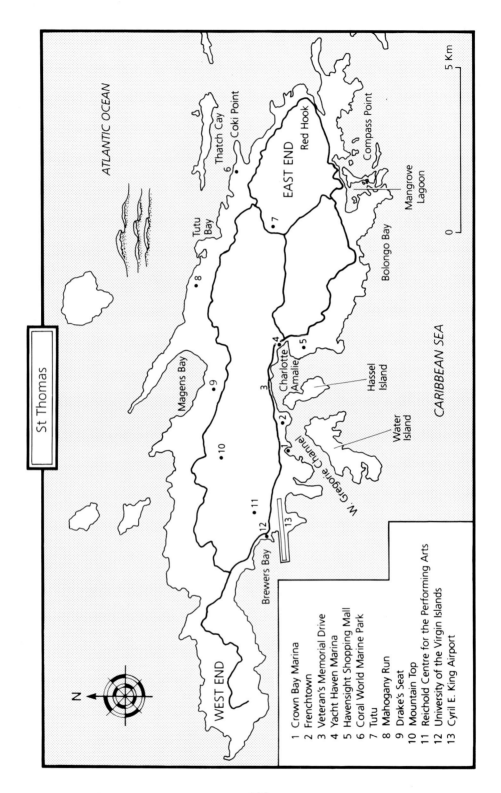

St Thomas

ATLANTIC OCEAN

WEST END

Magens Bay

Tutu Bay

Thatch Cay

Coki Point

EAST END

Red Hook

Compass Point

Mangrove Lagoon

Bolongo Bay

Brewers Bay

W. Gregorie Channel

Charlotte Amalie

Hassel Island

Water Island

CARIBBEAN SEA

N

0 5 Km

1 Crown Bay Marina
2 Frenchtown
3 Veteran's Memorial Drive
4 Yacht Haven Marina
5 Havensight Shopping Mall
6 Coral World Marine Park
7 Tutu
8 Mahogany Run
9 Drake's Seat
10 Mountain Top
11 Reichold Centre for the Performing Arts
12 University of the Virgin Islands
13 Cyril E. King Airport

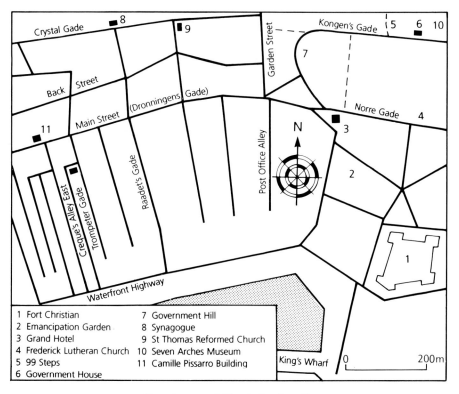

Street map of Charlotte Amalie

1 Fort Christian
2 Emancipation Garden
3 Grand Hotel
4 Frederick Lutheran Church
5 99 Steps
6 Government House
7 Government Hill
8 Synagogue
9 St Thomas Reformed Church
10 Seven Arches Museum
11 Camille Pissarro Building

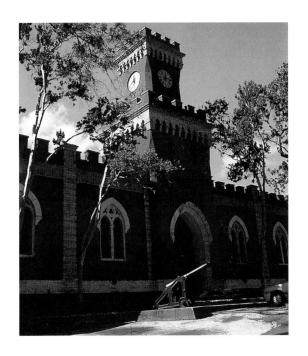

Fort Christian's crenellated clock tower
MICHAEL BOURNE

**The scaled-down replica of the US Liberty Bell
in Emancipation Garden no longer rings,
but the gazebo does – with steel pan music
or school band concerts** CHRIS HUXLEY

Emancipation Garden commemorates the 1848 freeing of slaves. Utilized for celebrations since, the park is a shady retreat to relax under the gaze of Danish King Christian IX, whose bronze bust stares silently toward the sea. Souvenir-hunters can shop under a sea of bright umbrellas at Vendors' Plaza. To the west of the park, the handsome brick building with street-level arcades that house a Little Switzerland shop, first served as the Danish Customs House. Around the corner on Main Street, the Emancipation Garden Station Post Office contains two Stephen Dohanos murals painted during the 1930s.

Opened as the Commercial Hotel and Coffee House on 44 Norre Gade, the Greek Revival-style **Grand Hotel** (1839-1840) dominates the eastern end of Main Street. It was once the island's favorite spot for social gatherings. Opposite the Grand Hotel, the Athenaeum hosted writers such as Somerset Maughan, who reportedly curbed his thirst with rum punch while composing *Of Human Bondage*.

The Jacob H.S. Lind House (once a two-story residence and now the parish hall 'Bethania') on Norre Gade dates from the early 1800s, when plastered brick and rubble masonry were popular. Its exterior brick stairways are notable.

Gothic Revival is well-defined in the adjoining church, **Frederick Evangelical Lutheran Church**, reconstructed in 1826 of buff-colored brick salvaged from earlier churches. It boasts a flaring stairway leading to a raised base that supports a bell tower and center pavilion. A peek inside reveals superb antique chandeliers.

As you climb up Government Hill from Post Office Square (by the bronze of J. Antonio Jarvis), the 1854 **Dominus Hus** (House) that greets you is constructed of yellow ballast brick. The **S'Agapo Cafe** up front will lure you with the sound of Greek music. Tucked into a cool courtyard accessed through an alleyway, **Zorba's** is the closest thing to a Greek *taverna* in this otherwise Danish town.

To the east of Hotel 1829, the famous **99 Steps** are typical of the Danish 'step-streets' that linked dwelling where hillsides were too steep for carriages. At the head of 99 Steps is an historic 18th century West Indian-style structure. The three-story hip-roofed **Crown House** served as the home of Peter von Scholten before he moved to St Croix as Governor in 1822. On the 'welcoming arms' stairway to the **Hotel 1829 Restaurant** watch for the boot scrape, one of two still existing in the district. Built for French Captain Lavalette, this stucco-over-rubble masonry residence on 30 A Kongens Gade is one of the island's

Constructed of ballast brick, the 99 Steps actually number 103 and run from Government Hill to Lille Tarne Gade (Little Tower Street)

CHRIS HUXLEY

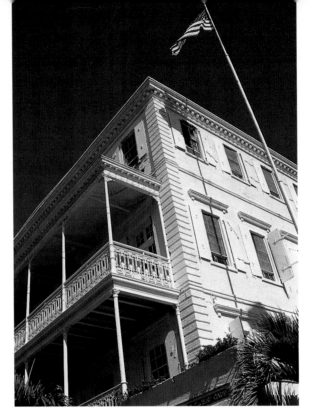

Government House, the official residence of the Governor
MICHAEL BOURNE

best remaining examples of a 19th century townhouse. Brick was artfully used to line the wall openings and accent corners. The original Moroccan tile still covers the first-floor rooms. Careful inspection of the railing design reveals Lavalette's monogram.

Next to Hotel 1829 is **Government House** (1865–67), an example of Neo-Classical Revival style and notable for its detailed brickwork and exceptional cast iron veranda. The sentry box outside the 21–22 Kongens Gade building was a 1967 gift from Denmark to commemorate the fiftieth anniversary of the transfer. The Government House art collection includes works by Camille Pissarro (see pages 21, 36, 44), Thomas Hart Benton and Gustave Courbet.

Seven Arches Museum is tucked away next to the Lt Governor's Office on Government Hill, accessed through Knut Hansen Alley (Freeway Alley) – a remnant from the era when slaves not allowed to walk on main streets traveled between buildings via 'freeways'. Once the 18th century home of a Danish craftsman, Seven Arches features an authentic stone kitchen and original mahogany antiques. Its 'welcoming arms' stairways built of yellow ballast brick, curve through a quaint courtyard.

Built on the slope of Government Hill at 32–33 Kongens Gade, the Greek Revival residence known as **Quarters 'B'** once served as the German Consulate. The grand mahogany staircase in this 1816 home was salvaged from a sailing ship. At the eastern end of Government Hill on Hospital Gade beyond Roosevelt Park, the two-story **Moravian Memorial Church** (1844) is constructed of local blue-bitch stone with sandstone corners and accented with a cupola above the bell tower. **Blackbeard's Castle** above Government Hill boasts one of the most commanding views of Charlotte Amalie. Contrary to popular legend, the conical *Skytsborg* watch tower was built in 1678 by Dane Charles Boggaert, not by the infamous English pirate Edward Teach (see page 13).

Glass was used sparingly in colonial dwellings as it was expensive and difficult to ship, so the first house to sport glazed windows was aptly named the **Crystal Palace**. At the corner of Crystal Gade and Bjerge Gade in the area known as Denmark Hill, this two-story residence is just a 'step-street' away from the Danish Consulate. A two-story structure built by Governor Hans Henrik Berg as a residence called 'Cathrinaberg' in 1830, the **Consulate** is easily spotted by the

**The 'toy soldier' sentry box
is a favorite backdrop
for photographers**
CHRIS HUXLEY

red-and-white Dannebrog that flutters in the wind. The 150-year-old landmark is the only spot on the island still 'ruled' by Denmark. Imposing in its dimensions and Greek Revival design, the Consulate is entered by way of double staircases.

The third building near the corner of Crystal Gade and Raadets Gade, the 1833 **Synagogue** named 'Blessing and Peace and Loving Deeds' is a fine example of Spanish Moorish architecture and the second-oldest in the Western Hemisphere (see also page 43). Once destroyed by fire, the Dutch Reformed Church on nearby Nye Gade was rebuilt from 1844–1846 as the **St Thomas Reformed Church**. An elegant example of Greek Revival, it features a triangular pediment supported by Doric columns.

Surrounded by a fortress-style masonry wall, the **Old Unity Lodge** on 15 Norre Gade served as a meeting place for Masons since 1908 and was converted in 1995 to a shelter for the homeless. The military-styled structure is softened by an elegant cast iron balcony.

A portal on Main Street, Charlotte Amalie CHRIS HUXLEY

Remember the Alamo? The **Villa Santana** guest house on Denmark Hill was built around 1860 for the Mexican Revolution's general, Antonio Lopez de Santa Anna, who occupied the Spanish-style one-story villa while in exile from 1858–1909.

Back on Main Street (14 Dronningens Gade), the birthplace and residence of painter Camille Pissarro is on the Historic Register and houses the **Caribbean Cultural Center**. **Apothecary Hall** was established in 1838 to dispense pharmaceuticals and Old St Croix Rum (see also page 149). The first 'fire-proof' building in town, the three-story masonry **Lang Residence** (Enid M. Baa Library) was built around 1800.

To capitalize on the slave trade, Denmark treatied with the German Duchy of Brandenburg to establish a trading post on St Thomas in 1685. A warehouse and auction block were constructed in the western edge of town, still called the 'head of paved street' by old-timers. Site of one of the most notorious 18th century slave markets, **Rothschild Francis Market Square** (connecting Main Street with Back Street) pre-dates the fires of the 1800s and is within the Historic District. The present iron and concrete shed was constructed in the late 19th century. The imposing building across the square with ornate iron doors and cast iron balcony, was built in the mid-19th century as the **Danish Brasilia Bank**. The Catholic **Saints Peter and Paul Cathedral**, down Kronprindsens Gade, dates to 1848. Carved of San Juan marble, the central altar features a beautifully rendered pastoral lamb. Marble angels and winged cherubs adorn side altars added during the 1960s.

By 1800, St Thomas' expanding population led to the development west of Denmark Hill known as **Savan**, where simple wooden cottages were built by the free-colored workers. Laid in a grid, this neighborhood of shingled dwellings became populated by freed slaves after the 1848 Emancipation. Savan remains an important comment on the island's social, historical and architectural history.

The warehouses that dominate mid-town are examples of plaster-over-rubble masonry that utilized any material available, including bits of stone, shells and brick, bound with mortar made of sand and lime. Molasses was sometimes used when water was scarce. Many of the two-foot-thick walls are original, rebuilt after 1832 when a series of devastating fires prompted revision of building codes. Converted following World War II to rows of beguiling restaurants and shops, each of the hip-roofed warehouses once had its own wharf. The alleys between were used to transport cargo on tracks that ran to the wharf. Visitors in search of duty-free bargains can now stroll shop-lined alleys with colorful names like Palm Passage, Royal Dane Mall, Creque's Alley and Trompeter Gade. Some residences in this area reflect the style of West Indian architecture typified by arcaded first floors with arched

doorways and massive wooden shutters hinged on wrought iron straps.

Now the site of a hotel by the same name that lies in the hills to the east above Charlotte Amalie, **Bluebeard's Castle** once garrisoned Danish troops who used its rounded tower (1688–89) as a lookout. Armed with 11 cannon, it served as a fort until 1735. Today, the harbor view is enjoyed by diners at **Entré Nous**. The legend of the fierce pirate who murdered multiple wives is fancy, though respected town burghers do lie buried under the terrace.

North of town, Mafolie Hill is home to the **Mafolie Hotel**, whose hillside restaurant is a favorite spot for viewing the sparkle of St Thomas harbor after nightfall.

Around the Harbor

The result of a landfill completed in 1954 that created the two-lane **Veterans' Memorial Drive**, the concrete waterfront that holds back the sea is still a center of inter-island cargo trade. Private yachts waiting for port clearance and passenger-carrying ferries berth alongside the **William Blyden Complex**, formerly known as Tortola Wharf, that was rebuilt in 1993. To the west are the remains of the 'Flying Goose' hangar and ramp facilities for the legendary Antilles Airboat service, begun in 1967 by Charles Blair, husband of actress Maureen O'Hara.

Hassel Island

Separated from St Thomas since 1865, when Haulover Cut was dredged to free the flow of water, the 120-acre Hassel Island is on the National Register of Historic Places. Most of the mile-long island that served as a coaling and ship-repair station for the Royal Mail Steam Packet Company, the Hamburg-America Line, and the East Asiatic Company now belongs to the National Park Service and there are plans to develop Hassel Island as an historic and recreational area. Of particular interest are the ruins of the Creque Marine Railway Complex (Slipway), Fort Willoughby, the Garrison House, and the Cowell Battery built by the British atop a 267-foot hill that was used as a ship signal station. Built in 1802, Shipley's Guardhouse and Battery is a rare example of a Napoleonic fort.

Careful readers of *Don't Stop the Carnival*, a novel set in the Caribbean that was authored by former St Thomas resident, Herman Wouk, may find the parallels between the once-popular Hassel Island hotel called the Royal Mail Inn and the fictitious Gull Reef Club quite revealing.

Frenchtown

A few minutes walk west along the waterfront takes you to **Frenchtown**, a community begun in the 1850s by patois-speaking fishermen from the French island of St. Barthélemy (or St Barths, pronounced without the 'h'). Set apart from guidebook St Thomas by its distinctive fishing village atmosphere, Frenchtown is one of St Thomas' best-kept secrets.

In the morning, Frenchtown fishermen clean and sell their catch by the **Gustave Quetel Fishing Center** near the landing where the brightly-colored fishing boats are typical of 18th century Normandy. Like the legendary Brigadoon, time stands still in Careenage, where the patois-accented adage 'dog was chasin' cat and both of dem was walkin' well-describes the laid-back atmosphere (see also page 52).

A Caribbean version of New Orleans' French Quarter, **Frenchtown** boasts a concentration of restaurants and colorful cubbyhole bars that range from the elegant to the slightly salty. Overlooking the waterfront, **Hook, Line and Sinker** offers casual dining by the breakwater and tales of the days when it was home to the Royal Frenchtown Yacht Club. Destroyed by Hurricane Hugo and rebuilt in 1994, the marina and retail complex on the boardwalk were designed with an 'old seaport look' to complement the flavor of Frenchtown. The petit **Epérnay** attracts an upscale crowd seeking sushi, champagne and monster martinis. The purple heart wood decorating its interior adds an exotic touch. **Alexander's Restaurant** next door offers fine dining with an Austrian-German flair. It shares its kitchen with the relaxing **Alexander's Grill**. Further down the Frenchtown Mall, **Betsy's Bar** offers a casual courtyard where locals love to congregate and visitors are warmly welcomed.

At the corner of Rue de St Barthélemy, the **Taste of Italy** restaurant occupies the site of what was once St Thomas' oldest saloon, Bar Normandie. Locals still speak with reverence of this beloved 1938 watering hole where regulars ordered libations through the shuttered side window and gathered to sing Christmas carols. Now a grocery store, the building across from the Rue de St Barthélemy intersection is reputed to be the original site of the Red Fox Inn, a notorious brothel during the pirate era. During carnival, it's not unusual for a masquerade troupe to dance through Frenchtown. The annual Father's Day celebration during French Heritage Week takes place in the parking lot near the ballpark.

Around the corner from Rue de St Barthélemy, **Craig and Sally's** is a popular dining spot where hand-painted wall murals and a creative menu are main attractions. The road to the left leads past old-style

family cottages to **Haulover Cut**. The masonry walls to the right are the remains of water catchment cisterns that once supplied St Thomas. Overlooking Haulover Cut, the **Chart House Restaurant** (formerly Villa Olga, the site of the Russian Consulate) was once a gambler's haven and 'bawdy' place. Continuing west out of Frenchtown, the road leads toward **Gregorie Channel**, home to shops and restaurants with views of Water Island.

Sub Base and Water Island

Heading west from Frenchtown is the area known as **Sub Base** that borders Crown Bay across from Water Island. Abutting the main road, **L'Escargot** offers French cuisine with a touch of the Caribbean. The landmark **Barnacle Bill's Restaurant** barely survived Hurricane Marilyn but fell victim to area development.

Crown Bay Marina is a full-service facility that's home to mega-yachts, visiting sailboats and the Virgin Islands America's Cup Challenge crew training vessel, the former *Stars & Stripes '92* built for Dennis Conner (see page 74). Locals like the array of shops and casual atmosphere at **Tickle's Dockside Pub** and **Pilot House Restaurant**. The nearby stone breakwater is an auxiliary cruise ship dock. Hidden away in the hillsides of Sub Base, **Victor's New Hide-Out** is noted for its native dishes.

Crown Bay Marina, basking in the sun MARC BLAZAR

Across the Gregorie Channel, **Water Island** has an uncrowded beach and anchorage on the western end called **Honeymoon Bay**. Residents commute with dinghies, while visitors wait for **Larry's Launch**, which departs regularly from Crown Bay Marina. Water Island has been totally residential since the 1989 Hurricane Hugo blew away Seacliff, the island's only resort.

Airport and areas west

Emerald Beach Resort occupies the eastern curve of Lindbergh Bay, near where the famous aviator once landed. The casual **Beachcomber Hotel** shares the sandy stretch along the Airport Road and the renovated **Carib Beach Hotel** dominates the western tip.

The old Harry S. Truman Airport has been demolished (to the dismay of those who miss the 'funky charm' of the former World War II hangar) and replaced with the modern **Cyril E. King Airport**. Past the airfield, accessible **Brewer's Bay Beach** is a favorite for locals. The **University of the Virgin Islands** (St Thomas Campus) occupies the hillsides and is home to the **Reichhold Center for Performing Arts**.

The West End of the island is residential, though private villas, like the restored 300-year-old **Fortuna Mill Estate** – that features a great house and sugarmill – are sometimes available for rental. Uncrowded and tranquil, some West End beaches offer great snorkeling, but are best approached by four-wheel drive with a well-informed local guide.

East from Charlotte Amalie

From the Legislature, **Veterans' Drive** along the Long Bay shoreline is often congested with two-lane traffic, but the splendid harbor view helps smooth ruffled feathers. The bulk of the island's charter yacht fleet calls **Yacht Haven Marina** home, as does **Seaborne Seaplane Adventures**, whose twin Otter VistaLiner provides aerial tours of the Virgins. Adjoining the marina, the **West Indian Company Dock** plays host to daily visits from cruise ships. The Dock's purchase in 1993 by the Government of the Virgin Islands officially ended any Danish ownership of commercial property in the Territory.

The intersection at **Nelson Mandela Circle** dispensed with the confusion of what used to be called the 'round-about' and leads to the commercial area of Havensight. **Havensight Mall** offers a selection of shops just steps away from where the mammoth liners dock. Some are unique to the Mall, like the **Dockside Bookshop**, perhaps the most comprehensive bookstore in the English-speaking Caribbean, while others have sister shops in town or at hotels. **Atlantis Submarine** is

Paradise Point tramway carries passengers to its complex of shops and restaurants at the apex, a choice spot for 'green flash' viewing and photography DEAN L. BARNES

based in Building Six at Havensight Mall, where you can reserve for the two-hour tour of the reef off Buck Island (see page 97, 139). Seating 46 passengers, the submarine can descend to 90 feet.

Across from Havensight Mall, **Paradise Point** offers a spectacular view of the harbor from its perch just beneath the crest of Flag Hill. A revival of a similar tramway that operated until 1973, the 1994 version features enclosed tram cars capable of carrying 2,000 passengers per hour.

The lighthouse at **Muhlenfel's Point** that once guided ships to the harbor entrance has been replaced by the lights of **Marriott's Frenchman's Reef Resort** that shares the beach with **Morning Star Beach Resort** and its well-regarded Tavern On the Beach restaurant.

South Shore

Along Frenchman's Bay Road, **Flag Hill** awaits the 1998 opening of the **Cultural Center of the Caribbean**, a retail mall with restaurants and an area for local performing artists. **Bolongo Limetree Beach Resort** cuddles a beautiful stretch of sand that curves along a shapely cove. Tame iguana populate the wooded area on the property. **Bolongo Bay Beach and Tennis Resort** on Bovoni Road, boasts a

powdery beach and interesting snorkeling. At **Watergate Villas** on Bolongo Bay, Mim's Seaside Bistro draws the crowds for lunch and dinner.

The drive past the Bovoni landfill isn't always pleasant, but then again, the island's trash has to go somewhere. If the roadside is packed with cars and food venders, chances are the horses are at the starting gate at the **Clinton Phipps Racetrack**.

East End

Estate Nadir (pronounced 'Nahdah') begins the area known as the East End, where Red Hook Road runs past the small **Fish Hawk Marina** and **Fabian's Landing**. **Saga Haven** is easy to miss, so slow down, because the riverboat restaurant with its **Puzzles** piano bar is worth the search.

On the south shore of the East End Lagoon, **Compass Point Marina** is home to charter yachts and **Paddy O'Furniture's Irish Brew Pub**, the first of its kind in the Caribbean. The waterfront pub and restaurant debuted in 1997 with four home-brewed beers, including the four-malt Pitbull Irish Stout. **Scott Beach** is where you can appease your appetite for Tex-Mex fare or dancing at the **For the Birds** restaurant.

Bottoms-Up is a salty eatery located on Benner Bay by Independent Boat Yard and La Vida Marine Center. The sunset views from **Secret Harbour Beach Resort** in Estate Nazareth are among the finest on St Thomas.

A favorite for boardsailors, **Bluebeard's Beach** is tricky to find, but rewards the persistent with views of St John and good snorkeling. **David's Restaurant** on Cowpet Bay hosts yachtsmen from the nearby **St Thomas Yacht Club**.

Situated on a 900-foot crescent cove, the deluxe **Bolongo Elysian Beach Resort** is noted for its elegant Palm Court Restaurant. Opened in 1996, the **Ritz-Carlton St Thomas** boasts Italian Renaissance architecture, legendary service and an upscale clientele.

Just off Red Hook Road, the Virgin Islands National Park sign announces your entrance to **Red Hook** proper. Once the backwater of sportsfishers and boaters, Red Hook has boomed as islanders established residences and resorts sprung up along area beaches. Today, busy Red Hook rivals Charlotte Amalie as a shopping and dining center.

American Yacht Harbor has been renovated since Hurricanes Hugo and Marilyn. The marina complex of retail shops, offices and restaurants is connected by boardwalks that begin at the Blue Marlin

Restaurant and continue west to Tickle's East. Within walking distance are numerous eateries and small businesses. The carnival-colored **Marina Market** offers gourmet treats. Across the harbor, **Vessup Point Marina** and **Latitude 18** restaurant are local hangouts. The **Red Hook Ferry Dock** is the major center for passage to St John and Tortola. Exiting east from Red Hook, the **Sugar Bay Plantation Resort** has three waterfall-fed swimming pools, a grotto and an array of restaurants. Bindley's Beach borders **Doubletree Sapphire Beach Resort and Marina**, which offers a magnificent view of St John and a chance to 'party hearty' at the Seagrape Lounge.

Located on 34 lush acres with a 1,000-foot stretch of beach barely separated from an elegant pool, the **Renaissance Grand Beach Resort** on Pineapple Beach has been called the 'most recognized resort' in the US Virgins. Be sure to visit its Smuggler's Steak and Seafood Grill.

Located amid a 12-acre garden, **Point Pleasant Resort** is home to the Agavé Terrace restaurant and the aptly-named Lookout Lounge, overlooking St John and the British Virgins. The century plant (from the genus *Agave*), incorporated into the resort's logo, thrives in nearby hillsides (see page 94).

Generally calm, **Coki Beach** is an ideal spot for snorkeling and diving or feeding tropical fish grown tame by bread-wielding beachgoers. Smith Bay is also home to **Eunice's Terrace**, a favorite spot for West Indian specialities. Dinner at **Romano's** on the road to Coral World Marine Park, is like being invited to an Italian home, complete with art gallery. The **Coral World Marine Park's** spectacular marine aquarium and underwater observatory were severely damaged in Hurricane Marilyn, but are expected to re-open by 1998.

Northside/Skyline Drive

Fairchild Park was named for Arthur Fairchild, who donated Magens Bay beach to the people of the Virgin Islands (see page 97). The park is a popular spot for weddings.

Off St Peter Mountain Road, follow the sign to **Mountain Top** for one of the world's most talked-about vistas atop Crown Mountain, the island's highest elevation (1,547 feet). Whether you visit Mountain Top for its breathtaking view of Magens Bay, Hans Lollick, St John and the British Virgins, or merely to quench your thirst with a banana daiquiri, you won't be disappointed. Rebuilt after Hurricane Hugo in West Indian-styled architecture with confectionery colors, the Mountain Top

Magens Bay, the 'pearl' of St Thomas' beaches CHRIS HUXLEY ▶

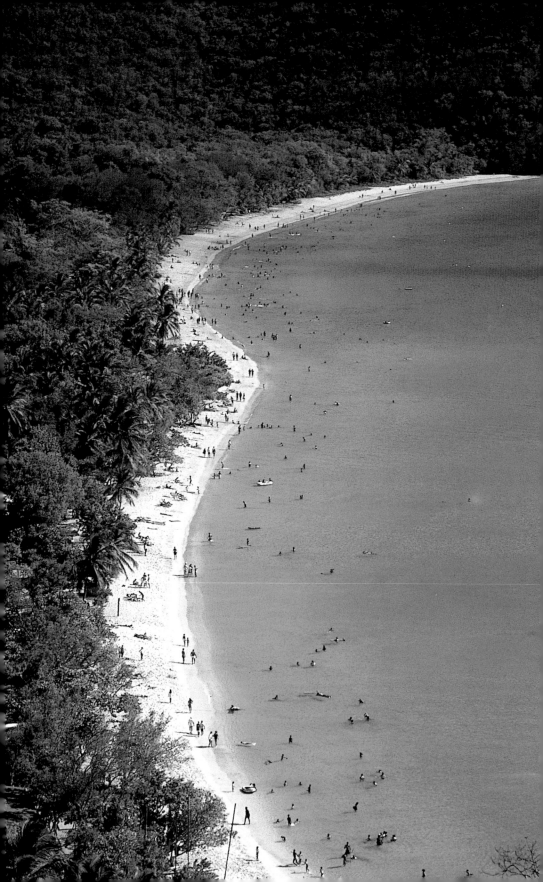

complex houses an aviary, aquarium, and an array of shops that offer everything from locally-crafted gifts to pirate treasures.

For a preview of Magens Bay, there's no better spot than **Drake's Seat**, the overlook that commands a panoramic view of the Sir Francis Drake Channel and the archipelago beyond. The cay called Hans Lollick is slated for development. Also visible are the uninhabited cays, Inner Brass and Outer Brass.

Follow Route 35 to mile-long **Magens Bay**, one of the most photographed beaches in the world. Be sure to stop at **Udder Delight**, which adjoins St Thomas Dairies, for a milkshake laced with Cruzan rum and make reservations for dinner at **The Old Stone Farm House**, a magnificent 200-year-old landmark that re-opened its restaurant in 1997. Built in 1683 as a plantation house for the Magens family, **Louisenhoj Castle** commands the corner of Skyline Drive by the entrance to Magens Bay Road. In 1918 the private 36-acre estate was sold to Arthur S. Fairchild, who began the current restoration.

Estate St Peter Greathouse and Botanical Garden on St Peter Mountain Road offers a popular tour of its contemporary estate manor house, art gallery and tropical gardens. Neighboring islands and cays can be viewed from elevated wooden walkways.

The elevated wooden walkways at St Peter Greathouse DEAN L. BARNES

A fun spot west of Magens Bay, **Hull Bay** beach offers a view of Hans Lollick and a chance to rub elbows with local surfers and fishermen. The beach surf can be rougher in winter when northern swells roll in. If you're lucky, you may catch a weekend pig roast at **Hull Bay Hideaway**.

Nightlife

Hard Rock Cafe at the head of International Plaza is a waterfront haunt for lunch by day and partying by night. Many make the pilgrimage to collect memorabilia. Originally opened in New Orleans, **Royal Dane Mall's Fat Tues Days** bar has decorated its Charlotte Amalie location with a 'Bourbon Street meets Mocko Jumbie' motif. Live entertainment can usually be found at resorts or by making the downtown circuit that includes **La Scala** in Palm Passage, the **Green House Bar and Restaurant** on the Waterfront and **Gladys' Café**.

Live entertainment and local DJs attract crowds to Mountain Top which takes on a party atmosphere for happy hour and on weekends. Formerly Club Z, the **Copa Cabana** nightclub off Crown Mountain Road is a happening spot that also offers dining.

Within American Yacht Harbor, **Mackenzies Harborview** offers pub fare and entertainment. Bordering the marina, the Shark Room features live entertainment, from jazz to blues, and a light menu. The adjoining **East Coast Bar and Grill** is a favorite East End watering hole and eatery.

Bolongo Limetree Beach Hotel is a one-stop shop for dining at the Green Cay Restaurant and entertainment at either the Paradise I West Indian-style nightclub or trendy Paradise II disco next door. Named for its iguana mascot, Iggey's is the spot to test your vocal chords to the accompaniment of a karaoke machine.

> *Nightspots and restaurants spring up in the Virgins like guinea grass after a heavy rain, so always check with local publications for an updated listing.*

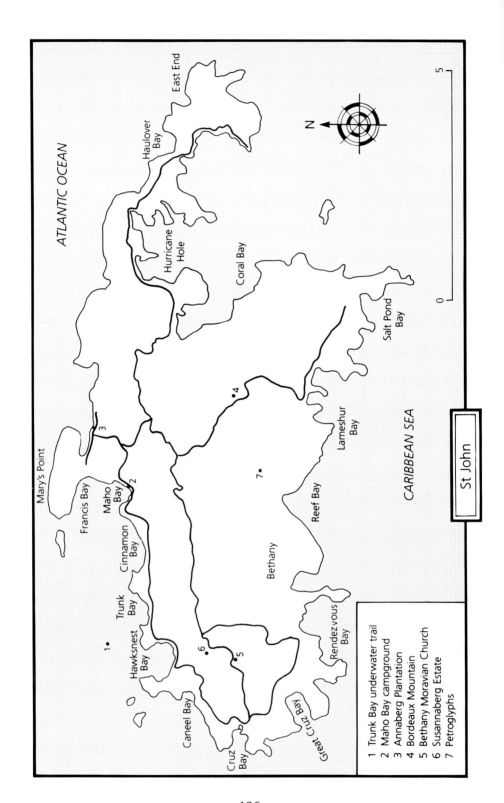

ATLANTIC OCEAN

East End

Haulover Bay

Hurricane Hole

Coral Bay

Mary's Point

Francis Bay

Maho Bay

Cinnamon Bay

Trunk Bay

Hawksnest Bay

Caneel Bay

Cruz Bay

Great Cruz Bay

Rendezvous Bay

Bethany

Reef Bay

Lameshur Bay

Salt Pond Bay

N

CARIBBEAN SEA

St John

0 5

1 Trunk Bay underwater trail
2 Maho Bay campground
3 Annaberg Plantation
4 Bordeaux Mountain
5 Bethany Moravian Church
6 Susannaberg Estate
7 Petroglyphs

12
St John: A walk through time

Named by Spanish explorers for St John the Apostle, the island of St John is barely nine miles long and five miles wide, but is steeped in history and overflowing with nature's treasures. From its lush green heartland to its 32 curving white sand beaches, this 20-square mile Virgin flourishes in the present by clinging to her past.

Whether your ferry trip departs from Charlotte Amalie (45 minutes) or Red Hook (20 minutes), the ride to idyllic St John requires crossing **Pillsbury Sound**, where the surface visibly ruffles as the waters of the Atlantic Ocean and Caribbean Sea mingle. Vacationers on St John can also enjoy a two-hour boat ride to San Juan, Puerto Rico, via ferry that transits the Mona Passage.

To the east, **Lovango Cay** is the largest of a cluster of tiny islands that includes uninhabited Grass Cay, Mongo Cay and Congo Cay. Possibly of Indian or African derivation, the word 'Lovango' is linked in

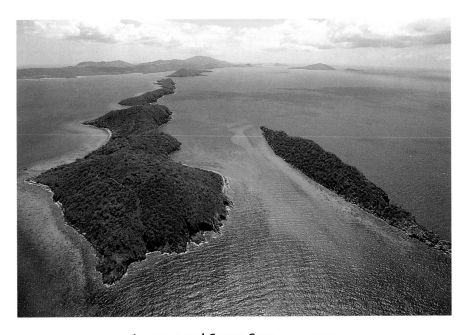

Lovango and Congo Cays CHRIS HUXLEY

local lore to the seafarers' brothel 'love-and-go' that once flourished on this rocky outpost. Lying just off Congo Cay, **Carvel Rock** so closely resembles a pirate ship that the British supposedly raked it with cannonballs.

Cruz Bay

As you approach Cruz Bay, the administrative center of St John, you'll disembark at the Port Authority dock, dedicated in 1994 to Lorendon L. Boynes Sr, who pioneered the inter-island ferry service. **Battery Point** to the left was once fortified with cannon and called Christiansfort. Built after the slave revolt, the administrator's residence forms the foundation of the modern building you see today. Its jail cells now house a museum. On the northern side, the US Customs and Immigration office clears vessels arriving from foreign ports.

Just to the right of the ferry dock, colorful **Wharfside Village** is a three-story shopping center chock-full of unusual boutiques. With several bars and restaurants to choose from, **Pusser's Wharfside** is a great spot to sip a 'Painkiller' and watch sailboats swing at anchor. Enjoy tapas at the **Saychelles Restaurant** at Wharfside Village or a sunset cocktail atop **Gallows Point** at Ellington's to learn why St John has earned its 'Love City' moniker. A half-mile uphill from the ferry

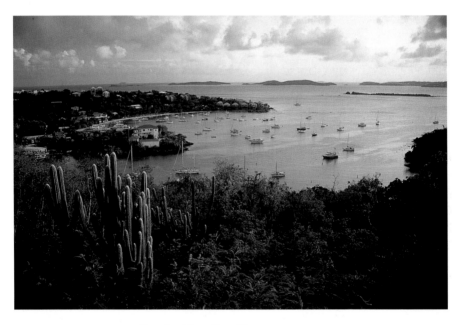

Overlooking Cruz Bay CHRIS HUXLEY

dock, the **Elaine Ione Sprauve Library and Museum** displays Indian and colonial artifacts as well as local crafts in the restored 1757 Enighed (Danish for 'concord') Estate manor house. Before you leave the Waterfront, stop at the **Cruz Bay Visitor Center** at Virgin Islands National Park Service Headquarters to stock-up on the latest tour information and maps. Created in 1956 by President Eisenhower, the park encompasses some 7,200 acres of land and 5,650 acres of near-shore waters laced with reefs and mangroves (see also page 95).

Whether you yearn for refreshment or an unusual gift, the Cruz Bay area offers an abundance of shops and restaurants that will introduce you to the casual lifestyle of the island. Some favorite eateries right in 'town' that are noted for their fare (and fanciful names) include the Fish Trap at Rain Tree Inn, the Back Yard Bar and Restaurant, Chilly Billy's, Paradiso, Crash Landing, Fred's, JJ's Texas Coast Cafe, Café Roma, Morgan's Mango and The Lime Inn at the Lemon Tree Mall, just two blocks from the ferry. The Secret Garden Cafe, A Lotta Coladas, Garden of Luscious Licks and Divine Desserts, and Beni Iguana's have a whimsical appeal all their own.

A must for exploring this mountainous island, safari busses and rental jeeps are clustered around the Cruz Bay village square, but you won't need transportation other than comfortable walking shoes to visit the rambling West Indian-style shopping center called **Mongoose Junction**, just a short stroll outside of Cruz Bay. Arts, crafts and unique boutiques with an international offering of wares abound in this two-story arcaded stone complex, joined by a circular stairway. One of the oldest on St John, the **Mongoose Junction Cafe and Bar** offers refreshment in its breezy bar, open-air gazebo or tropical garden. Across the way, the wooden **Keating House** with gingerbread trim, is an example of early 19th century dwellings.

North Shore Road

Heading north from Cruz Bay (Route 20) you'll skirt a coast with spectacular views. In 1956, philanthropist-conservationist, Laurance Rockefeller purchased the property from the Danish West India Company and donated 5,000 acres to kick-start the **Virgin Islands National Park** (that celebrated its 40th anniversary in 1996) and the 170-acre **Caneel Bay Plantation and Resort** that now occupies the plantation once owned by Dane, Peter Durloe. Known as 'Klein Caneel' (Danish for 'Little Cinnamon'), the estate sheltered survivors of the 1733 rebellion at Coral Bay. The animal-driven mill with vaulted stalls beneath may date to 1780. Other ruins of interest include the chimney of a steam-powered sugar factory, a bell tower with exterior

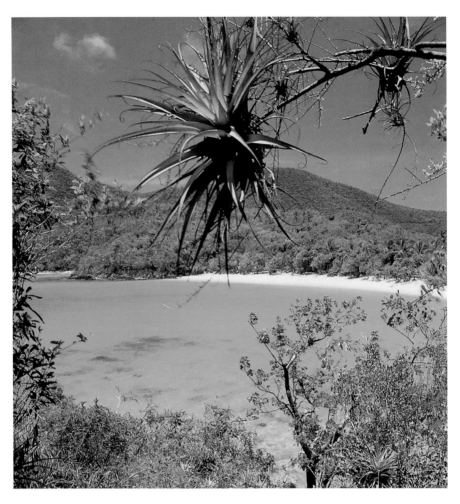

Caneel Bay CHRIS HUXLEY

stairway and an overseer's dwelling. Elegant **Caneel Bay Resort** treats its guests to a choice of seven beaches and three restaurants. Visitors are welcome if they make their presence known before rambling through the property.

Beyond Caneel, one of St John's five remaining wind-driven mills, dating from the late 1700s, can be found on Denis Bay Estate. Lined with seagrapes that dip into the sea, **Hawksnest Bay** is a refuge for honeymooners. To the north of Hawksnest Point, the offshore islands you see are Henley Cay, Ramgoat Cay and Durloe Cays. Past Hawksnest Bay, a towering Christ of the Caribbean statue dedicated to world unity in 1953 by Colonel Julius Wadsworth, was toppled off Peace Hill by Hurricane Marilyn. The ruins on the right approaching Trunk Bay are a sugar factory and animal mill.

Sunrise at Hawksnest Beach, Caneel Bay CHRIS HUXLEY

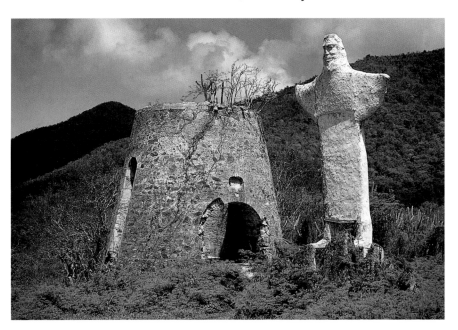

Christ of the Caribbean statue, toppled by Hurricane Marilyn in 1995
CHRIS HUXLEY

**St John's spectacular Trunk Bay takes its name from
the 'trunkback' (leatherback) turtle** CHRIS HUXLEY ▶

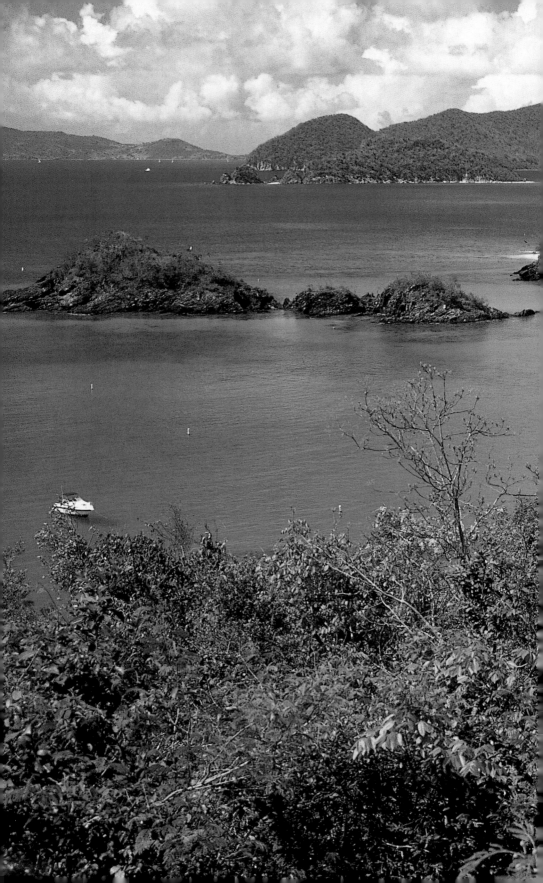

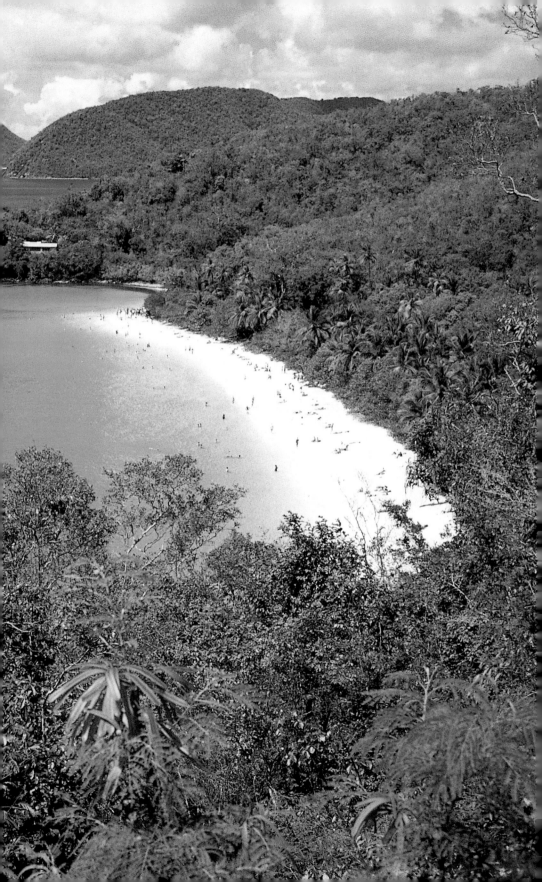

Further up North Shore Road, **Trunk Bay** was named one of the world's '10 most photogenic' beaches by *National Geographic* Magazine. In the middle is tiny Trunk Cay. Both names are derived from the 'trunkback' (leatherback) turtle (see page 86). The Trunk Bay underwater trail is marked with plaques for snorkelers to identify marine life. Directly north is the infamous **Johnson Reef**, which has claimed its share of boats.

Cinnamon Bay and Cinnamon Cay are part of the Park, but Peter Bay is privately-owned. **Cinnamon Bay** has an extensive campground with cottages, tents and baresites. Don't be surprised to spot wild donkeys in search of snacks. Across the road, the **Cinnamon Bay Hiking Trail** begins a self-guided nature tour past the ruins of a sugar factory, an estate house, a horse mill and a Danish cemetery. Follow the road down to **Maho Bay** with its fine beach and eco-minded campground. For a peek into the future, visit adjacent **Harmony Resort** built almost entirely of recycled materials (see page 96).

A favorite anchorage for yachtsmen, **Francis Bay** offers a sheltered beach and seagrass for turtles to pasture in. The short Francis Bay Trail is perfect for scouting pelicans. Best viewed from the water, the roofless stone Customs House on Whistling Cay was once used to clear vessels from neighboring British islands. Local lore says that the shore below **Mary's Point** runs red on the May anniversary of the 24 slaves who leaped to their deaths from the cliffs of Minna Neger Ghut during the 1733 insurrection.

Once the road turns inland, you can follow either fork to the **Annaberg Plantation Ruins**, though the road on the right passes through the remains of **Windberg Estate** and the romantic lichen-covered ruins of **Frederikdal**. Beyond Frederikdal, the road to Annaberg rejoins the other from Maho. Traces of the cobblestone path that once connected the plantations can still be found. Hidden in the bushes, the brick corner and staircases of a school for slave children built in the 1830s is worth searching out. The road that forks to the left ends at the ancient barn of **Estate Mary Point**. Hidden by the flame-colored flamboyant are the ruins of the abandoned estate house.

The right-hand fork leads to the restored **Annaberg Plantation sugar factory** at Leinster Bay. The large animal-driven mill was built prior to 1780, but the wind mill and sugar factory buildings were added later. A National Park Service brochure describes the fascinating cane-processing operation in detail. The slave quarters, molasses and rum vats, storage rooms, and dungeon are still visible, as are the ballast brick, local stone and coral used for construction. Below Annaberg, the track leads to **Leinster Bay Estate**, called 'Water Limon' in Danish

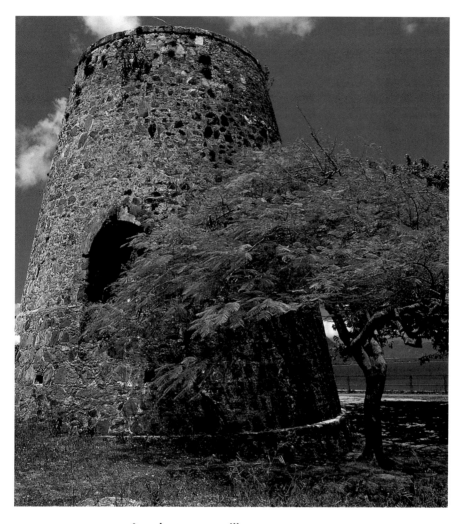

Annaberg sugarmill JAMES 'HUCK' JORDAN

after the local passion fruit. The island on the far corner is Waterlemon Cay, a choice spot for snorkelers seeking starfish. From Annaberg to Centerline Drive you'll need to backtrack to reach **Coral Bay**.

The British Virgin Islands of **Little Thatch** and **Great Thatch** appear on the northern horizon. Both were likely named for the roofing thatch gathered there, though local legend hints at a derivation of Edward Teach (alias Blackbeard) who may have visited while pirating (see page 13).

Centerline Road/North Side

Switching from Centerline Road to Kings Hill Road (Route 10) you'll sight the first Danish West India Company settlement on St John and the magnificent **Coral Bay** below, encompassing Coral Harbor, Round Bay and Hurricane Hole. Derived from the Dutch 'kraal' (corral enclosure), Coral Bay was home to an early Arawak settlement and a primary anchorage during the slavery era.

On the crown of the thorny hill overlooking Coral Bay, the Danes built the 1723 Fredericksvaern stockade (Fort Berg) later fortified in stone with bastions at its corners. More than 100 sugar and cotton plantations sprang up within the next decade, but plans to develop Coral Harbor as a Danish port town vanished with the 1733 revolt, led by the El Mina slave king Juni. Nearby Estate Carolina was the first to be attacked in the uprising that was prompted by a year of drought, two hurricanes, destruction of crops by insects and the threat of widespread famine.

Coral Harbor has been called a modern-day 'Margaritaville' for its eclectic collection of bars, restaurants and businesses that are the very essence of laid-back St John. The casual **Coral Bay Yacht Club** calls it home, as does the Skinny Legs Bar, the Out-A-Hand gallery, Sputnik Bar, The Still eatery, Sea Breeze Cafe and the Shipwreck Landing, host of the St John Music, Arts and Crafts Festival in February.

Looping northeast along Route 10, **Hurricane Hole** is well-respected for its protecting mangroves that provide a haven for boats in a storm. Residents of the settlement of Emmaus ('Amy-us') congregated at the Moravian Church built in 1782 and the 18th century masonry parsonage adjoining it. On the lower road by the shore is a British battery built during the early 1800s.

On the way to East End Point, the cobble beach in **Haulover Bay** is a good snorkeling spot. To avoid the sail upwind around East End Point and Privateer Point, goods were likely 'hauled over' this isthmus by mule to Coral Bay.

Centerline Road scenic drive

From Coral Bay, follow Centerline Road (Route 10) through the mountains that form the backbone of St John. **Bordeaux Mountain** appears to the south, rising to 1,272 feet above sea level. A natural catchment for showers, the lush rain forest abounds with bayberry, whose leaf adds spice to bay rum (see also page 149). From the overlook on Kings Hill Road, Peter Island, Tortola, Cooper Island and Norman Island in the British Virgins are visible. Perched atop Bordeaux

Mountain, **Le Chateau de Bordeaux** offers romantic dining in the rainforest and a remarkable view.

Within the Bordeaux Mountains, roadside markers indicate the entrance to the two-mile **Reef Bay Trail** which can also be reached from Cruz Bay. There are several options for hiking the trail; from Centerline Drive down and back; from Reef Bay to Lameshur to rendezvous with a taxi; or by arrangement with the Park Service to be met by boat at Reef Bay. At one point, the trail drops 800 feet through thick vegetation, then passes ruins sprouting orchids, the mysterious petroglyphs (see page 9) and a freshwater pool. Opinions about the origin of the carvings are divided; some favor Carib Indians, others claim slaves of Ashanti ancestry.

The masonry Greek Revival **Reef Bay Estate Great House** (c. 1844) is the best preserved and perhaps the most beautiful on St John. Listed on the National Register of Historic Places, the last working plantation in St John was stabilized by the Park Service in 1993 with the assistance of the US Navy who landed 200,000 pounds of material by helicopter.

Continuing along Centerline Drive you'll pass the road to the privately-owned Hammer Farm (Cathrineberg) and the stone gateposts of the private Adrian Estate. Manufactured in Scotland in 1854, the triple-boiler steam engine here is the oldest on the island. The **Susannaberg Estate** that lies beyond, was the walled courtyard residence of Neptune Richards. Its upside-down flowerpot-shaped windmill is one of the island's oldest. Just before Cruz Bay, you may want to examine the 18th century **Bethany Moravian Church** and parsonage (see page 43), one of the early outposts of missionary efforts.

Along the South Shore

Continuing south along the coast (Route 107) from Coral Bay toward Ram Head, **Salt Pond Bay** boasts a beautiful beach for off-the-beaten-path adventuring. The one-mile Ram Head trail climbs from Salt Pond Bay through a cactus-studded landscape to Ram Head Point and the salt pond. Meaning 'drowned' in Danish creole, Drunk Bay is rough and rocky, but perfect for beachcombing.

Cabritta Horn (Cabrithorn Point) announces the approach to **Great Lameshur Bay**, home to the **Virgin Islands Ecological Research Station** that studies reefs and tropical ecosystems. **Little Lameshur Bay** has a small beach with picnic tables. Near the shore are ruins of a sugar factory, a bay rum still and overseer's quarters. The trail from Little Lameshur joins the Reef Bay Trail that splits toward the petroglyphs or to the steam-powered sugar mill ruins of the Reef Bay Estate,

which was still producing sugar in 1917. Once a meeting place for pirates, Fish Bay and Rendezvous Bay are secluded. Around Bovocap Point, Chocolate Hole offers a small beach.

Along Route 104, **Great Cruz Bay** is home to the luxurious **Westin Resort**, St John, renovated following Hurricane Marilyn. Nearby is the **Palm Plaza**, a commercial building that opened in mid-1996 that offers a good variety of shops with plenty of parking.

Dog Island, Little St James and Great St James are separated from St John by Pillsbury Sound. **Little St James** was purchased in 1982 by Arch and Di Cummin who built a West Indian style plantation house composed of numerous pavilions with 362 mahogany doors and a helicopter pad. Abundant plantings, deer and sea turtles complete this private vacation paradise.

Letting loose on St John

Like their neighbors in 'Rock City' (St Thomas), St Johnnians enjoy a reprieve from daily work routines and have even been known to break out a collared shirt for a night on the town, though such extremes are rarely required. You would be wise to follow them to **Crash Landing** (above Love City Surf Shop), **Jerry's Club Eclipse**, **Don Carlos Mexican Seafood Cantina**, **The Purple Door** or **Ellington's**. For a quick bite, visit **Cap's Place** for 'World Famous Conch Fritters' or look for the humorous sign with two barracuda dining on 'tourist delight' that marks the **Barracuda Bistro**.

In the heart of Cruz Bay, **Meada's Plaza** features wrought iron railings, lattice fences and a palm-filled courtyard and restaurant. It's home of the popular shop, **Sparky's**. In the hill overlooking Cruz Bay, the St John Lumber Company has been converted into a cluster of shops and restaurants, like the **Lumber Yard Cafe**. **A Taste of Paradise** is a sure bet to stock up on jams, jellies and condiments.

East of town on Centerline Road, the Inn at **Tamarind Court's Courtyard Bar and Grill** usually jumps-up with bands on weekends. A lazy Sunday brunch is a St John tradition so be sure to visit **Grumpy's** in Cruz Bay or check the local newspapers *Tradewinds* and The St John Times, for suggestions.

The last Saturday of every month, the whole island swings into a weekend extravaganza called **St John Saturdays** that appeals to locals and visitors alike looking for arts and crafts, island delicacies, music and fun contests. Enjoy!

13
St Croix: Discovering the Danish jewel

Once the most prosperous of the Danish West Indies colonies, this 84-square-mile 'Danish jewel' displays its wealth in rich architectural detail, picturesque towns with *gades* that invite discovery, and rolling landscapes sprinkled with historic ruins. Situated some 40 miles south of St Thomas and stretching more than 22 miles in length and little more than 6 miles in width, St Croix is the only US Virgin Island to lie entirely within the Caribbean Sea.

St Croix is best explored in sections, concentrating on walking tours of the towns of Christiansted and Frederiksted at either end of the island. Areas outside of 'town' can be toured by car or as part of a guided package. Air-conditioned bus service on Centerline Road between Christiansted and Frederiksted is available.

Since its earliest inhabitants fought off Columbus, St Croix has been plucked at by pirates and smugglers and made a pawn in international games of conquest, yet its natural beauty has continued to cloak its hillsides in dignity. The most fertile of the Danish islands and rival to Barbados as the Caribbean's 'Sugar King', St Croix is content today to sweeten its coffers with a blend of tourism, industry and agriculture.

Buck Island and Protestant Cay

A popular day anchorage for yachtsmen, Buck Island sits six miles off Christiansted and is home to the 850-acre **Buck Island Reef National Monument**. In the 1700s the Dutch named it 'Pocken-Ey' for the lignum vitae that bloomed there. Buck Island's major underwater trails, Turtle Bay and East End Trail, are ideal for casual snorkelers on day charters. Divers may want to take the plunge off St Croix's outer reef in search of shipwrecks, elkhorn coral castles and seemingly endless undersea canyons that are among the world's finest dive destinations (see pages 78, 97).

Moored in the midst of Christiansted Harbor and Gallows Bay, aptly-named **Protestant Cay** (Green Cay) was once reserved for non-

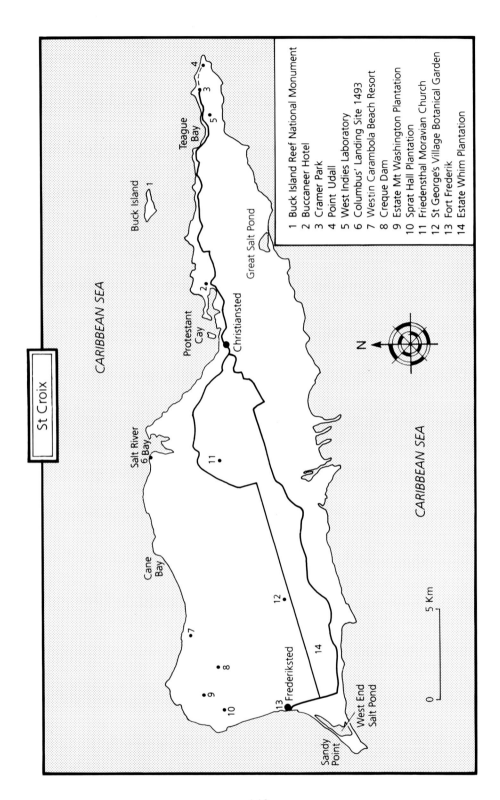

St Croix

CARIBBEAN SEA

Buck Island
1

Teague
Bay
4
3
5

Cane
Bay

Salt River
6 Bay

Protestant
Cay
2

Christiansted

Great Salt Pond

7

8

9

10

11

12

13 Frederiksted

14

Sandy
Point

West End
Salt Pond

CARIBBEAN SEA

N

0 5 Km

1 Buck Island Reef National Monument
2 Buccaneer Hotel
3 Cramer Park
4 Point Udall
5 West Indies Laboratory
6 Columbus' Landing Site 1493
7 Westin Carambola Beach Resort
8 Creque Dam
9 Estate Mt Washington Plantation
10 Sprat Hall Plantation
11 Friedensthal Moravian Church
12 St George's Village Botanical Garden
13 Fort Frederik
14 Estate Whim Plantation

140

Catholic burials. A quick ferry ride from the waterfront, the harbormaster's quarters now house **Hotel on the Cay**. Soak up the salty ambiance just three miles east of Christiansted at **Green Cay Marina**, home of the Galleon House Restaurant and **St Croix Marina**. Yachtsmen anchored in Christiansted Harbor dinghy ashore to the landing here by Club Comanche's windmill.

Christiansted

The capital of the Danish West Indies from 1755–1871, the town of Christiansted lies nestled between a busy harbor and verdant hillsides. The pastel-hued architecture and arcaded shops validate its claim as one of the loveliest in the Caribbean.

Though not as extensive as Charlotte Amalie, shopping in Christiansted has a special appeal. Its boutique merchants specialize in unusual and locally-crafted items and its cubbyholed shopping district is compacted into an area just under one square mile. Be sure to visit those blocks designated as the **National Historic District**, including

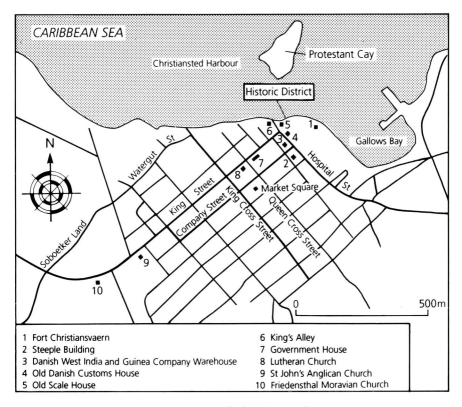

1 Fort Christiansvaern	6 King's Alley
2 Steeple Building	7 Government House
3 Danish West India and Guinea Company Warehouse	8 Lutheran Church
4 Old Danish Customs House	9 St John's Anglican Church
5 Old Scale House	10 Friedensthal Moravian Church

Street map of Christiansted

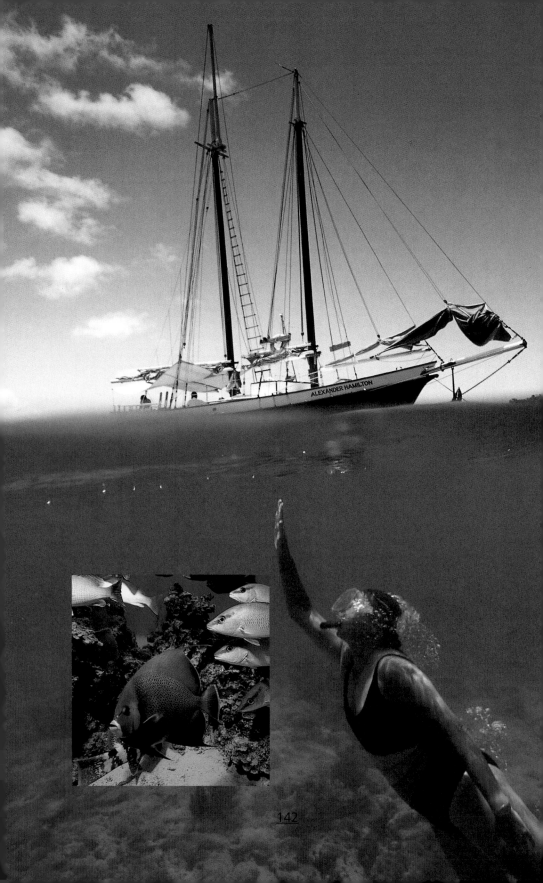

**Yellow Danish brick
gives a mellow feel
to Christiansted's
Fort Christiansvaern**
CHRIS HUXLEY

the six buildings within the 27-acre preservation area administered by the National Park Service, and well as the **St Croix Aquarium and Education Center** in the Caravelle Arcade.

Founded in 1734 at the site of the earlier French settlement of Bassin (basin or port), Christiansted is no ill-planned tangle, but rather a structured grid of streets with lemon-tinted Fort Christiansvaern and the Danish West India and Guinea Company as its focus. Then, as now, the massive structures that were reserved in Europe for palaces and court towns, reflect the Danish determination to prosper.

The best preserved of five Danish forts remaining in the West Indies, **Fort Christiansvaern's** four-pointed citadel is an historic monument and a prime example of 18th century colonial military architecture. Built around a square courtyard, its ramparts contain corner bastions and dank dungeons. Constructed from 1738–1749 of yellow Danish brick carried as ballast on sailing ships, the fort has withstood the test of time as the guardian of the first successful settlement on St Croix. During its centuries of silent service (its cannon have never known combat) it has garrisoned the Danish army, Lutherans, prisoners and been assaulted by hurricanes.

◄ The Virgin Islands' warm, clear waters offer maximum comfort and visibility
CHRIS HUXLEY

Across from the fort, a fine Georgian spire draws the eye to the rectangular design of the **Steeple Building**, built in 1753 by the Danish West India and Guinea Company as the island's first Lutheran Church, the state church of the colony at the time. The Steeple Building was later utilized by the Danish government as a military bakery. Restored to its 1800s appearance, its **National Park Service Museum** now houses Carib and Arawak artifacts (see page 9), a model sugar plantation and architectural exhibits. A third of its original size, the **Danish West India and Guinea Company Warehouse** (US Post Office) across Company Street formed part of a complex that housed both trade goods and employees. Herded into its inner courtyard, human cargo was auctioned at one of the Caribbean's largest slave markets.

St Croix once supplied coffee-lovers in New Orleans with molasses to sweeten their *café creole*, so the New Orleans-bred owner of **Morning Glory Coffee and Tea** in modern-day **Gallows Bay** returned the favor by providing the island's first fresh-roasted coffee beans.

At the corner of Hospital Street, the yellow-brick **Old Danish Customs House** (National Park Service Headquarters) greeted those paying duties to the colonial government with a 'welcoming arms' stairway of 16 brick steps.

Near the center of Wharf Square, the yellow-walled **Old Scale House** (Visitors Bureau) was erected in 1855–1856 to measure taxable goods such as sugar. Constructed of cedar, the roof is well-suited to the tropics. Customs troops once lived in the barracks to the back, now converted to a hotel.

Named for the labor leader, D. Hamilton Jackson, the park across from the parking lot is a pleasant place to relax. The historic **King Christian Hotel** that dominates Christiansted harborfront was once a warehouse. Be sure to stroll along the **King's Alley Walk** near the seaplane ramp which completed the $8 million renovation of the King's Alley Hotel, waterfront shops and restaurants in 1996.

At the intersection of Queen Cross and King Street, **Government House** is a fine specimen of colonial architecture and Danish authority. Made of brick, its 'welcoming arms' stairway narrows to an arch that bears the date 1830 and a Danish crown. Rare tropical trees inhabit the adjoining garden. Once the largest governor's residence in the Lesser Antilles, its two buildings were joined in the 1830s by a common facade. A monumental staircase graces its eastern entry and the second-story ballroom contains reproductions of furniture, a gift from the Danish Government who took the originals with them in 1917. The arched iron gate leads to a maze of European-style gardens. Gutted in a fire, the series of arcaded buildings across from Government House once contained the store where Alexander

Hamilton reportedly worked as a boy. Hamilton was the Nevis-born statesman who appears on the US ten-dollar bill and served as Secretary of the Treasury under George Washington.

The church of the Dutch Reformed congregation, the **Christiansted Lutheran Church** was constructed before 1740. The floor tiles, pulpit and even the gravestones now set into the walls were salvaged from the Steeple Building when it was a place of worship. The Gothic Revival tower is noted for its detailing, while the older sections display elements of Dutch Renaissance architecture.

At the western end of town, the Neo-Gothic **St John's Anglican Church** built in 1849, displays a limestone block construction and intricately-designed roof support system. Tombstones from an early cemetery have been set into the floor. Near the town limit's the 1854 **Friedensthal Moravian Church** is perhaps the oldest of its congregation under the American flag.

Company Street and King Street have several fine specimens of arcaded shops and town houses. **Little Switzerland** has an unusual twin arcade of brick. **Newton House** (Mahogany Inn) has a hanging fire hook by the entrance that was once required of every household with a thatch roof. A block further up Company Street, the solidly-constructed **Apothecary Hall** was an 18th century pharmacy. Another half-block further on Company is **Christian ('Shan') Hendricks Market Square**, the island's largest outdoor market since 1735.

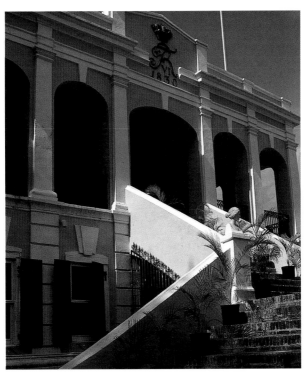

Founded in 1948, the **St Croix Landmark Society** periodically conducts Open House Tours of private residences. If you're lucky, entertainer Victor Borge's fine arcaded town house, Bjerget, located on Bjergegade, may be included. Just outside of Christiansted on Questa Verde Road, the **Hilty House** villa was built on the ruins of a late 18th century rum distillery. Just west of Christiansted on 12 acres of beachfront, the **Cormorant Beach Club** has been dubbed the 'best small hotel' in the US Virgin Islands.

Exploring the East End

From Christiansted's central location, most any point on the island can usually be reached within a half-hour's drive. Heading east from Christiansted onto East End Road (Route 82) you can view the northern seascape as you pass the 350-acre **Buccaneer Hotel** (see also pages 79, 97), St Croix's oldest hostelry with a 300-year-old greathouse built by the Knights of Malta.

The only hotel with boat slips as well as suites, **Tamarind Reef** plays host to yachtsmen at Green Cay Marina. Popular tourist resorts in the area include **Chenay Bay Beach Resort**, known for its watersports, and the **Reef Condominiums** which boast a nine-hole golf course. The castle-like villa in the distance belongs to Romanian-born heiress Contessa Nadia Farbo Navarro.

Teague Bay is an ideal anchorage for boaters visiting the St Croix Yacht Club and an ideal spot for windsurfers and beach-lovers. (See also page 79.) **Duggan's Reef** offers casual dining beachside at Teague Bay. Nearby is the **West Indies Laboratory**, a research station for marine biology and **Villa Madeleine**, a gem of a resort tucked into the hills of Teague Bay, with a contemporary two-story West Indian Great House Restaurant noted for its architecture and fine dining.

At the arid easternmost tip of St Croix – and of any land under the US flag – **Point Udall** can be explored with four-wheel drive. The lowland area below is home to **Cramer Park**, a restive northern shore retreat operated by the Department of Agriculture. In the valley across from Cramer Park, is a 260-ton radio dish that explores the mysteries of the universe. When linked with nine others throughout the US mainland and Hawaii, it creates the world's largest integrated astronomical instrument and its most powerful radio telescope. Funded by the National Science Foundation, the $5 million 'eye to the sky' is linked to the Internet.

Travelling west along the coastal South Shore Road (Route 60), you'll pass the seaside **Grapetree Bay Beach Hotel**. Night-blooming cactus and dry landscapes eventually turn to grassland where tropically-suited

Senapol cattle graze on **Annaly Farm** alongside the ruins of a sugar factory. The property is owned by the Danish West Indian family of former legislator, Frits Lawaetz, the son of Danes who arrived in St Croix in the late 19th century. After preening the Senapol of insects, white cattle egrets may whirl west to the protection of **Great Salt Pond** (Hartmann's Great Pond), a nature reserve for birds that thrive in its complex mangrove ecosystem.

Scenic North Shore

Heading west out of Christiansted, you can take a detour toward the sea to examine **The Pink Fancy** and **Club St Croix Resort** near Sugar Beach and Colony Cove. **The Cormorant Beach Club**, **Hibiscus Beach Hotel** and **St Croix by the Sea** hug the northern coast (Route 751). Hamilton Drive loops toward the **Columbus Landing** site at Salt River (which once divided the island in two), now part of the Salt River Bay National Historical Park and Ecological Preserve (see pages 97, 99). To celebrate the 1993 Quincentennial of the Columbus visit, the US Postal Service issued a series of commemorative stamps.

Minutes from the famous Salt River undersea canyon walls, Anchor Dive Center and America's largest custom multihull manufacturer, Gold Coast Yachts, are located in the mangrove lagoon at **Salt River Marina**. Following the coastal North Shore Road (Route 80) through the former French settlement northwest of Christiansted is **Judith's Fancy**, the former home of the Governor of the Knights of Malta.

Divers may want to head for **Cane Bay** where underwater thrills await on The Wall and the 12,000-foot abyss beyond. Visitors who prefer to stay topside can visit the colorful **No Name Bar and Grill**. Surfers may want to catch a wave off the point of Judith's Fancy. St Croix's highest peak, the 1,165-foot **Mount Eagle** looms behind. Dating to 1650, the greathouse at Cane Garden was used as a Jesuit monastery during the French colonization.

Painted with monster paw prints, the steep (600-foot rise within seven tenths of a mile) **Parasol Hill** (Route 69) on North Shore Road has been known to test auto transmissions as well as bikers competing in the St Croix International Triathlon (see page 81) who have aptly dubbed it 'The Beast'.

Continuing south, the luxurious **Westin Carambola Beach Resort** and **Carambola Golf Club** (see page 79) has a championship Robert Trent Jones golf course that combines scenic vistas with challenging sport in a Caribbean village-like setting. The namesake star-shaped fruit, carambola, is grown here and may well appear on the menu of the Mahogany Room, a favorite Sunday brunch spot on the property.

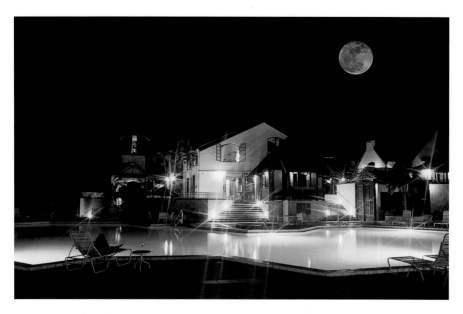

After dark at Westin Carambola Beach Resort CHRIS HUXLEY

The adventurous driver may continue through tunnels of mahogany tree along **Mahogany Road** (Route 76) to reach the lush 15-acre private Rain Forest. Miss Piggy, the beer-swilling swine, is the resident celebrity at the **Mt Pellier Domino Club**. The artisans at **St Croix Life and Environmental Arts Project** create fabulous gifts in mahogany and other local wood. The entrance to mahogany-lined Creque Dam Road is marked by the 150-foot high **Creque Dam**.

Beyond Frederiksted to the north, **Estate Mt Washington Plantation** sells authentic mahogany reproductions of fine furniture. A mile north of Frederiksted, **Sprat Hall Plantation** is the only estate house built by the French still remaining on the island. Built around 1670, it is possibly the oldest country house in the Territory. The 20-acre property also houses guests in cottages and horses in its own stable. Sprat Hall's one-mile stretch of beach is a favorite spot for horseback riding.

Sightseeing on the Central Plains

The flatlands once supported thriving sugar and cotton plantations. The last mill to crush sugarcane closed during the 1960s, but the remains of 150 mills scattered across St Croix are signposts of the wealth and power once vested in this land.

Departing Christiansted by way of King Street, the 1852 **Friedensthal Moravian Church** appears at the outskirts of town on Midland Road. Called 'Cruzana', the 18th century greathouse of Estate Orange Grove has twin staircases that curve upwards to the main entrance. The greathouse is closed to the public, but you may follow the drive as far as the **Alexander Hamilton Monument**. **Estate Peter's Rest** contains the ruins of a public school for children of slaves, a revolutionary concept when introduced by Governor von Scholten (see page 25).

Estate Golden Grove on Centerline Road (Route 70) is home to a 19th century greathouse and the St Croix Campus of the **University of the Virgin Islands**. Near Frederiksted, the drive along Queen Mary Highway (Centerline Road or Route 70) leads to the **St George's Village Botanical Garden** (see page 98). Covering nearly 17 fertile acres cultivated with native plants and shrubbery, the garden provides a perfect setting for the restored ruins of a 19th century rum factory and plantation village, complete with dwellings for workers, a bake oven, stone dam and blacksmith shop. It may be the world's only botanical garden growing out of a pre-Columbian settlement.

Follow your nose along West Airport Road (Route 64) to the **Cruzan Rum Distillery**, home of our famous Virgin Islands Rum, where a guide will brief you on the rum-making process and let you sample the finished product. For history buffs, the seven flags that have flown over St Croix surround a sugarmill ruin on the property.

If locally-brewed beer is more to your liking, the **Santa Cruz Brewery** (housed in the former Brugal Rum Factory behind the Paul E. Joseph Stadium in Frederiksted) became the first local brewery in the

Cruzan rum is a Virgin Islands' treasure
AUSTIN ADVERTISING

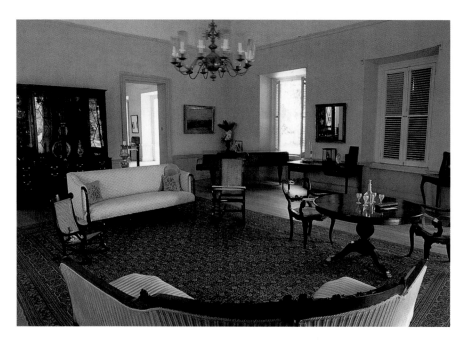

The elegant interior of Whim Greathouse CHRIS HUXLEY

Sugar mills on the Whim Plantation CHRIS HUXLEY

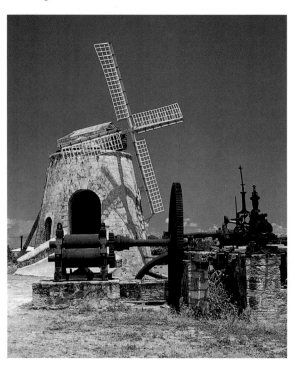

USVI. Begun in 1997 by Spanish entrepreneur Alberto de Comenge, the site features a restaurant, bar, rum museum and gift shop.

Within two miles northwest of Frederiksted, the pillars at the entrance of **Estate Whim Plantation** on Queen Mary Highway lead you to the island's only restored sugar plantation, a sprawling showplace of the era of 'King Sugar', managed by the St Croix Landmark Society. Built in the late 1700s, the three-room Whim Greathouse is noted for its unusual rounded ends, cooling dry moat and three-foot thick masonry walls glued with molasses, which was often mixed with sand and lime as mortar during periods of drought. To experience the full flavor of plantation-era opulence, the interior has been furnished with traditional West Indian furniture and antiques from Europe. The Whim Museum's collection of mahogany masterpieces, many in the style of St Croix master craftsmen, has been reproduced for worldwide sale. Of particular interest is the planter's chair, whose extended arms were used to support weary legs after a long day in the saddle.

A tour of Whim plantation, once owned by Scotsman Christopher MacEvoy, will guide you past a silvery green canefield, surrounded by a mill once driven by animals, a sugar factory complete with rum-processing area and steam mill chimney, a pot still and a working windmill. Village life is easy to imagine as you peer inside servants' quarters, an apothecary and bathhouse. The cook house still turns out

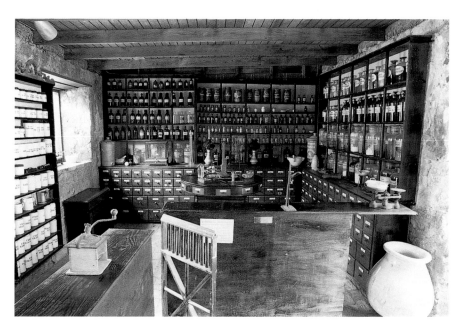

Glimpse a different age in the Whim apothecary CHRIS HUXLEY

traditional johnnycakes (see page 51). To raise funds, the gift shop sells 'counterfeit' Danish West Indies currency, the only currency ever circulated in a territory under the US flag to portray a member of royalty (Danish King Christian IX).

Southwest of Frederiksted, Sandy Point is home to the **West End Salt Pond**, the largest in the Territory, and a protected nesting place for the hawksbill and leatherback turtle (see page 86). Its powdery beach is the longest in the Virgins and the perfect spot to sit at sunset watching for the elusive 'green flash' – an atmospheric phenomena that occurs as the sun sinks below the horizon, sometimes visible from locations on the West End.

Connecting Frederiksted (at the end of Route 70) west to mid-island on a southerly swing, the two-lane divided Melvin H. Evans Highway (Route 66) brushes by the Alexander Hamilton Airport and leads to the southside **Hess Oil Refinery**, the largest in the Western Hemisphere. The container port once serviced the Martin Marietta Alumina plant, used to process Australian and West African bauxite.

Frederiksted

Easily covered in a day, the settlement that early English settlers called West End now welcomes cruise ship passengers who disembark at the Frederiksted docks that jut out into the deep-water harbor. Destroyed in the 1989 Hurricane Hugo and re-opened in 1994, the docks reflect the spirit of survival that dominates this Danish colonial town.

Frederiksted's business district has been rebuilt in wood and masonry splendor on the Danish masonry that survived the fires of the 1878 labor revolt. Decorated with jig-sawed 'carpenter's lace' the symmetric two-story frame houses on Queen Street are typical of the type of reconstruction that gives the town its characteristic Victorian flavor. Surveyed in 1751, its carefully-laid streets lined with sturdy shade trees, arcaded walkways and gingerbread designs reveal its role as a colonial outpost for shipping sugar.

When construction was begun in 1752 on **Fort Frederik** (to dissuade Spanish attacks and curb smuggling of sugar and rum), the town's growth as a port of trade was hampered by competition from Christiansted, but the seaport still known as 'Freedom City' earned its place in history as an ally of the British colonies that became America: Frederiksfort fired the first foreign salute to honor their flag in 1776. The fort's arcaded **Commandant's Quarters** reflect typical 18th century designs. Restored to the red-and-white colors of the mid-

Twilight at Frederiksted dockside CHRIS HUXLEY ▶

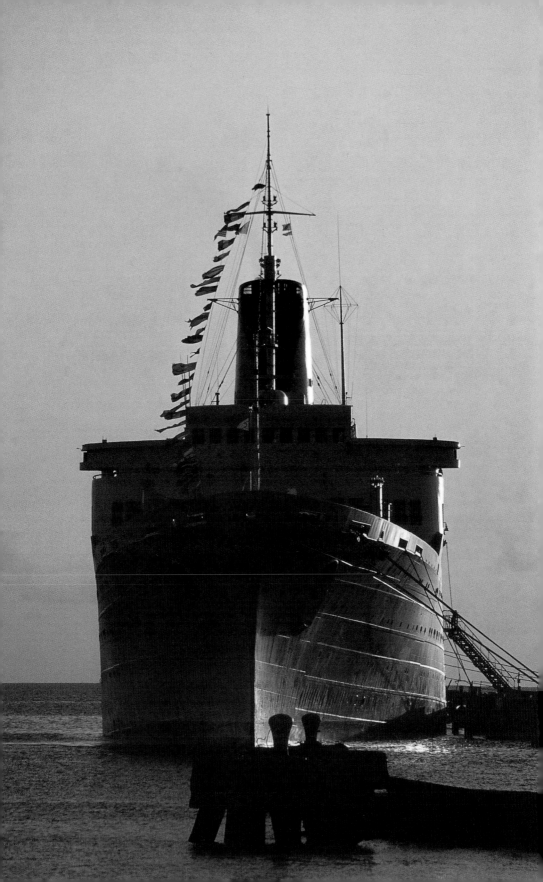

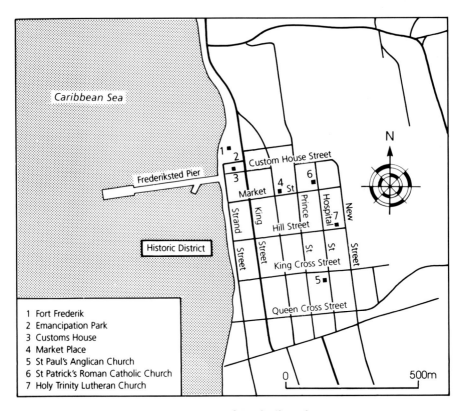

Street map of Frederiksted

1 Fort Frederik
2 Emancipation Park
3 Customs House
4 Market Place
5 St Paul's Anglican Church
6 St Patrick's Roman Catholic Church
7 Holy Trinity Lutheran Church

1800s, the garrison, stables, canteen and courtyard walls vibrate with history. A museum provides a feel for what life was like for soldiers garrisoned at the water's edge.

Nearby Buddhoe Park, sometimes called **Emancipation Park**, honours the slave revolt leader, General Buddhoe, and recalls the 1848 proclamation by Governor Peter von Scholten from the fort's ramparts that freed the slaves of the Danish West Indies, 17 years before their counterparts in the United States. Von Scholten was later court-martialed, but the proclamation that stopped the riots stood.

Protected by the fort's proximity, the 1751 **Customs House** at the head of the pier still displays a trace of the tracks that once carried trade goods through its central portals. Lending character to the waterfront area, Strand Street's block of brick warehouses have breezy arcades that overlook the sea. Nearby, the lavishly gingerbreaded **Victoria House** is a landmark. For a peek at a 19th century interior, visit the upstairs bar at the **Royal Dane Hotel**.

At the corner of Strand and Queen Cross Streets, the center stairwell of the aptly-named **Bell House** was ornamented with bells by its

owner, G.A. Bell. Still utilized as it was in 1751, the **Market Place** lends its name to the block on Torvegade. Considered one of the finest homes in Frederiksted, constructed of brick with a wrought iron balcony and unusual arcade, the **Benjamin House** on Queen Street survived the Fireburn of 1878, started by slaves (see page 22, 36), thanks to the fairness of the judge who lived there.

Built in 1812, **St Paul's Anglican Church** on the corner of Prince Street and King Cross Streets has a main section of plastered masonry in restrained Georgian style. The Greek Revival bell tower was constructed of sandstone. **Tina's Shop** is housed in No. 53 Prince Street, a building with a charming curved stairway and an upper level that is a tribute to the woodworking art called 'carpenter's lace'. The **Old Danish School** in the middle of Prince Street was designed by the Danish architect Hingleberg in the 1830s.

The **St Patrick's Roman Catholic Church** at the corner of Prince and Market Streets is noted for its unusual Gothic Revival-style construction of hand-cut stone blocks with Danish yellow brick used for detailing. For a moment of quiet reflection on the hardships of life in the early West Indies, take notice of the tombstones that fill the walled churchyard. The oldest in Frederiksted, the simple Georgian-styled **Holy Trinity Lutheran Church** on New Street dates to 1791 and features a cupola on the tower and a barrel-vaulted ceiling of wood.

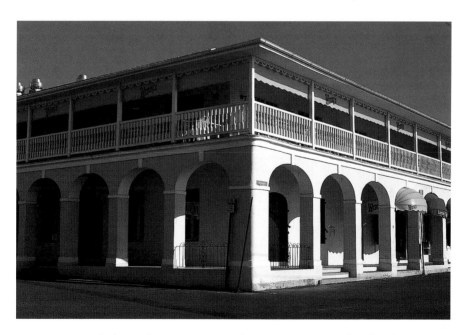

Arcaded warehouses on Strand Street now serve fast food
VIRGIN ISLANDS FILM PROMOTION OFFICE

Dining among the ruins

For a quick bite or candlelight dinner while soaking up some history, try some of the St Croix eateries located in renovated warehouses, greathouses, sugarmills, and romantic courtyards: Kendrick's Le Petit Gourmet, Mango Grove, Tivoli Gardens, Top Hat Restaurant, Tradewinds, Tutto Bene, Paradise Sunset Beach Hotel, Sprat Hall Plantation, Cocktails, and Indies.

For some added salt without the sodium, check-out a restaurant with a harbor view, a casual or elegant seaside setting: Antoine's, Banana Bay Club, Carambola Beach Resort, Chenay Bay Beach, Cormorant Beach Club, Duggan's Reef, The Galleon at Green Cay Marina, Harbormaster Beach Club, Hibiscus Beach Hotel, Royal Palm Steakhouse, Serendipity Inn, Sprat Hall Beach Restaurant, Stixx on the Waterfront, West End Beach Club, Frederiksted Hotel, The Brass Parrot, and the King Christian Hotel.

If you want to sip on a cocktail while waiting for the 'green flash' you might try Cafe du Soleil or No Name Bar and Grille. Visitors searching for off-beat experiences or night-time entertainment might try some time-tested favorites with fun-loving Crucians such as The Wreck Bar (crab races and pet mongoose), Domino Hut Club (beer-guzzling Miss Piggy), Harbormaster Restaurant (broken bottle dancing), Montpellier Club (sipping maubi in the rain forest), Picnic In Paradise (candlelight dinner surrounded by rain forest) and the Aqua-Lounge Club ('decompression hour' cocktails).

I dare you to finish the mud pie at **The Chart House** and do try the shark cakes at **Comanche Club**. **Camille's Café** offers a 'New York deli goes Caribbean picnic' and the **Bombay Club** an island version of 'Cheers goes Caribbean' that's sure to delight. Be sure to sample a *Buba Touee* cocktail (a liqueur made with Virgin Islands Rum, West Indian limes and spices) wherever you can find it.

For a real treat, plan your visit to this Virgin during the December-January **Crucian Christmas Festival** (see page 67) and stay for the **Annual St Croix Blues and Heritage Festival** when the whole island becomes a blues-lover's paradise.

14
Movie magic: The 'flip side' of paradise?

A growing center of film and video production, the US Virgin Islands have long been a cinematic backdrop for producers weaving fantasy tales of romance, history and mystery. Generally, the islands are asked to impersonate other places as scripts demand, but hawk-eyed movie and television buffs may recognize some of the more 'fabulous fakes' that have successfully combined the magic of our islands with the mystery of movie-making. Just for fun, see how many locations you can spot while touring the Virgins. Here's some hints to get you started.

Actor George Correface starred as Christopher Columbus and

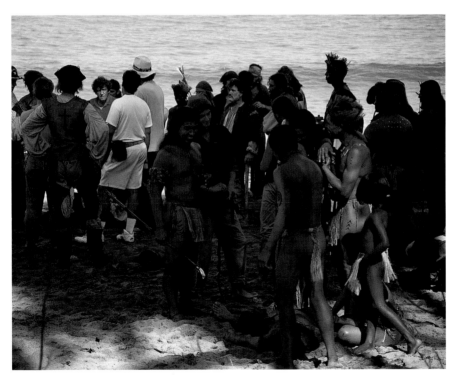

On the set of *Christopher Columbus – The Discovery*
VIRGIN ISLANDS FILM PROMOTION OFFICE

St John's tranquil Trunk Bay sparkled as the navigator's 15th century New World landing site in the 1992 Alexander and Ilya Salkind film production, *Christopher Columbus – The Discovery*, while St Thomas' rocky Santa Maria Bay at the western end of the island hosted the special-effects sinking of the flagship *Santa Maria* and the spectacular burning of the *faux* San Salvador fortress, La Navidad. St John's Hawksnest Beach was the secret home of the feature film *The Four Seasons*, starring Alan Alda and Carol Burnett, who also sailed away together on-screen to Congo and Lovango Cay. St John's Hurricane Hole was the romantic hideaway for *The Big Blue*, starring Rosanna Arquette and Jean-Marc Barr. The sun-drenched cast of *Bare Essentials*, including Gregory Harrison, Mark Linn-Baker, Lisa Hartman and Charlotte Lewis, got back to basics on St John in the 1988 CBS movie.

Davis Bay in St Croix ghoulishly doubled as the jungle setting for *The Island of Dr Moreau*, the Michael York-Burt Lancaster 'genetic-experiments-gone-wild' movie classic adapted from the H.G. Wells novel. St Croix's town of Frederiksted twinned as the Key West base of Mel Fisher's search for *Atocha* sunken treasure in *Dreams of Gold* shot for CBS. Christiansted got a starring role in NBC's *Miami Vice* and ABC's *The Greatest American Hero*. Dan Aykroyd and Eddie Murphy kept busy *Trading Places* in Davis Bay for Paramount Pictures.

Charlotte Amalie harbor has sheltered its share of celebrities, too, from CBS' Captain Stubing and his *Love Boat* passengers to soapy stars of *The Bold and the Beautiful* and ABC's curvaceous *Charlie's Angels*, who cavorted through carnival with stilt-walking mocko jumbies. Fans of the CBS-TV daytime drama, *The Young and the Restless*, may recognize locations on St Thomas and St John used as settings for a ten-segment island production tour. Blasé islanders on St Thomas barely blinked when shopkeepers altered storefronts signs from English to Greek and a pretend Mr and Mrs Aristotle Onassis (actors Roma Downey and Joss Ackland) strolled down Charlotte Amalie's Main Street in the award-winning NBC mini-series, *A Woman Named Jackie*.

Hundreds of St Thomians, including The Rising Stars Youth Steel Orchestra and carnival troupes, appeared as extras in the 1993 'Bernie's back and he's still dead' comedy sequel, *Weekend At Bernie's: Part II*, one of the few features to deliberately identify its USVI location. Shot on St Thomas, the aptly-named feature, *Paradise*, starred a partially-clothed Irene Cara. When Time Life/BBC Productions needed a look-alike for London in the *Voyage of Captain Cooke*, St Thomas' Crown Bay dock was happy to oblige by reproducing a fake fog-shrouded waterfront from another century. Stacy Keach, star of ABC's *Caribe*, chased the bad guys all over St Thomas' Market Square and into Hotel 1829. NBC's *Gavilan* squirmed out of tight spots at Coral

World and the East End Lagoon. Sports fans may recall the *Iron Man* flick, starring Douglas Kennett, shot during the America's Paradise Triathlon in St Thomas.

St Croix's Davis Bay doubled for the mountains of Hawaii in the famous Kenny Rogers commercial for Dole pineapple. Butler Bay is home to several fabulous shipwrecks, including the *Northwind*, a 75-foot tugboat, used in the filming of *Dream of Gold*, that was later scuttled in 50 feet of water to create a spectacular dive site. A prop boat designed to reappear in the Devil's Triangle as part of an elaborate

**Charlotte Amalie played along with the hoax
for the filming of *A Woman Named Jackie***
VIRGIN ISLANDS FILM PROMOTION OFFICE

visual trick in CBS' *Magic of David Copperfield*, took a little longer to disappear. St Croix's Sandy Point Beach – a nesting area for endangered leatherback turtles – was one of several settings in the Virgins for shooting *Saturday Disney*, a three-hour children's program produced by Walt Disney's Buena Vista Productions for broadcast in Europe. Other *Saturday Disney* segments were shot on Atlantis Submarine, at Lindquist Beach, Bolongo Bay, and at St Croix's Hibiscus Beach Hotel. Sandy Point reappeared in the sensational Pepsi Cola 'Innertube' commercial that made its debut during the Super Bowl.

Celebrities are no stranger to the Virgins, whether working on productions, vacationing at plush resorts, or settling into island villas of their own. In 1948, Jane Gottlieb, a star of the Ziegfeld Follies opened a hotel in a former Danish town house in downtown Christiansted, inviting the likes of Noel Coward to frolic in what is now called The Pink Fancy (see page 147). St Thomas' historic Fortuna Mill Estate Greathouse was home to Pulitzer prize-winning playwright John Patrick (*Teahouse of the August Moon*) and served as inspiration for Eleanor Heckert's Caribbean novel *Muscavado*. Former St Thomas resident and author, Herman Wouk's novel *Don't Stop the Carnival* is the perfect introduction to the 'flip side' of paradise and should be on every visitors must-read shortlist.

In more recent times, newlyweds Eddie Murphy and Nicole Mitchell cruised into St Thomas' Crown Bay Marina, a way-station for celebrity-chartered megayachts, which has also played host to Sylvester Stallone, model Jennifer Flavin, singer-actress Barbra Streisand, former CBS anchorman Walter Cronkite, and world-renowned magician John Calvert.

15
We're glad you asked

Air travel arrangements

(Subject to change, so check with your travel agent)
From the United States: American Airlines; Carnival Airlines; Continental Airlines; Delta Airlines; Prestige Airways; US Air.
From the Caribbean: Air St Thomas; American Eagle; Bohlke International Airways (Medical Evac); Leeward Island Air Transport (LIAT); Seaborne Aviation Incorporated.

Communications

The Territory has numerous radio stations, a CBS-affiliate TV station, a local PBS TV station, cable TV and some satellite TV and wireless providers. There are several movie theaters. *The Virgin Islands Daily News* is published daily, except Sunday. Other local newspapers include *Tradewinds* (St John), the *St John Times*, *St Croix Avis* and the *Virgin Islands Business Journal*. Several US mainland newspapers and some foreign publications are flown in daily.

Cruise ships

Major cruise lines operate year-round Caribbean cruises from Miami and San Juan (Puerto Rico) to St Croix, St John and St Thomas. St Thomas's Charlotte Amalie is the world's most visited cruise ship port of call. There are also less frequent calls by cruise ships from the West Coast of the United States.

Currency

The US dollar is official currency. Major credit cards are widely accepted. Major banks operate during regular banking hours and have branches throughout the islands. Most have automatic teller machines.

Customs

The US Virgin Islands are regarded as the 'duty-free shopping mecca of the Caribbean' where each US visitor is allowed a duty-free quota of $1,200 every 30 days – double that of other Caribbean islands. Members of a family may make a joint declaration. If you exceed your exemption, the next $1,000 is dutiable at a flat rate of five percent (rather than the standard 10 percent). Purchases following by mail can be included in your exemption. For information, contact 1–800–6–NO-DUTY or http://www.dutyfree.com/.

Baggage and travelers departing from the US Virgin Islands to the US mainland are subject to inspections by US Customs. You may be required to provide proof of purchase.

US residents over 21 are allowed six 750 ml bottles of duty free liquor (one must be produced in the USVI), plus five cartons of cigarettes and 100 cigars. Island-made products (perfume, fashions, straw products, jewelry), original art and loose unset gems are duty-free. Plants in soil and most fruits cannot be removed to the US mainland.

Driving

Driving is on the left. A valid US drivers license or foreign license is accepted. Speed limits are posted, but lower than stateside. Seat belts are required by law.

Electricity

Current is standard US 100v/60 cycle. American appliances do not require adapters. Local current is subject to short-term periodic outages so substitute battery-operated appliances when possible.

Holidays

(Unless indicated, dates may vary.) All US Federal holidays are observed. USVI enjoys numerous local holidays as well. The VI Government offices close for all holidays, banks close for most. Shops remain open except for major holidays.

January	1	New Year's Day (Global)
	6	Three King's Day (VI)
		Martin Luther King Day (US Federal)

February		Presidents' Day (US Federal)
March		Transfer Day (VI)
		Holy Thursday (VI)
April		Good Friday
		Easter Sunday
		Easter Monday (Traditional)
		St Thomas Carnival
May		Mother's Day (Traditional)
		Memorial Day (US Federal)
June		Flag Day
		Father's Day (Traditional)
		Organic Act Day (VI)
July	3	Emancipation Day (VI)
		St John Carnival/Festival
	4	Independence Day (US Federal)
		Hurricane Supplication Day (VI)
September		Labor Day (US Federal)
October		Columbus Day (US Federal)
		Virgin Islands–Puerto Rico Friendship Day (VI)
		Hurricane Thanksgiving Day (VI)
November		Liberty Day or D. Hamilton Jackson Day (VI)
		Election Day (VI)
		Veterans' Day (US Federal)
		Thanksgiving Day (US Federal)
December		Crucian Christmas Festival (VI)
	25	Christmas Day (US Federal)
	25	Kwanzaa (Traditional)
	26	Christmas 2nd Day or Boxing Day (VI)
	31	Old Year's Night or New Year's Eve (Global)

Passport requirements

On arrival, US citizens don't need a passport, but everyone needs appropriate proof of identity at departure, either a voter registration card, birth certificate or passport.

Postal and courier services

The US Virgin Islands are part of the US Postal Service. There are several US Post Offices and independent mail services on each island. Federal Express, United Parcel Service, Sprint and other major courier services maintain offices.

Taxes

There is no local sales tax, but a room tax (8 percent) is applied to hotel room rates. Airport fees are included in the ticket price, as are departure fees for local ferries.

Taxis

Taxis are not metered, but the official tariff is displayed in the vehicle by law. Always determine the fare beforehand, especially if traveling with a number of people, late at night, or with luggage. Group tour rates are negotiable.

Telecommunications

Local calls from coin-operated phones are 25 cents for the first five minutes. Prepaid debit cards may be purchased at post offices and retail stores. Direct dialing is available to most places in the world. Visitors with cellular phones may dial 6611 for roaming information. AT&T maintains a telecommunications center in Havensight, St Thomas, that is equipped with calling booths, fax, copy services, video phone and TDD (hearing impaired) equipment. The new area code 340 replaces the old 809 effective June 30, 1998.

Time zone

Atlantic Standard Time year-round, one hour ahead of Eastern Standard, same as Eastern Daylight Savings.

Tourism information

To contact the USVI Department of Tourism, call 1–800–372-USVI. A representative will be happy to answer any questions and provide island-specific information. The USVI world-wide web site links

CHRIS HUXLEY ▶

to shopping news, community events – even our own US Virgin Islands America's Cup Challenge site.The address is:hhtp:/www.usvi.net.

For your convenience, the USVI also maintains tourism offices in the following US cities and foreign countries:

Atlanta, GA (404) 688–0906
Chicago, IL (312) 670–8784
Los Angeles, CA (213) 739–0138
Miami, FL (305) 442–7200
New York City, NY (212) 332–2222
Washington DC, (202) 624–3590
San Juan, Puerto Rico (787) 724–3816

St Croix (340) 773–0495
St John (340) 776–6450
St Thomas (340) 774–8784
Canada (416) 233–1414
Denmark 86–181933
England 171–978–5262
Italy 2–33105841

Water

Average annual rainfall is 50 inches, with no particular rainy season, though May, September and October are generally less dry than winter months. Wells are scarce, so residents collect rainwater from rooftop cisterns. In some areas, salt water distillation plants supplement the supply. Most major hotels have water plants, but water is still considered precious and conserved everywhere.